THE ART OF
IAN MILLER

For Jenny and Dan

Immense thanks to Alison Eldred and everyone at Titan Books.

THE ART OF IAN MILLER
ISBN: 9781781167793

Published by
Titan Books
A division of Titan Publishing Group Ltd.
144 Southwark St.
London
SE1 0UP

First edition: March 2014
10 9 8 7 6 5 4 3 2 1

What did you think of this book?
We love to hear from our readers. Please email us at:
readerfeedback@titanemail.com,
or write to us at the above address.

To receive advance information, news, competitions,
and exclusive offers online, please sign up for the
Titan newsletter on our website: www.titanbooks.com

A CIP catalogue record for this title is available from the British Library.

Printed and bound in China.

The following images appear in this volume with permission:

Page 14 Dragon, page 42 (bottom two images) page 43 (top) Ent Assault, page 96 The Hornberg – *A Tolkien Bestiary*, Octopus Publishing Group.

Page 15 Three Dragons, pages 54-55, & page 92, bottom image, Castle Scape – *Eragon's Guide to Alagaesia*, Templar Publishing.

Pages 102-3 Backgrounds Scorch, page 112 Backgrounds – *Wizards*, Ralph Bakshi Productions.

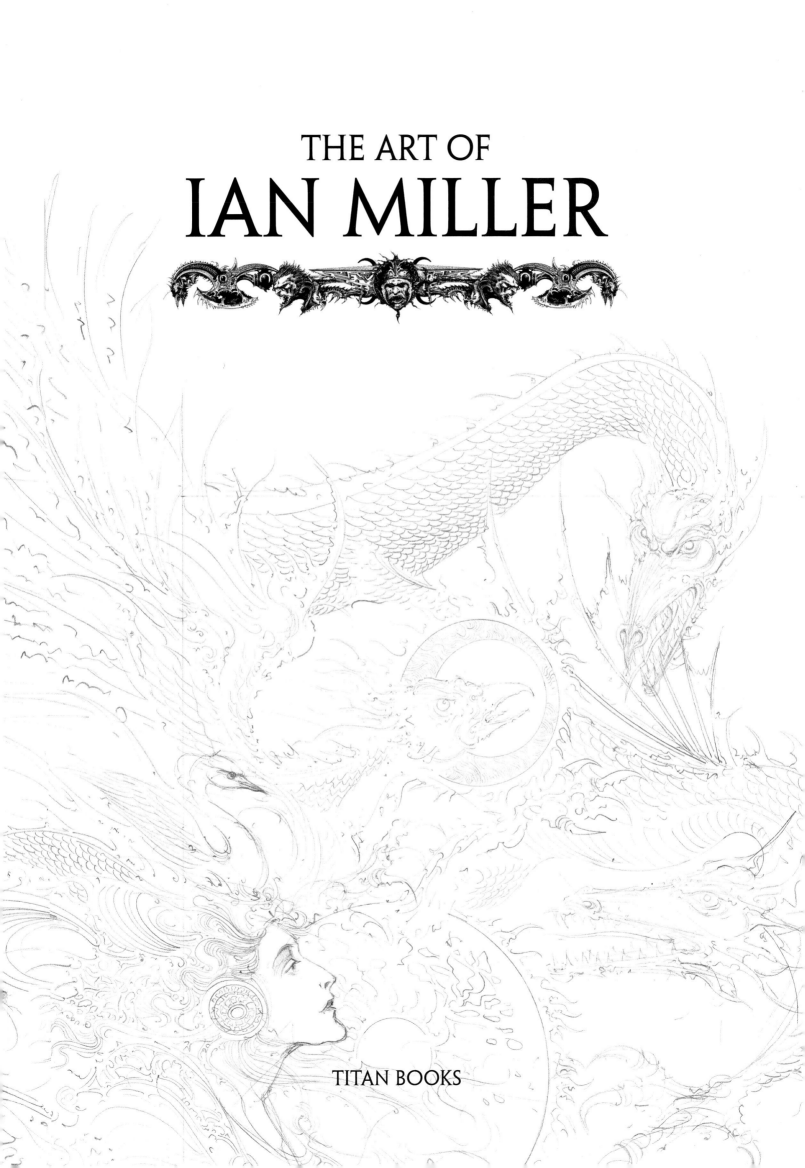

THE ART OF
IAN MILLER

TITAN BOOKS

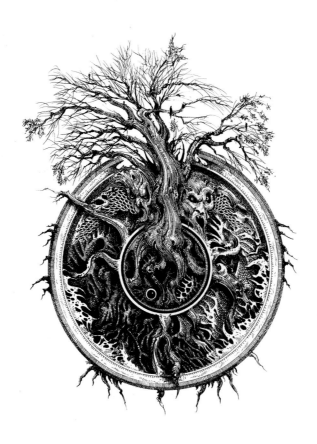

INTRODUCTION
BY BRIAN SIBLEY

Flying fish, walking trees, floating cities and mechanical warriors: these are among the creatures and worlds of Ian Miller's unconventional imagination. A good illustrator may capture the essence and detail of an author's work, transforming word into image, but a truly great illustrator transports us into the silences between sentences, evokes the possibilities between paragraphs, illuminates the shadows that lurk in the turning of a page.

This volume celebrates the staggering craft of just such an artist. Produced for books, games, films, or simply for his own amusement, Ian Miller conjures visceral hallucinations from that disturbing limbo between waking dream and living nightmare.

I first became aware of Ian's work over thirty years ago when he illustrated a new edition of Ray Bradbury's sci-fi masterwork, *The Martian Chronicles*, and I wondered at his forbidding array of rockets, spacemen and alien landscapes. A decade later I was marvelling at his Wizards, Dwarves, Orcs and rococo-armoured dragons in *A Tolkien Bestiary*. On the far-flung corners of ancient maps it used to say: 'Here there be dragons' and this collection boasts a veritable blaze of these magnificent creatures erupting in torrents of fire.

Having once identified the Miller line, I kept encountering his artwork on book cover after book cover: more Bradbury volumes along with works by H P Lovecraft, Philip K Dick, William Hope Hodgson and Frank Herbert. I not only liked his work, I really liked the fact we seemed to share a taste in the fantastic, the gothic, and the grotesque. Later, I would discover his *Green Dog Trumpet and Other Stories* and realised that he didn't just visualise the phobias and neuroses of others, but was more than capable of envisaging and fashioning surreal worlds of his own.

With so much in common, it was perhaps inevitable that our paths would, eventually, cross and that we would become friends. It was friendship that subsequently led us into collaboration when Ian illustrated a series of beastly fables I had written in a bitter, somewhat cynical perversion of Aesop. Alas we found no publisher brave (or foolish) enough to take on the project, so it is small wonder, having failed to get our names into a book together, that I jumped at the opportunity of introducing this collection of his drawings.

In creating his realms, he juggles the rigidity of geometry – ruled and compassed lines, protractor angles, floating spheres and voids – with a maelstrom of swirling elemental forces in which water foams, fire blisters, air thickens and earth burgeons with terrifying life-forms.

The Miller trees – and there are many of them – are the spawn of centuries of ancient woodlands: from the dryads of Greek mythology and the tree-imprisoned suicides on the Seventh Circle of Dante's Inferno, via the anthropomorphic fairy-tale forests of Arthur Rackham and Walt Disney to the ancient race of Ents in J R R Tolkien's *The Lord of the Rings*.

In one illustration, the mighty Treebeard leads his army against Isengard and Saruman's impregnable stronghold, the Tower of Orthanc and there are numerous other cityscapes in the pages that follow. Impressive, and sometimes improbable,

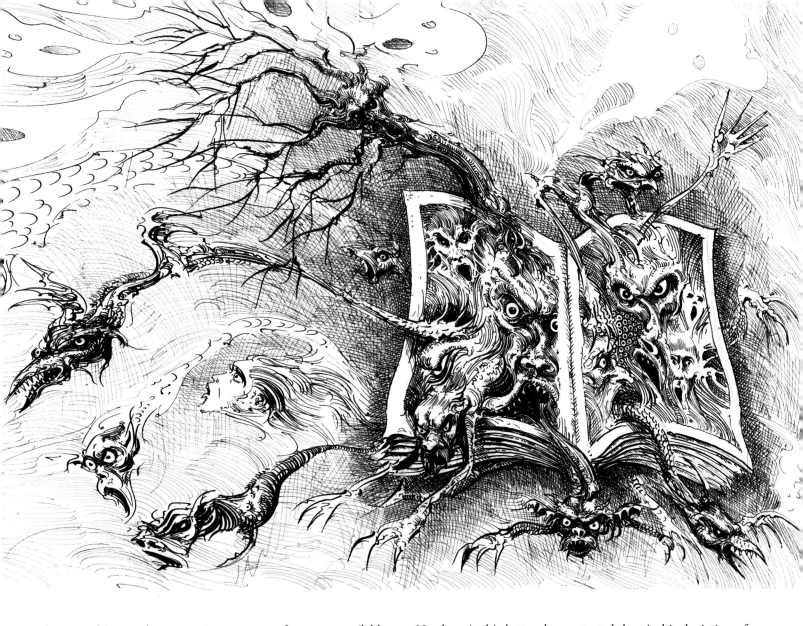

these architectural masterpieces range from unassailable monoliths of stone that loom out of mists to ramshackle edifices, leaning this way and that, that totter on the brink of collapse or – suddenly freeing themselves of the restraints of gravity – take flight. Repeatedly, wood splinters, stone cracks, metal rusts and corrodes and finally sinks in a rising tide of mould, mildew and fibrous growths.

Without doubt (and I say that because, once more, a Miller obsession perfectly chimes with one of my own) his greatest constructions are his frequent imaginings of the endless, dust-enshrouded realm of Mervyn Peake's *Gormenghast* with its towering piles of masonry and its centuries-added accretions of battlements, buttresses and balustrades protecting the ancient kingdom of arcane, blindly-observed ritual from unwanted incursions of change and revolution.

Upheaval and rebellion, however, are ever-present concepts in many of the pictures in this book. The clashes and conflicts depicted may be intimate or vast: animal and plant-life colliding with brutish machineries or armies of robots, men or mutants marching into ruinous onslaughts. And again and again, we find imagery that conveys an overwhelming sense of death, destruction and sickening decay.

Miller's palette when he infuses his stark black-and-white environments with colour is uncompromisingly primal: the blue of steel, the yellow of fire, the purple of bruising, the grey of corpse-flesh, the red of fresh-spilt blood and, most disturbing of all, the livid green of bile and spew.

Nowhere is this better demonstrated than in his depiction of Cthulhu, the monstrous creature given life by H P Lovecraft. 'If I say,' wrote the master of horror, 'that my somewhat extravagant imagination yielded simultaneous pictures of an octopus, a dragon, and a human caricature, I shall not be unfaithful to the spirit of the thing. A pulpy, tentacled head surmounted a grotesque and scaly body with rudimentary wings; but it was the general outline of the whole which made it most shockingly frightful.' Turn to pages 48-49 to see the Miller portrayal of this monstrosity in its full hideousness: its 'gelatinous green immensity' depicted as a conglomeration of feelers, claws, teeth and wings in the midst of a seething mass of unspeakable beings whose red eyes glare and scowl from a swamp of verdigris.

In Miller's worlds, people and creatures alike invariably engage with us eyeball-to-eyeball, staring out of the ink and paint with expressions of hatred, revenge and loathing or gazing blankly back at us with resigned expressions of fear and despair; their lives are both absurd and tragic.

Their creator is a true child of Dürer, Doré, and all the great masters of crosshatched illustration, and an heir to the grotesque heritage of Brueghel and Bosch. But Ian Miller is an artist and illustrator of unique vision and striking originality, who sees with the alien eye of the misfit and the outsider. He possesses an unnerving talent for disturbing our mundane surroundings with haunting glimpses of weird and wondrous places and beings from somewhere just beyond the edges of our fragile human comprehension.

MAELSTROM

In Edgar Allan Poe's story, *A Descent into the Maelstrom*, a whirlpool of deadly terror "such as never happened before to mortal man", everything is sucked into the abyss. Ships, trees and fish all disappear into the whirlpool vortex. As part of a broader multimedia project, I was asked to supply artwork that would show alongside a film documentary and an Irish weaver's woven interpretations of the Moskstraumen, the Norwegian whirlpool from which Poe drew his inspiration. This provided a wonderful opportunity to combine organic and mechanical elements in an extended meditation on the power of the sea.

I wanted to react to the story of the *Maelstrom* rather than tell it. To develop an emotive response that would pull me into the project I began by turning the text of the story into a visual tool. First I made strikes on the page which underlined certain words in a process designed to get both my body and mind working as one. Then I used the text itself to make images with. I cut out lines of text and re-arranged them in patterns – enabling me to make new connections and to see new structures. All this freed me from the structure of the story and enabled me to react with a strong emotive response.

I originally intended to create eight inter-relating panels and had completed four of them by the time the project was pulled due to financial constraints elsewhere.

A few years ago we held a show in the Shetlands to display all three interpretations of the maelstrom theme.

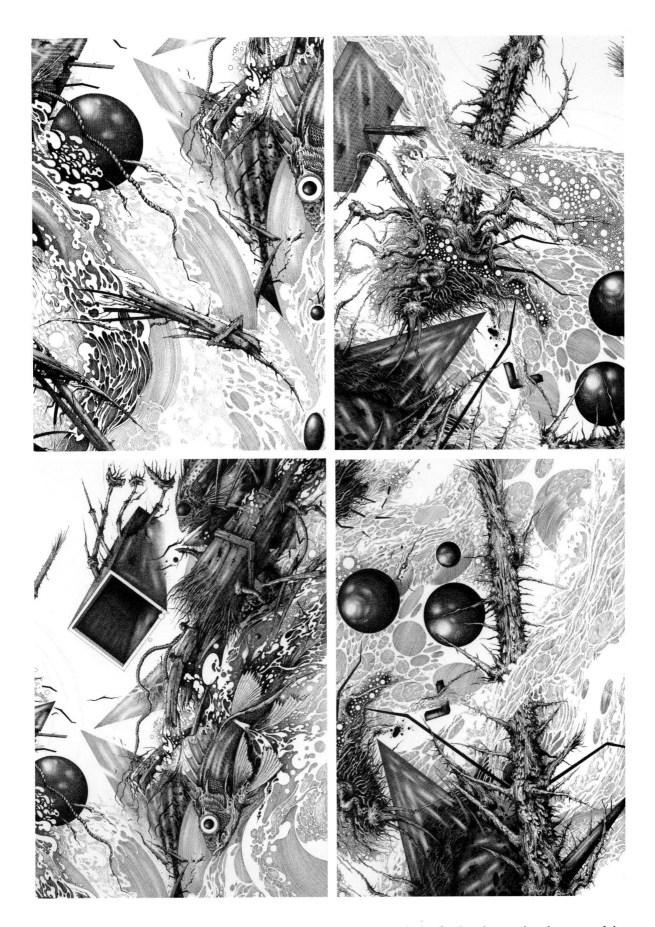

This chapter consists of the four panels and several blown up details from them, juxtaposed in what I hope is a visually pleasing and informative way.

I very much enjoy pulling details from the larger panels and rearranging them in new configurations. Images accidentally reversed also offer new and interesting possibilities, all of course very much in keeping with the fluid and convoluted nature of the subject matter.

The maelstrom by its nature is chaotic/anarchic even, and these qualities are highly seductive for the image maker, because they allow for all manner of interpretations. Accidental reversals seemed especially fitting here, lost as it were inside the maelstrom.

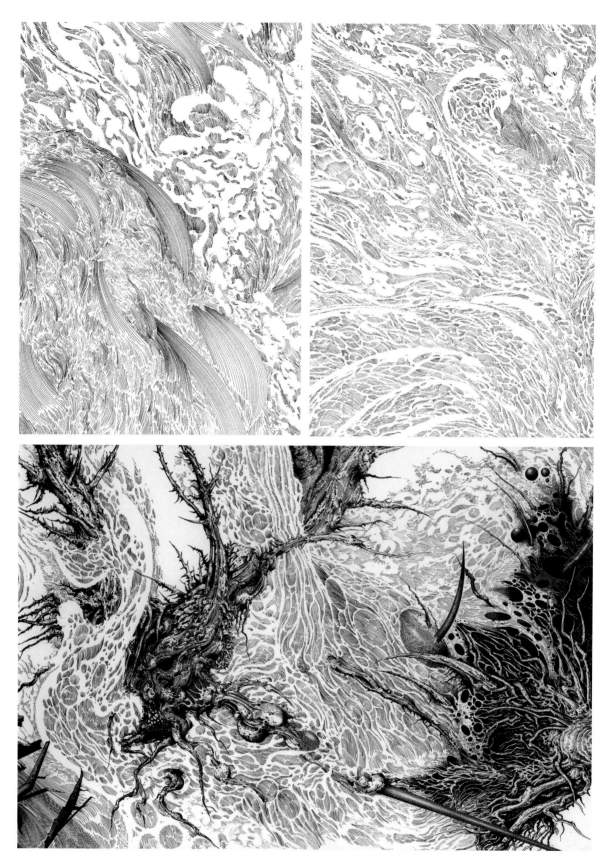

I often think of the sea as a powerful animal or beast because of the way it claws and paws at the shoreline. Everytime I capsize a sailing dinghy, I think the sea is going to swallow me down. I nearly drowned as a child, in the deep end of the swimming pool. I dived in so well everybody thought I could swim. I'd seen Jane Russell dive in the film *Sea Hunt* and mimicked it, almost fatally. The images above and on the opposite page (details from the larger panels) show my attempts to describe the directional and fluid forces at work in the whirlpool and the impact they have on solid objects caught in their thrall.

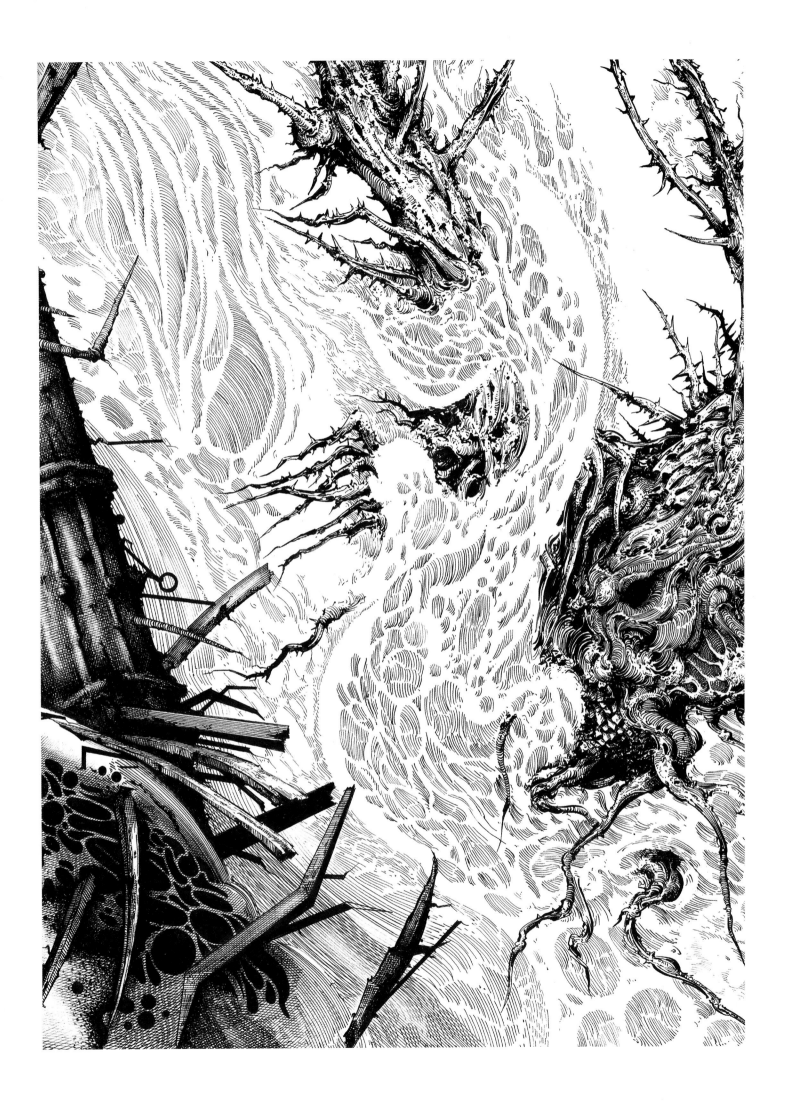

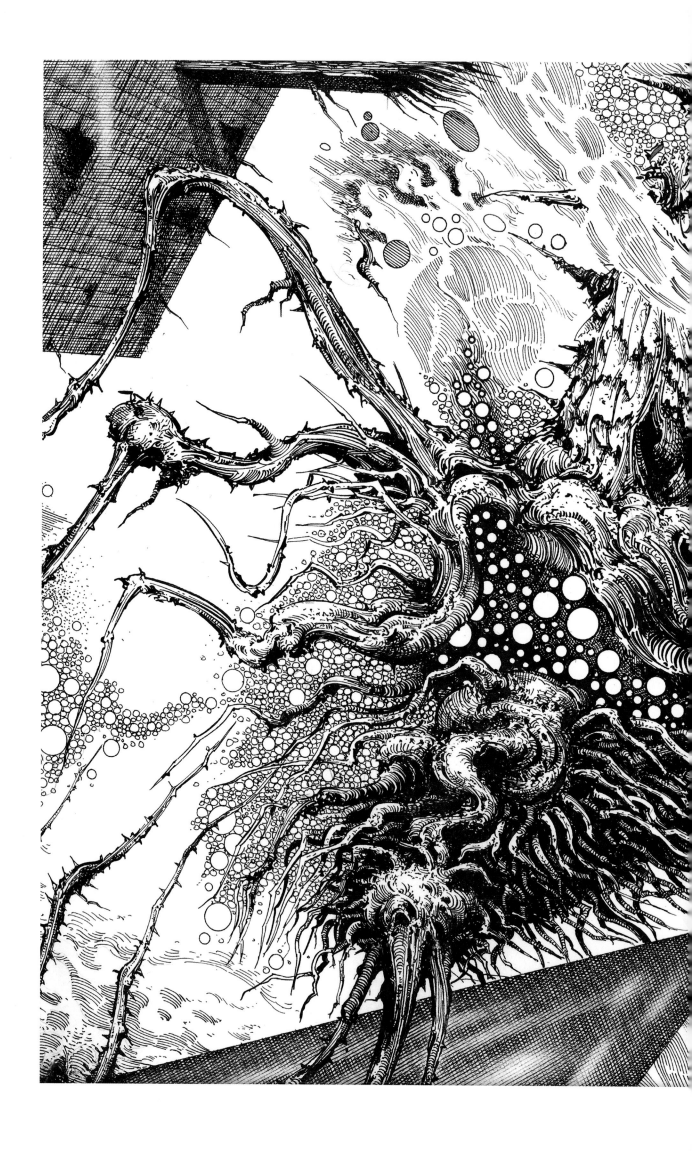

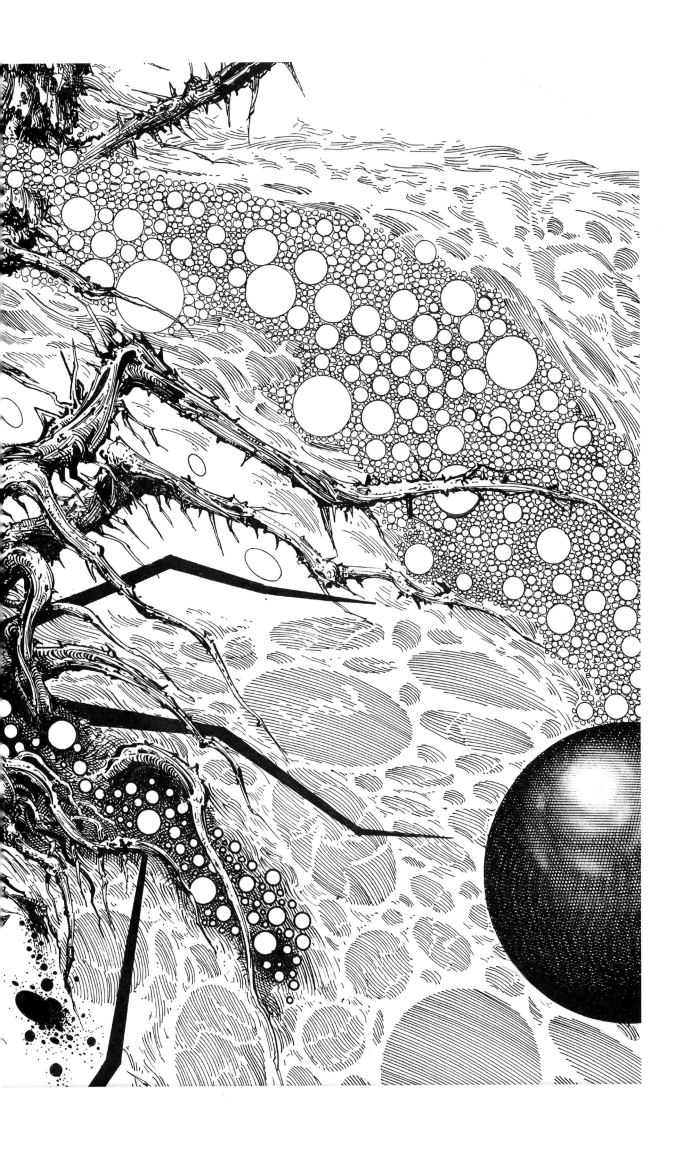

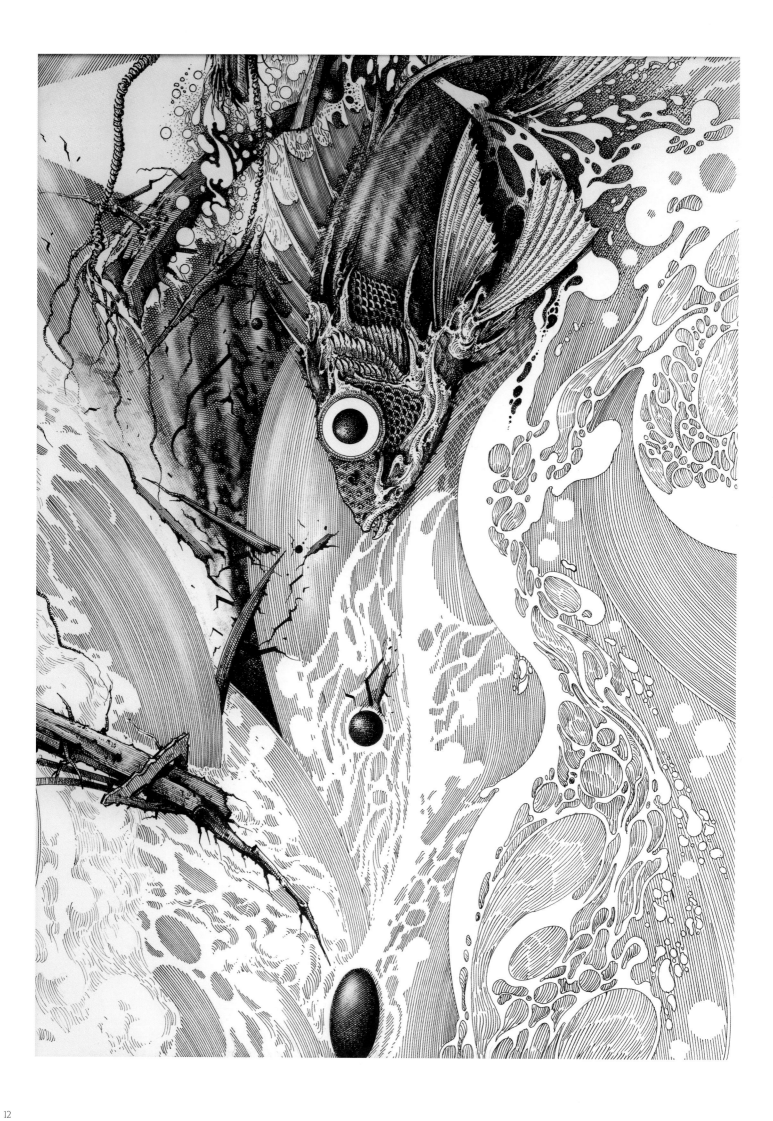

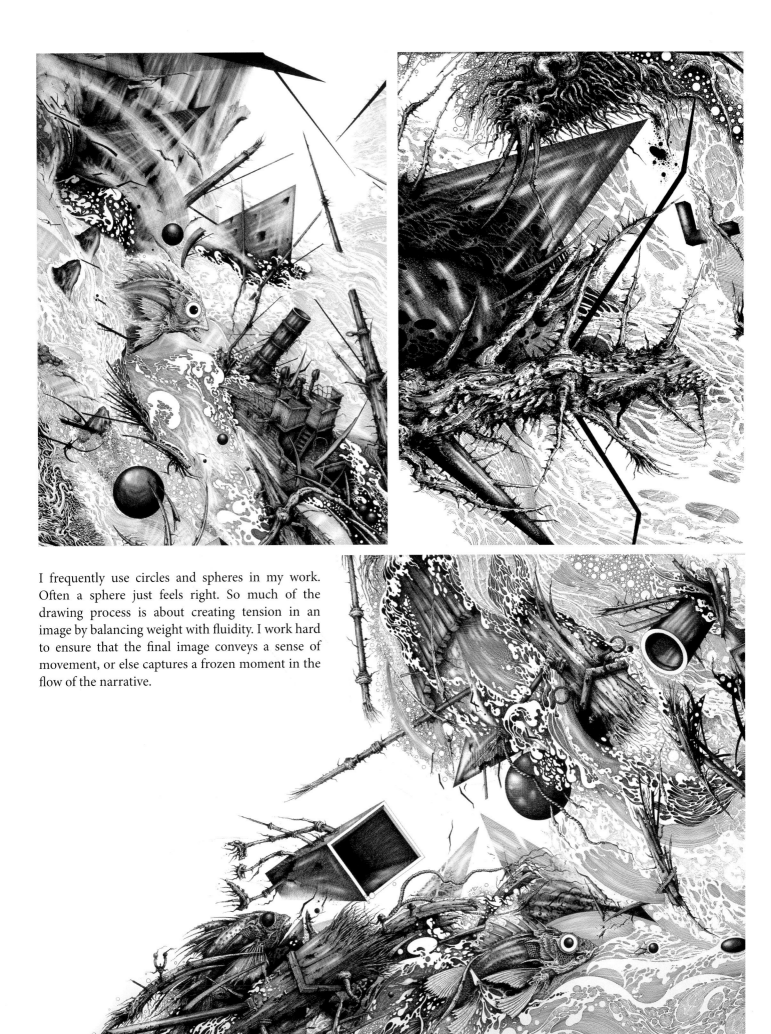

I frequently use circles and spheres in my work. Often a sphere just feels right. So much of the drawing process is about creating tension in an image by balancing weight with fluidity. I work hard to ensure that the final image conveys a sense of movement, or else captures a frozen moment in the flow of the narrative.

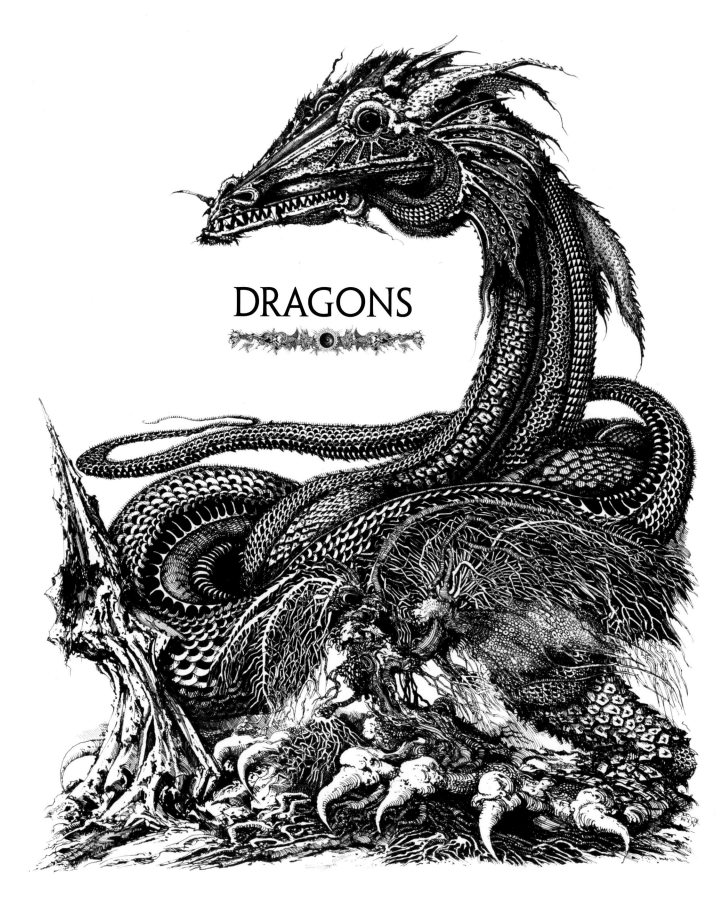

DRAGONS

I remain very fond of Alfred Bestall's Ming the Dragon in *Rupert Bear* and discovered Tolkien whilst I was studying at St Martin's in the late 60's. These formative encounters are how I found myself caught up in the genre that led to *Tolkien Bestiary*. The fiction that captured my early imagination in turn made my first dragons great to draw – I had particular long-snouted dragons embedded in my psyche.

Every image I draw is a struggle but dragons are always fun to do. Because they are fantasy creatures you can do pretty much anything you like with them, all things are possible. Drake, worm or dragon, whatever you choose to call them, they are a pattern-maker's dream. For me, they are the perfect visual coat hanger; though I suppose hanging is more the preserve of bats than dragons.

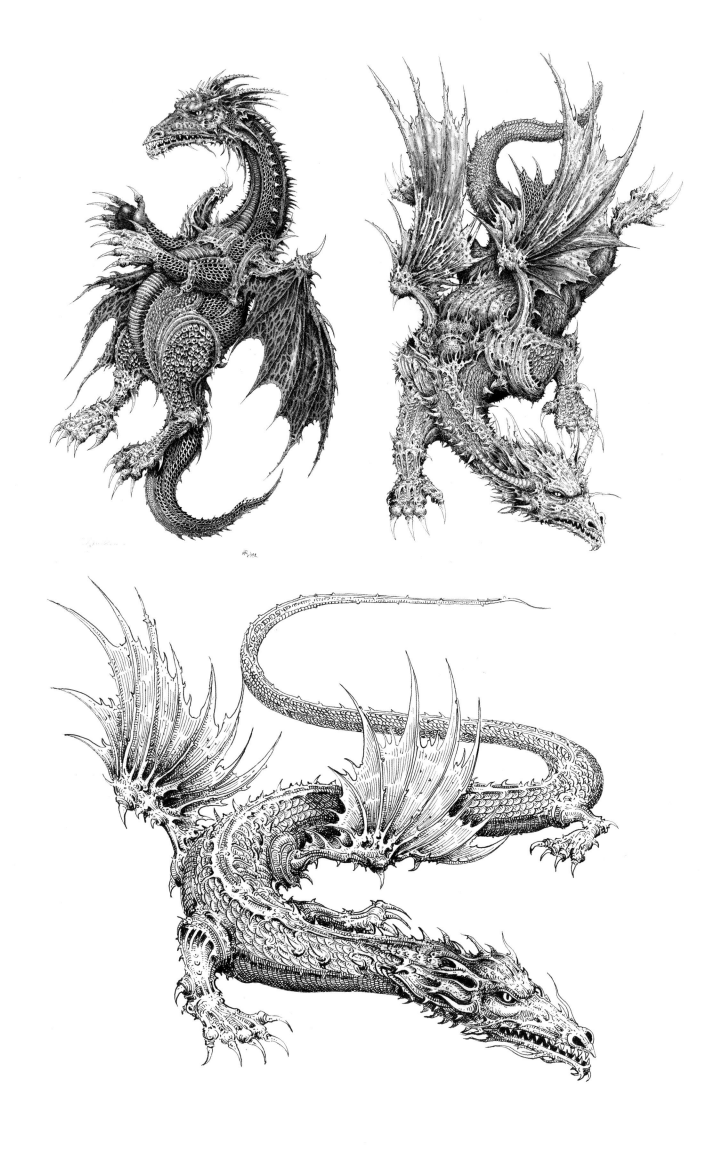

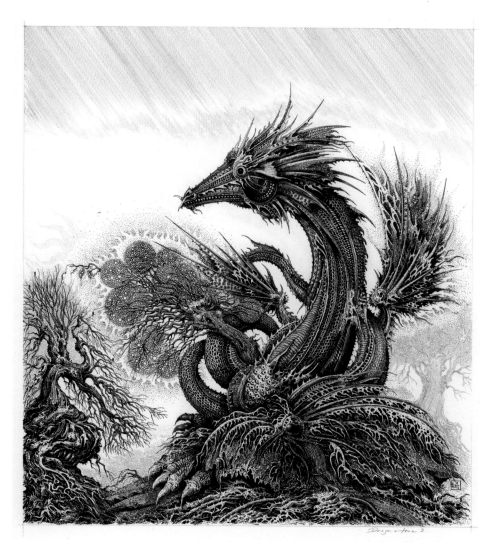

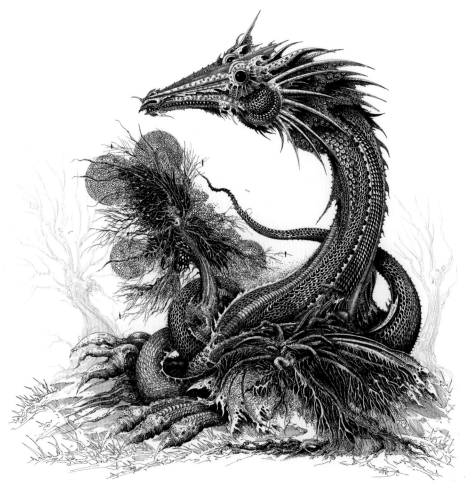

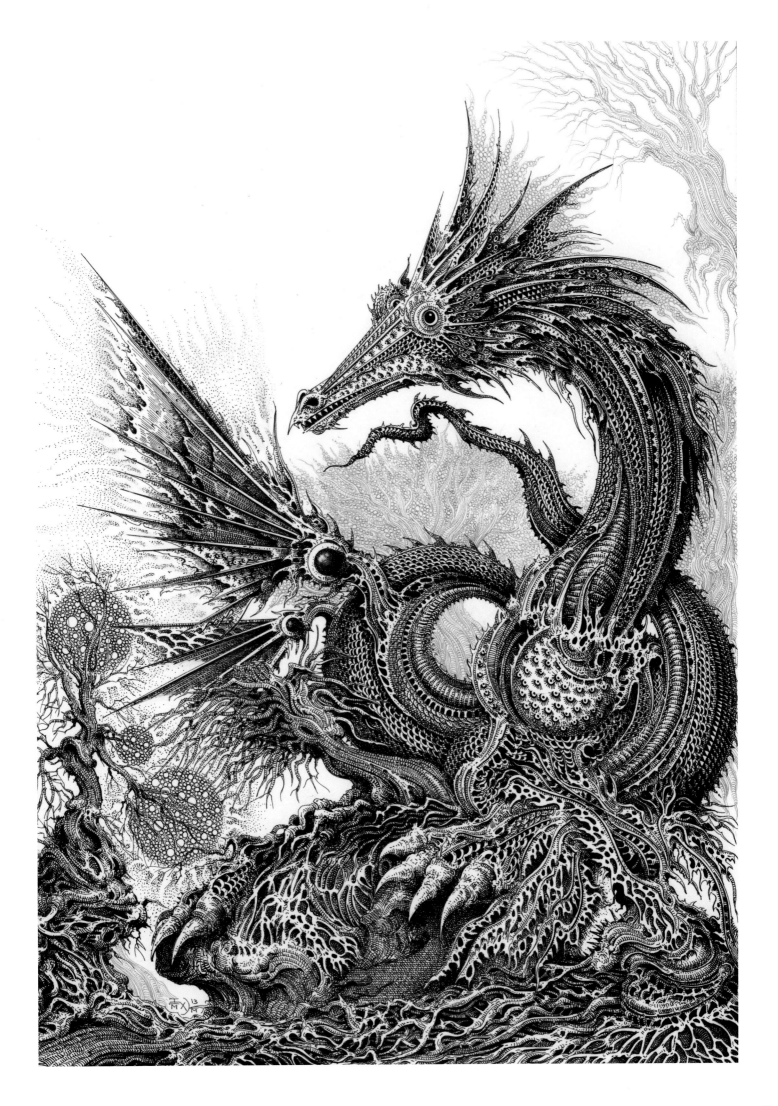

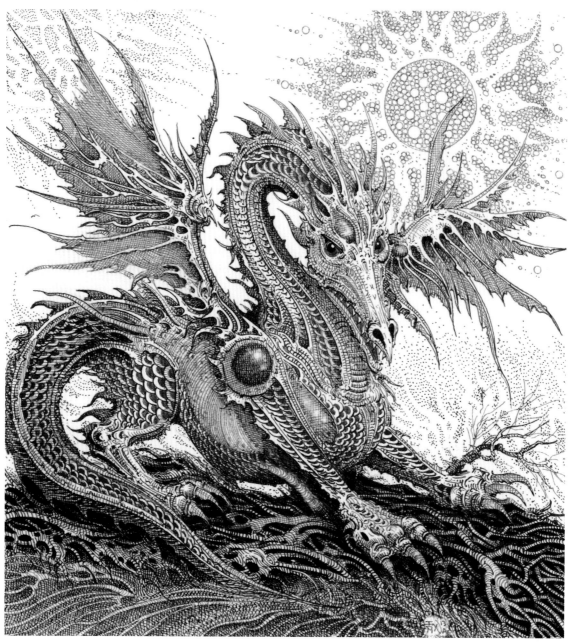

I drew these recent re-workings of the *Bestiary* dragon (a book illustrating Tolkien's *Lord of the Rings* creatures) for people who want a dragon of their own. Private work often feels very liberating because there are fewer creative constraints. When commissioned to illustrate a graphic novel, for example, the need to create an image that works alongside the text might prove restrictive. But these dragons didn't begin life with my mind on a brief. I'm not saying here that there's some kind of ranking order between self-generated projects, private commissions and corporate work: I do what I do to create. The key is to do it as well as one is able, the pursuit of excellence is all that matters. I am often pigeon-holed as working in one particular genre but whatever medium I choose to employ in executing an image, the same rule applies; 'Do it well or not at all.'

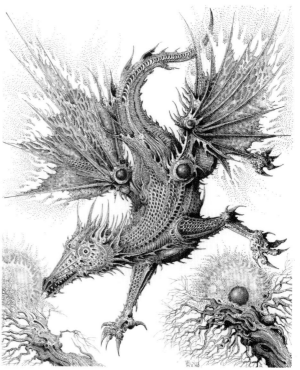

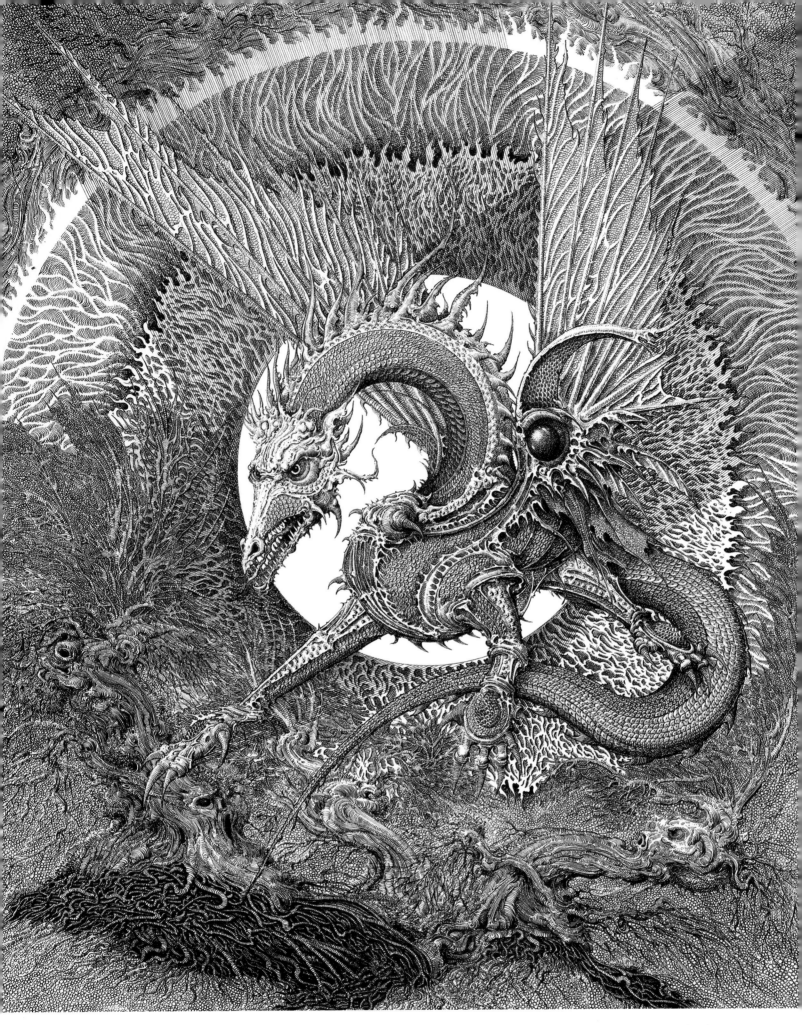

This dragon appeared recently in a book called *There and Back Again* about the origins of *The Hobbit* by Mark Atherton. The drawing began life as a technical exercise in pattern-making then evolved gradually into a creature that reminded me of Smaug, the dragon from *The Hobbit*, so Smaug it became. Circles and spheres are motifs that appear frequently in my improvised work.

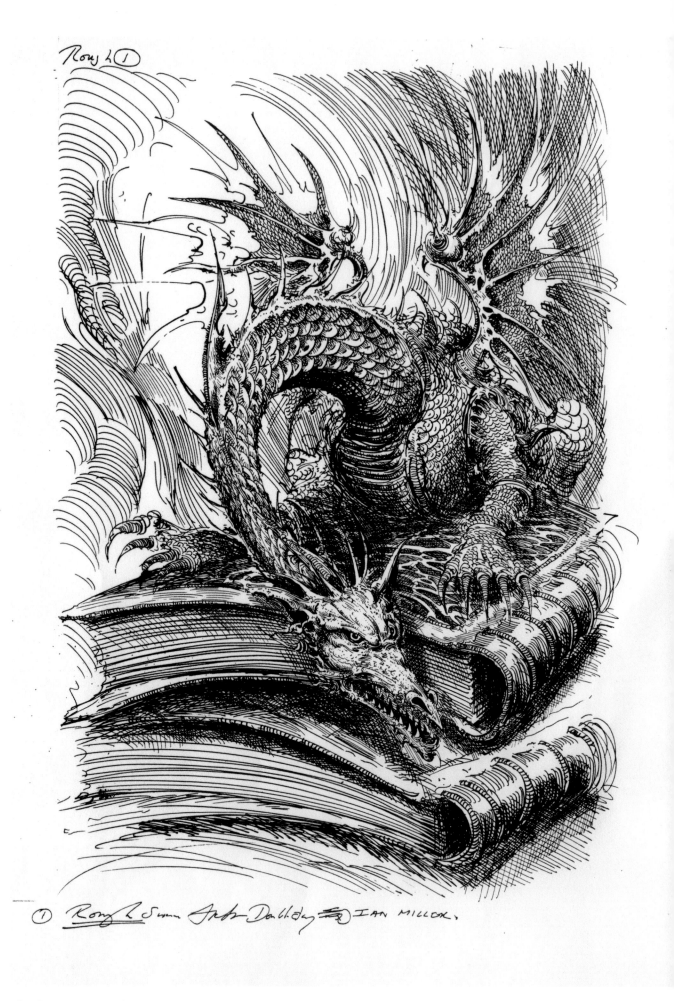

The dragon images featured on these two pages are both preparatory studies for the same book cover. Whenever I am asked to create a cover, I always ask the publisher for as much information as possible and always insist on reading the book. For me, a successful book cover image is one that reflects the essence or some striking aspect

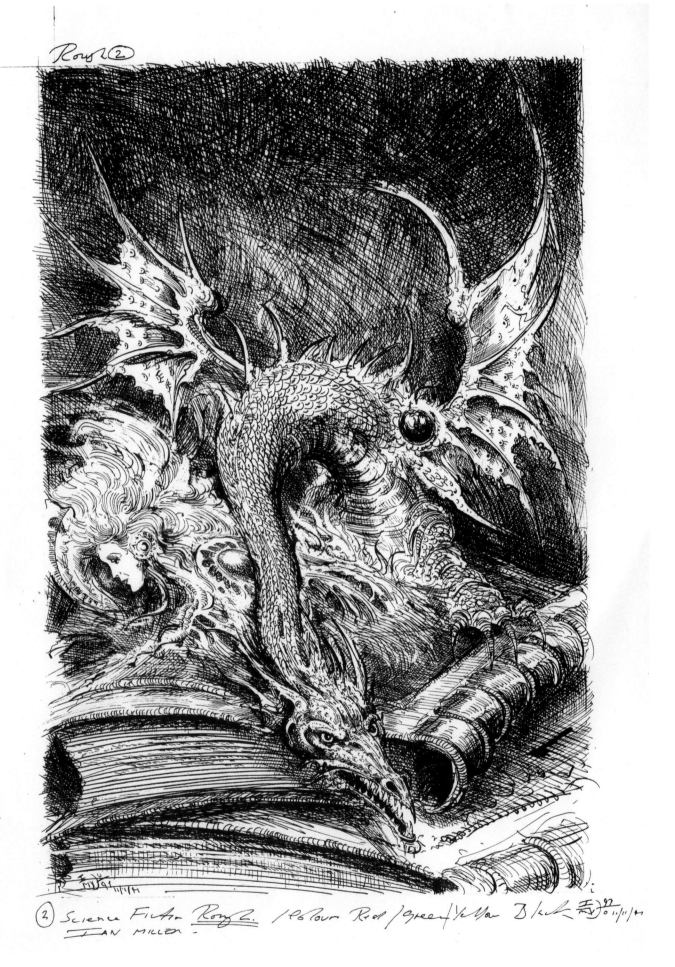

Rough ②

② Science Fiction *Rough.* 1 Colour Red / Green / Yellow Black ... 0 11/11/91
— IAN MILLER.

of the storyline within. Knowledge is power. The more information you have, most especially the space you have to draw in is vital to the successful execution of the commission.

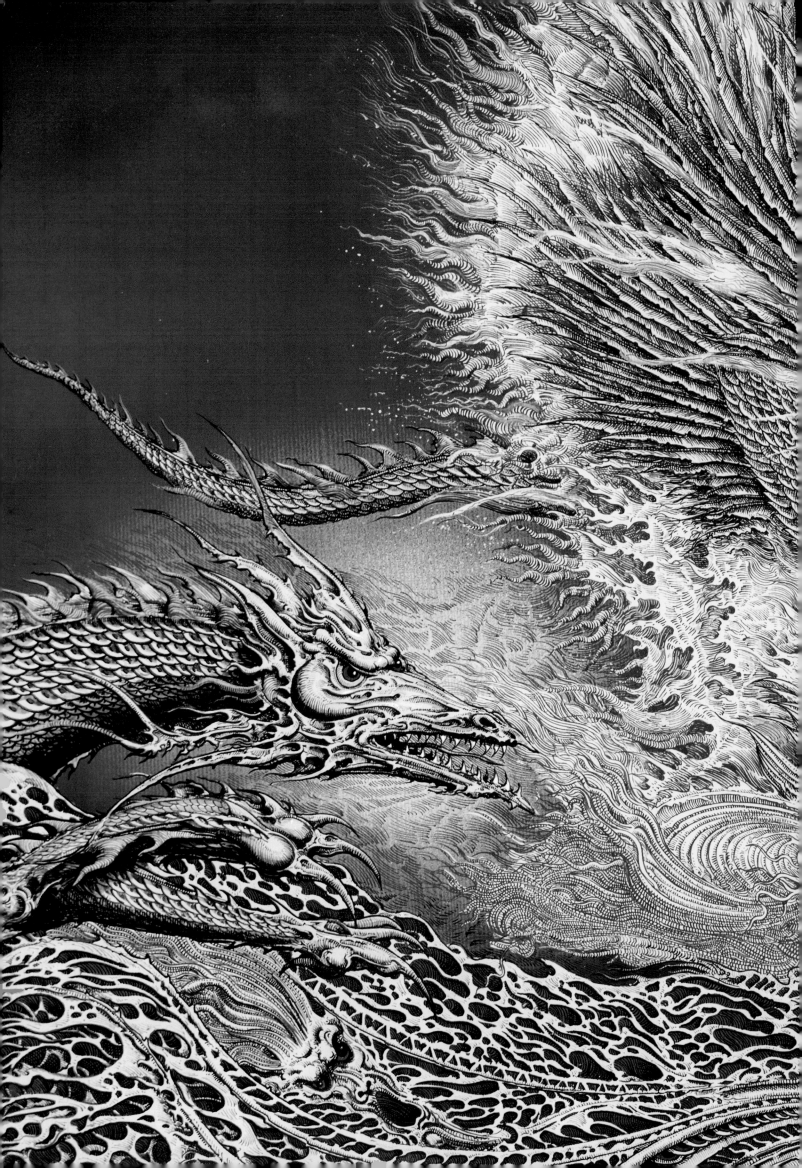

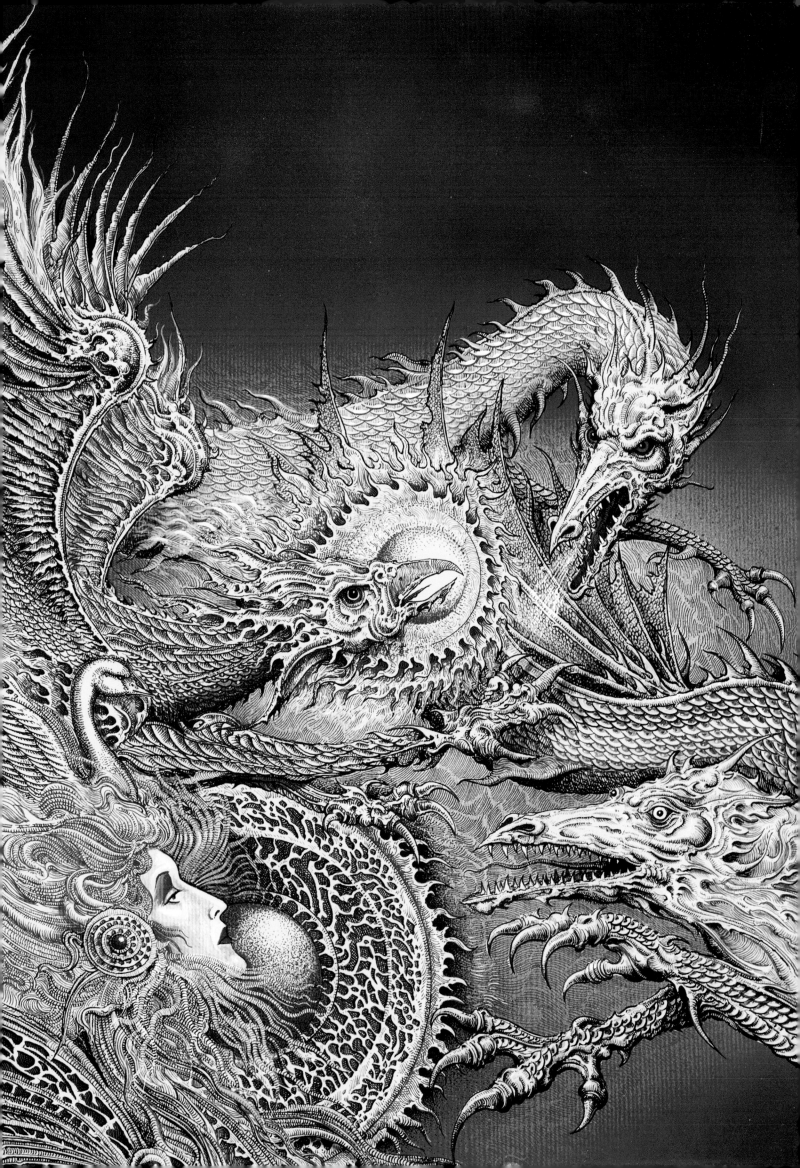

MEN, MONSTERS & MACHINES

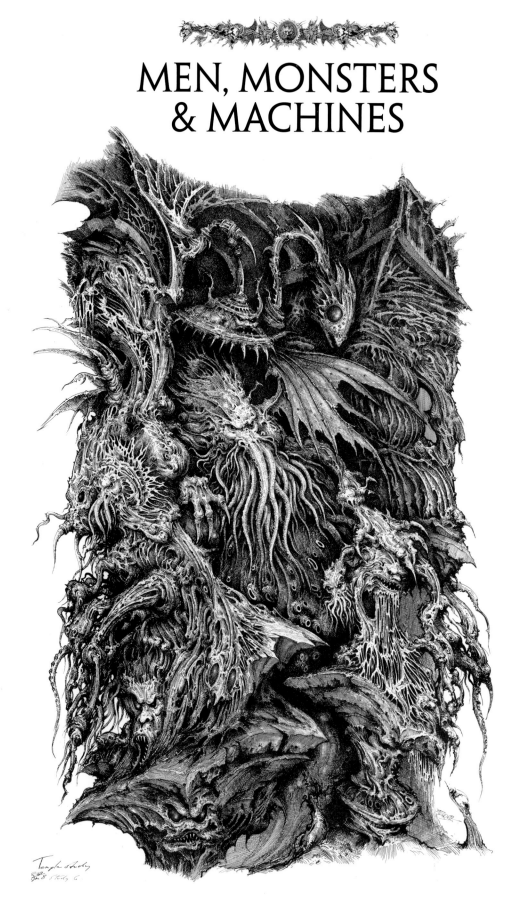

I have always loved machines, the idea of mechanisms, of engineering three-dimensional forms. Back in the halcyon Meccano days I'd build impossible things. I'd also take working mechanisms apart and then not be able to put them back together. And I flew with Flash Gordon.

The machines I draw nowadays may not actually work, but I strive to make them plausible. Whilst stretching my imagination to depict what might be possible in different universes some of the elements of the fantasy worlds I have created are steeped in the traditions of Victorian fantasy, Jules Verne, and all things medieval. The Teutonic Knights are alive and well and much the better for a squirt of oil and a flame gun. My machines are a meld of the arcane and modern, assembled and prefabricated from a plethora of visual fragments I keep hidden in the dark cupboard.

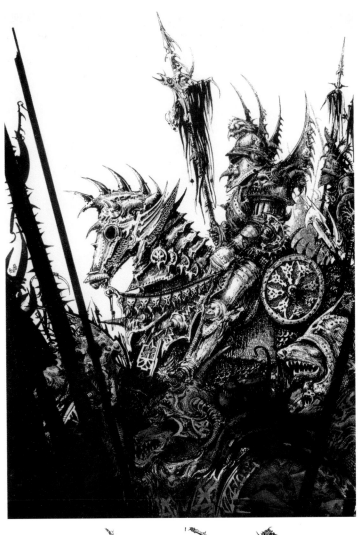

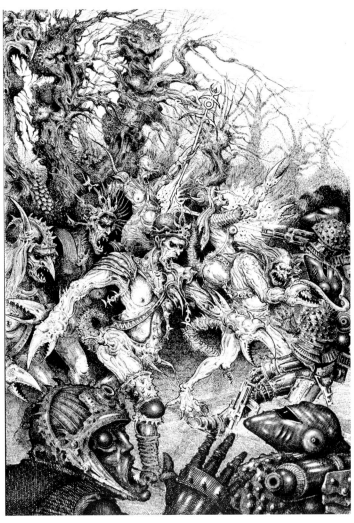

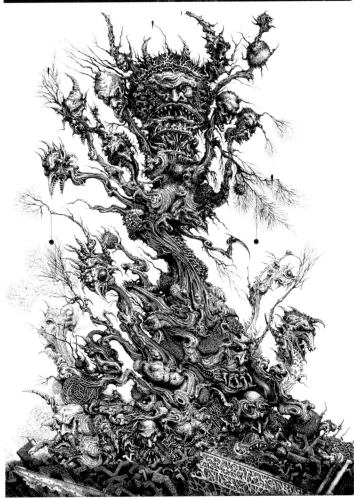

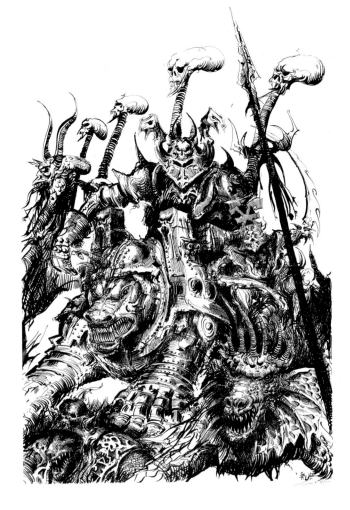

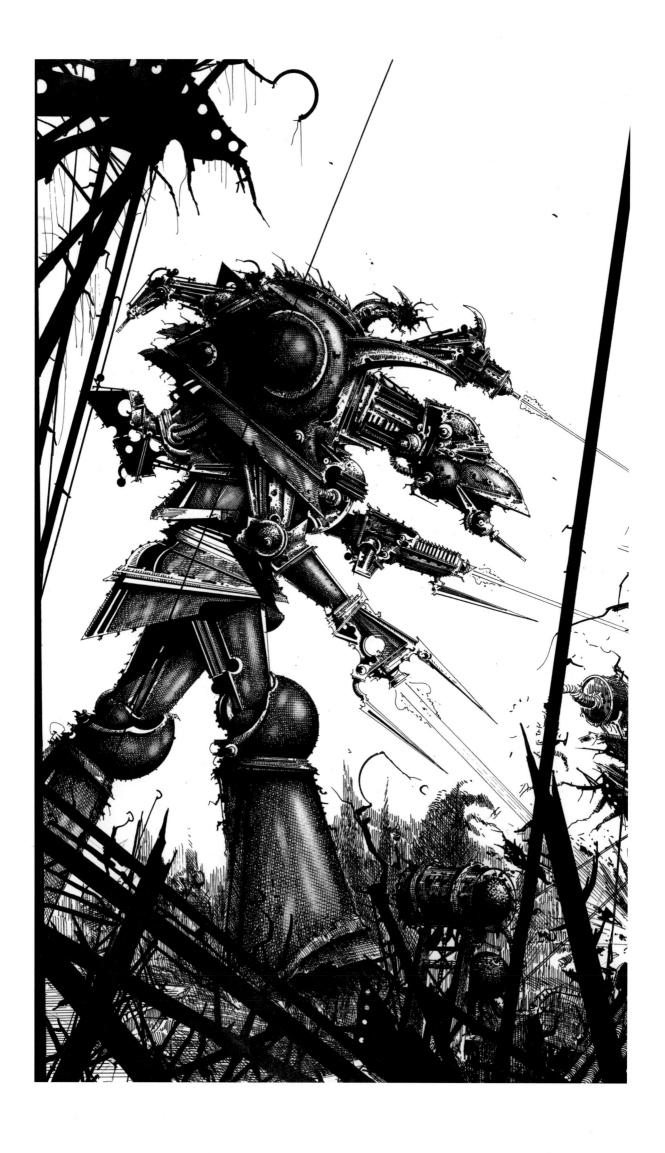

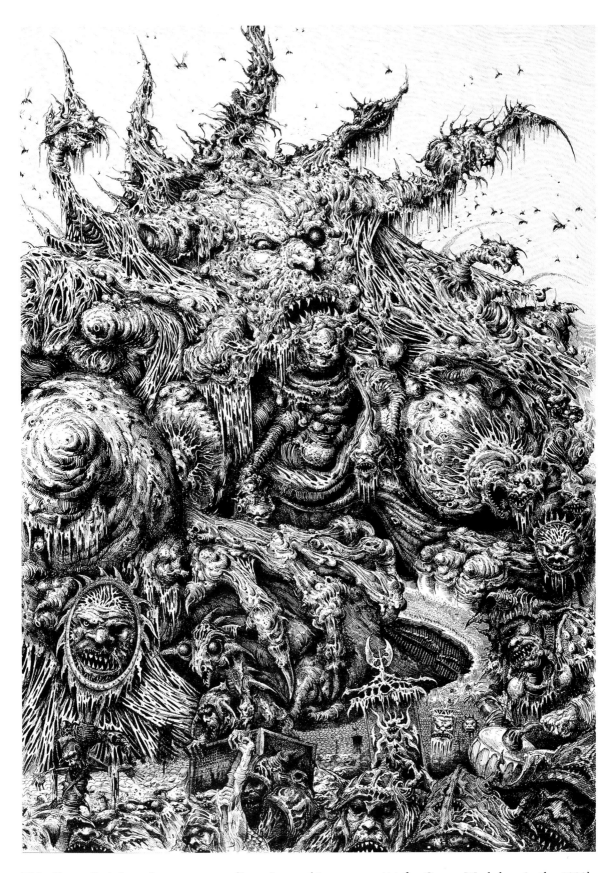

This Chaos God dates from my rewarding stint working as an artist for Games Workshop in the 1980's. The brief was simply 'we need a Chaos God' and I had a rough idea that this was an apocalyptic, pestilential figure. Beyond that, I had full freedom to construct my own customized nightmare; a devil with faces in its belly emerging in a new pattern of melting flesh with attendant hordes.

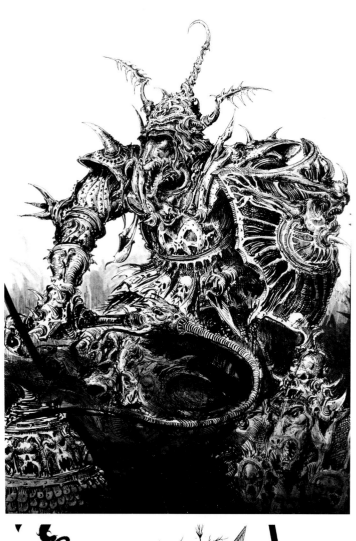

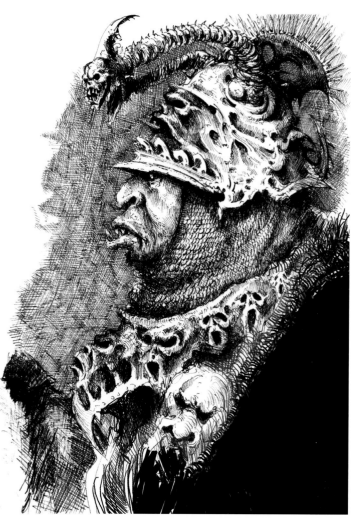

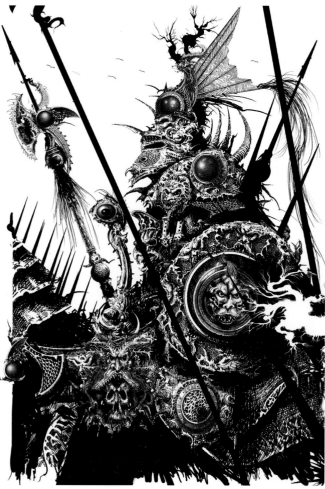

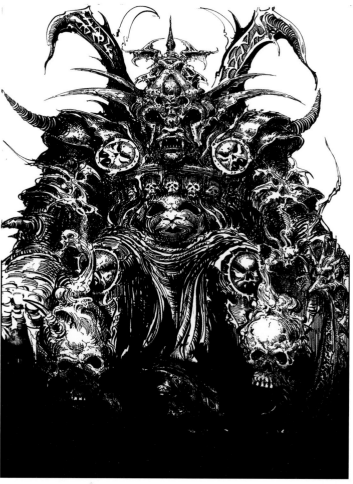

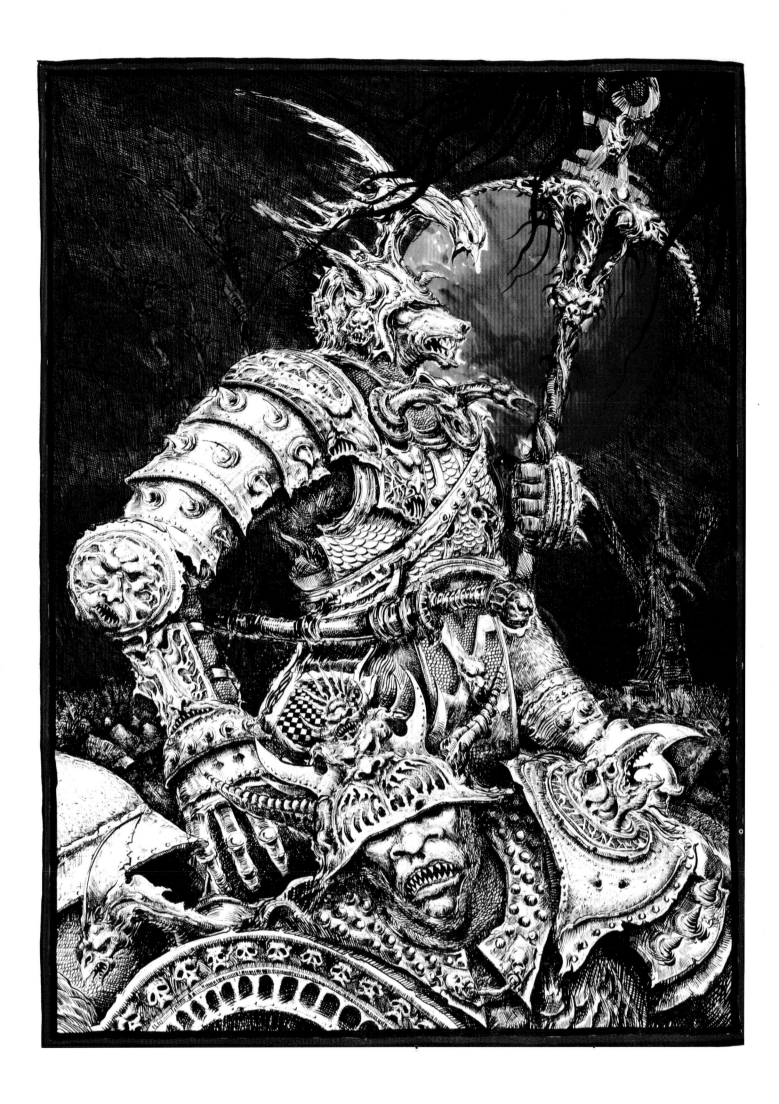

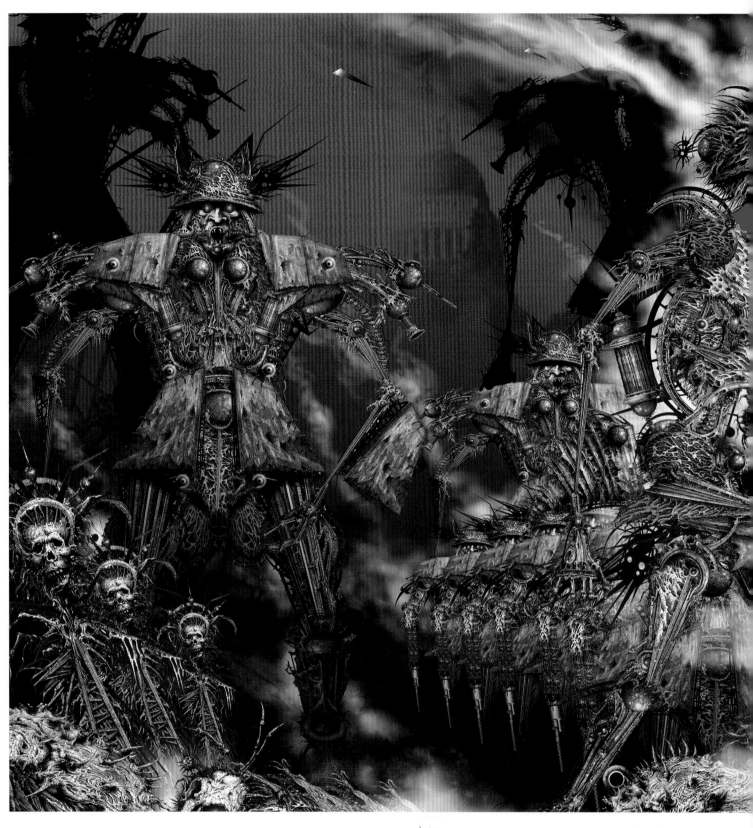

I developed this album cover by first drawing a set of body parts then having scanned them in to the computer arranged/built/constructed a variant selection of figures. These in turn I then mixed digitally with a landscape created in much the same way. This method of working allowed me to offer the band several alternative covers. I describe this process as working with 'elements', different components brought together to create the final figure or image.

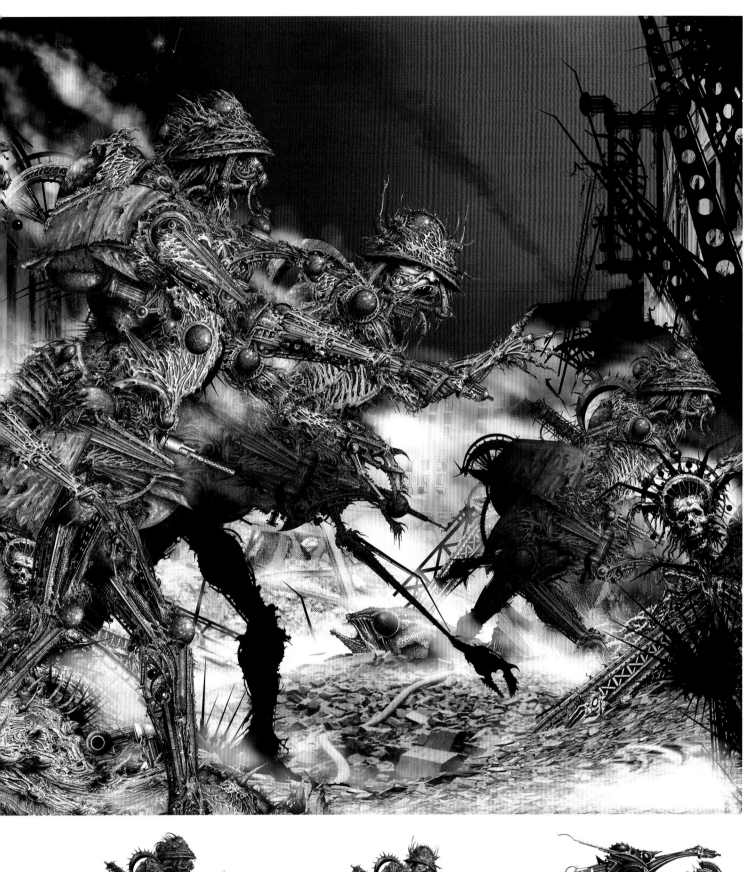

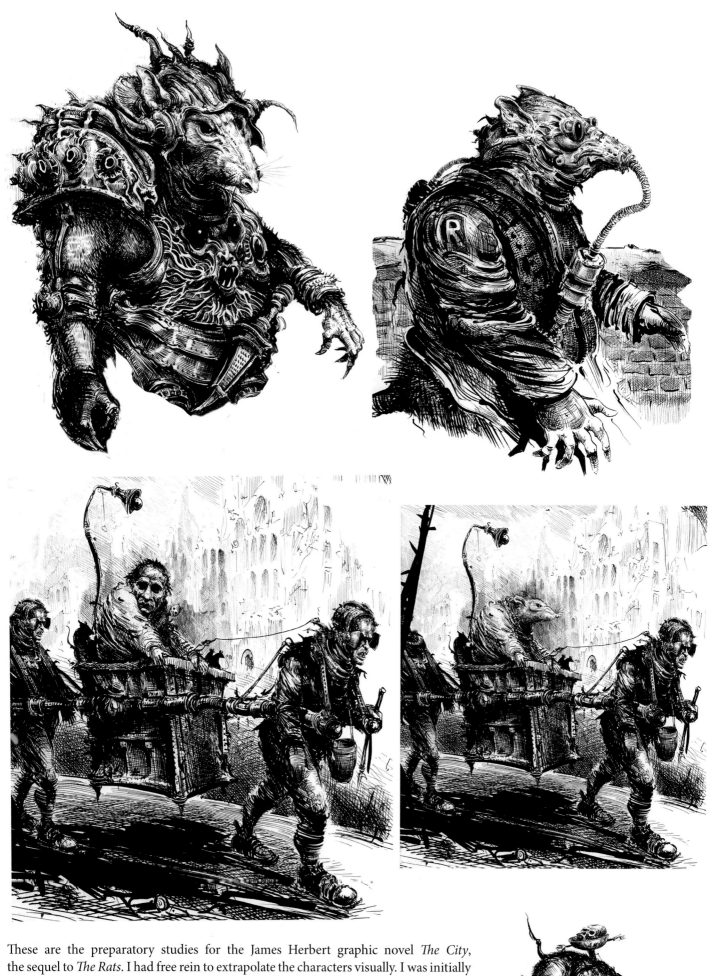

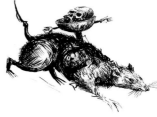

These are the preparatory studies for the James Herbert graphic novel *The City*, the sequel to *The Rats*. I had free rein to extrapolate the characters visually. I was initially led to believe the rats had continued to evolve and so most of them are on two legs in humanoid postures. I often develop the characters before the landscape they will occupy.

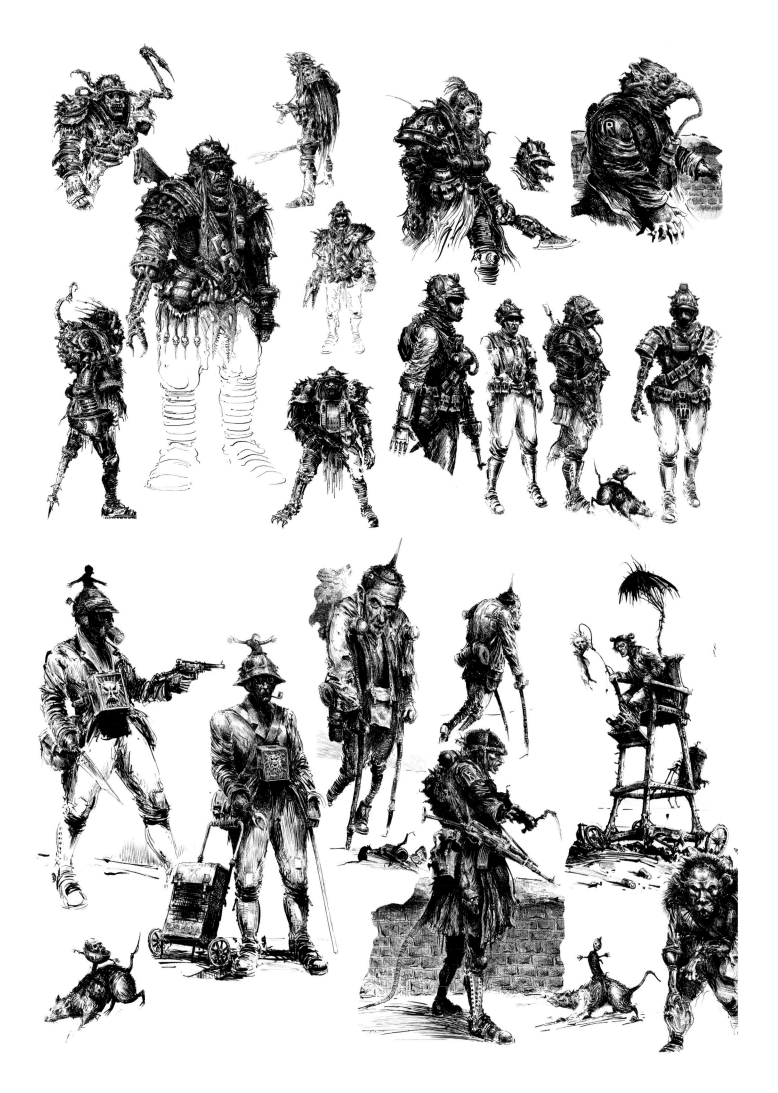

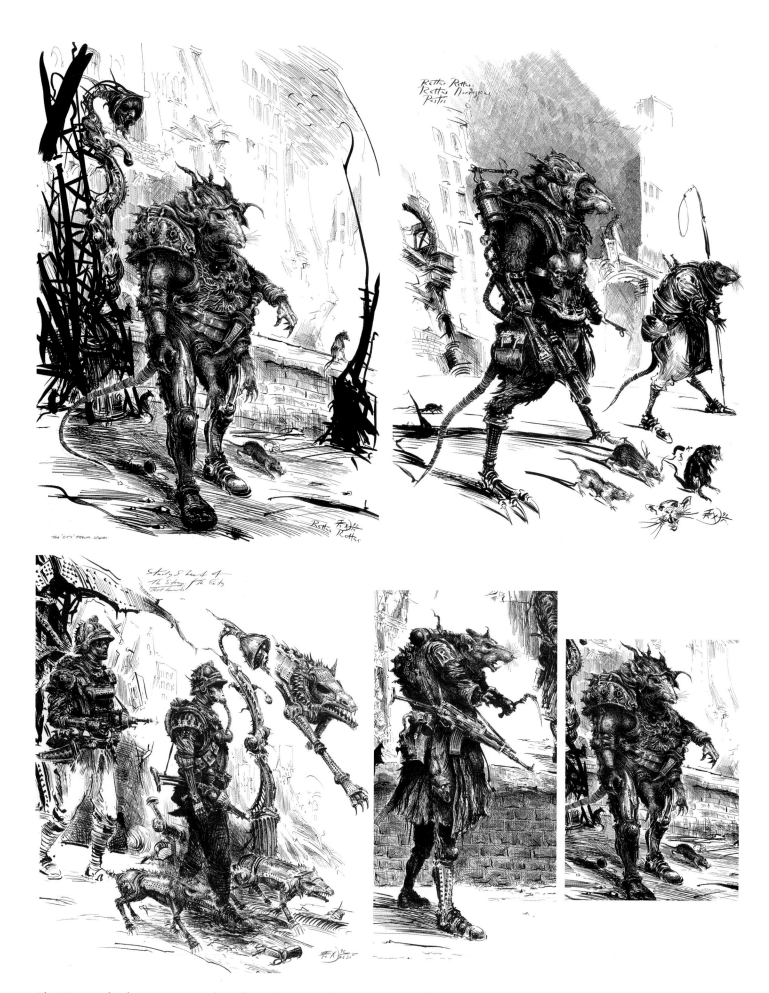

The City involved extensive storyboarding, developed from brief notes. The graphic novel evolved over two years and involved countless changes. I have immense respect for all comic artists and writers, in fact anybody involved in that industry. The skill and dedication required, the sheer tenacity of purpose is daunting. Arr - but it is magic when it works. I was endeavoring in these initial studies to establish a feel, an atmosphere, in which the City world could evolve and come alive.

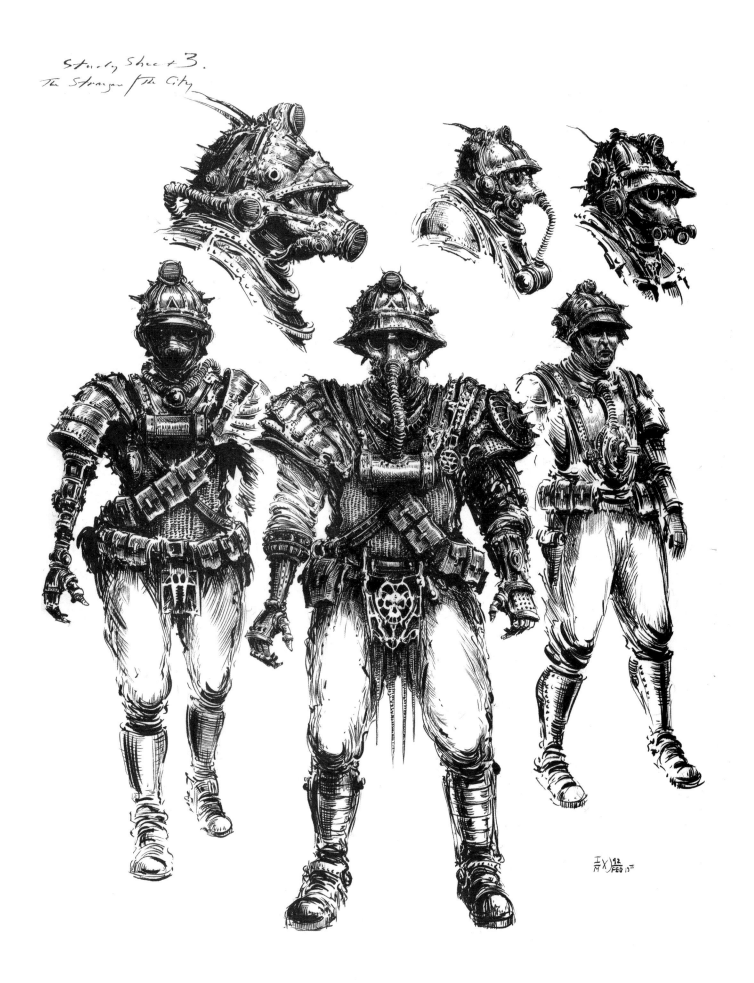

Study Sheet 3.
The Stranger / the City

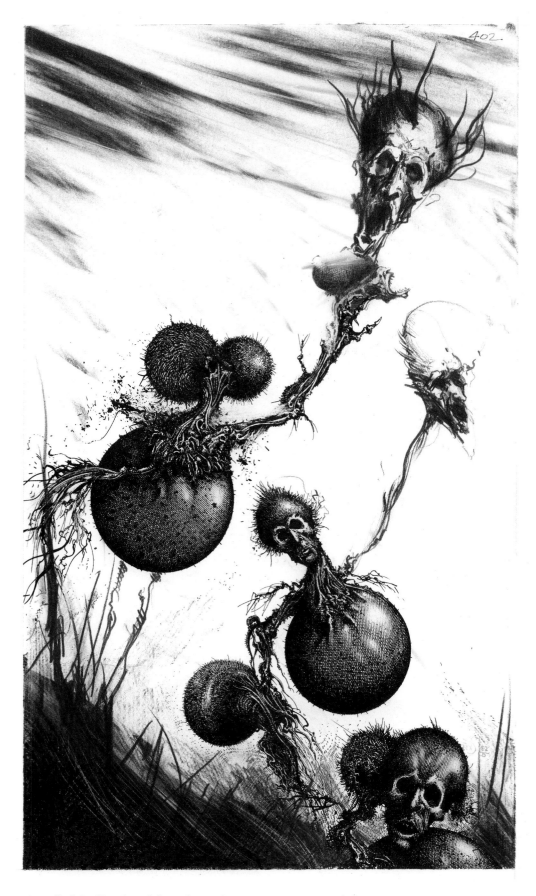

ABOVE: This image is called Podhead and has always been a favorite of mine. I'm not sure it is liked by many other people though. I like the interplay between the pencil and ink and the depth of field the softer pencil work allows. It has been called embryonic and orgasmic, but I think germination suits it better. Someone once asked me if I hated garden peas? I said I had a nightmare about them once.

OPPOSITE: This was a private commission to design a mythological style creature for a company logo. The brief changed several times, with several restarts, having started out as something nearer to a crimson dragon in appearance. After a somewhat roundabout route, always amiable, and lots of changes and adjustments, the client went away happy with one of these chicken birds.

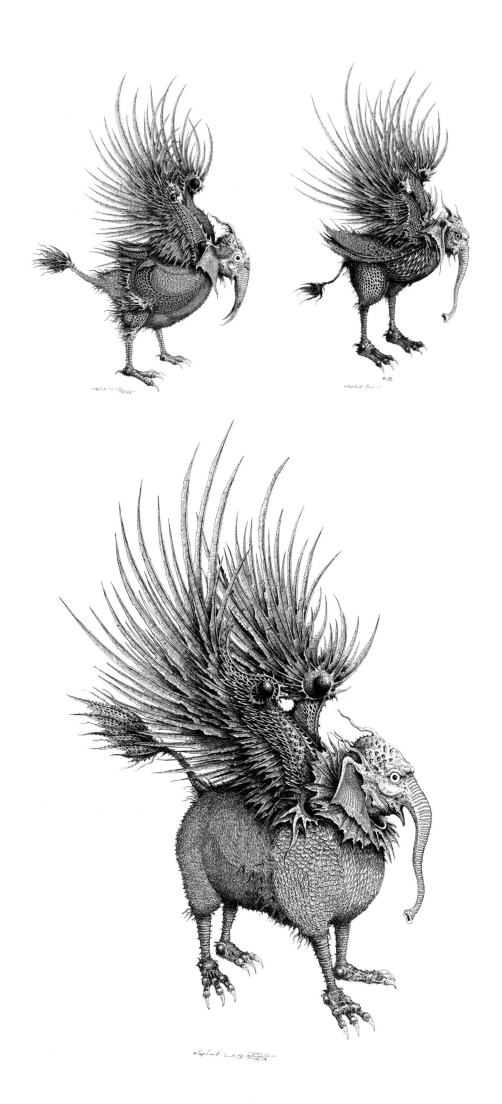

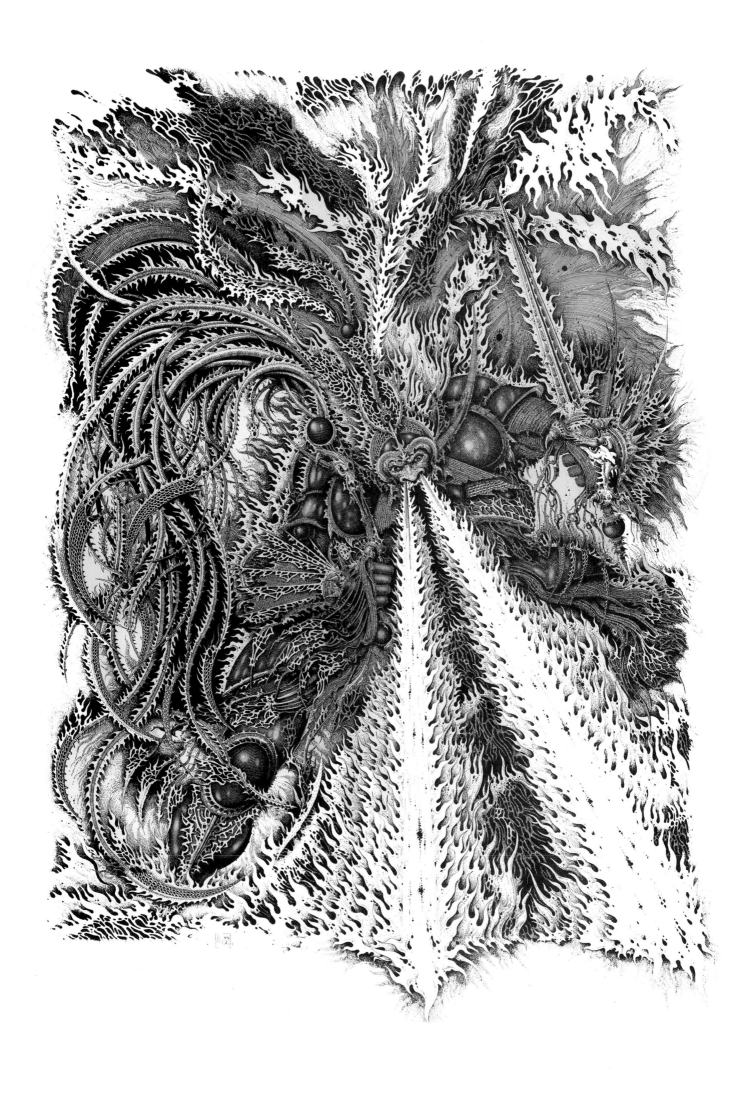

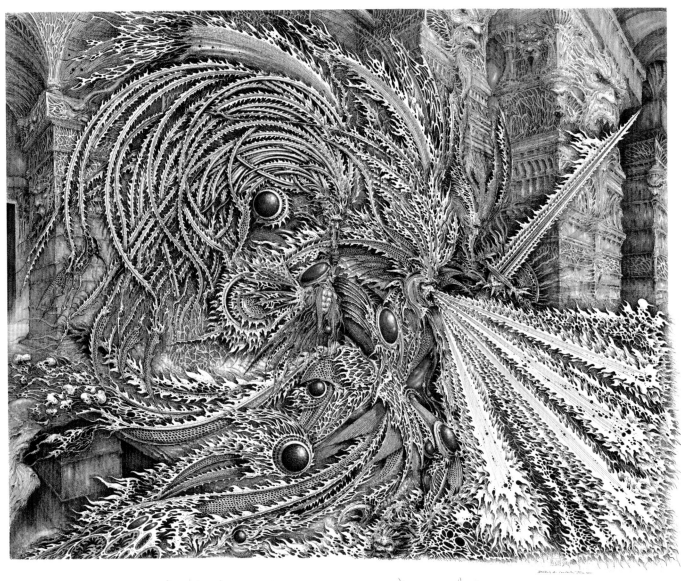

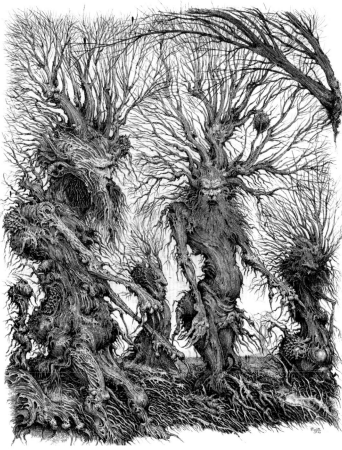

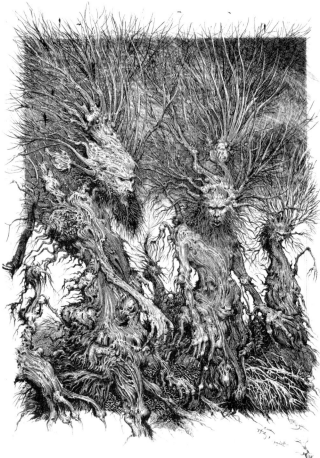

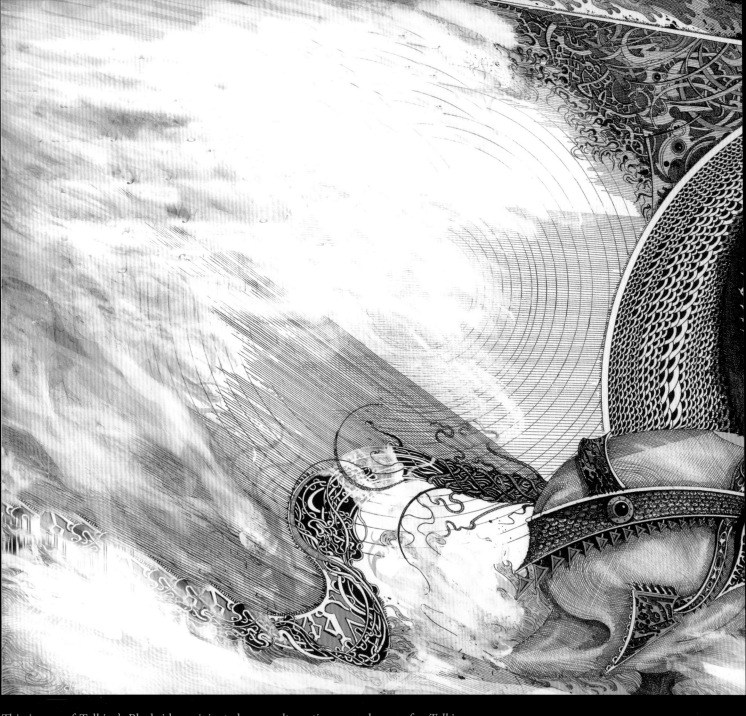

This image of Tolkien's Blackrider originated as an alternative second cover for *Tolkien
Bestiary*. It wasn't used and disappeared. Some years later, it was rescued from the back of
the publisher's drawer and was sent to me as a possible cover for the second edition.

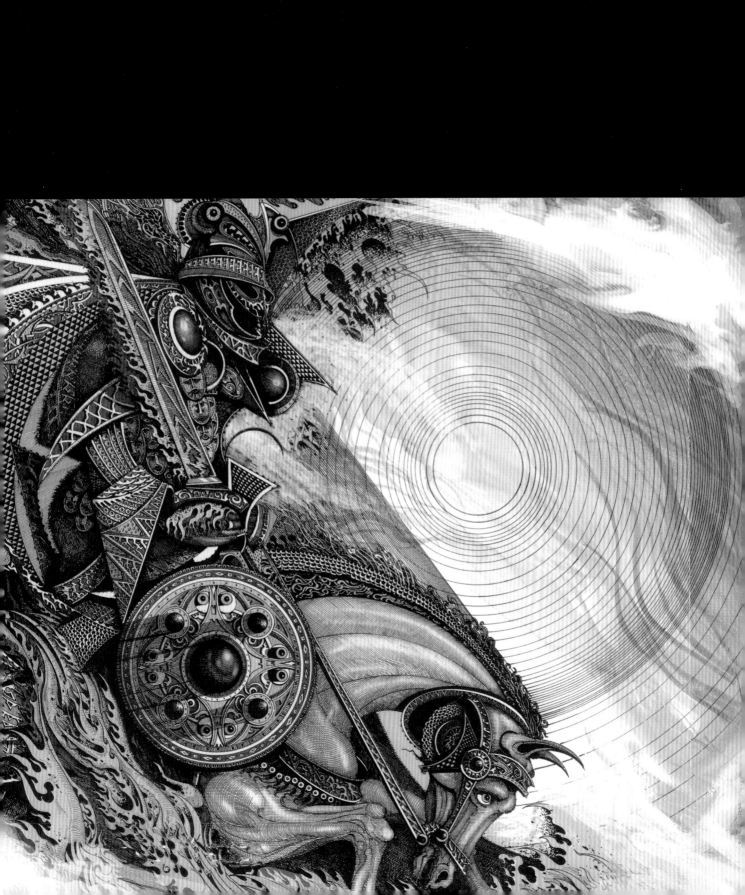

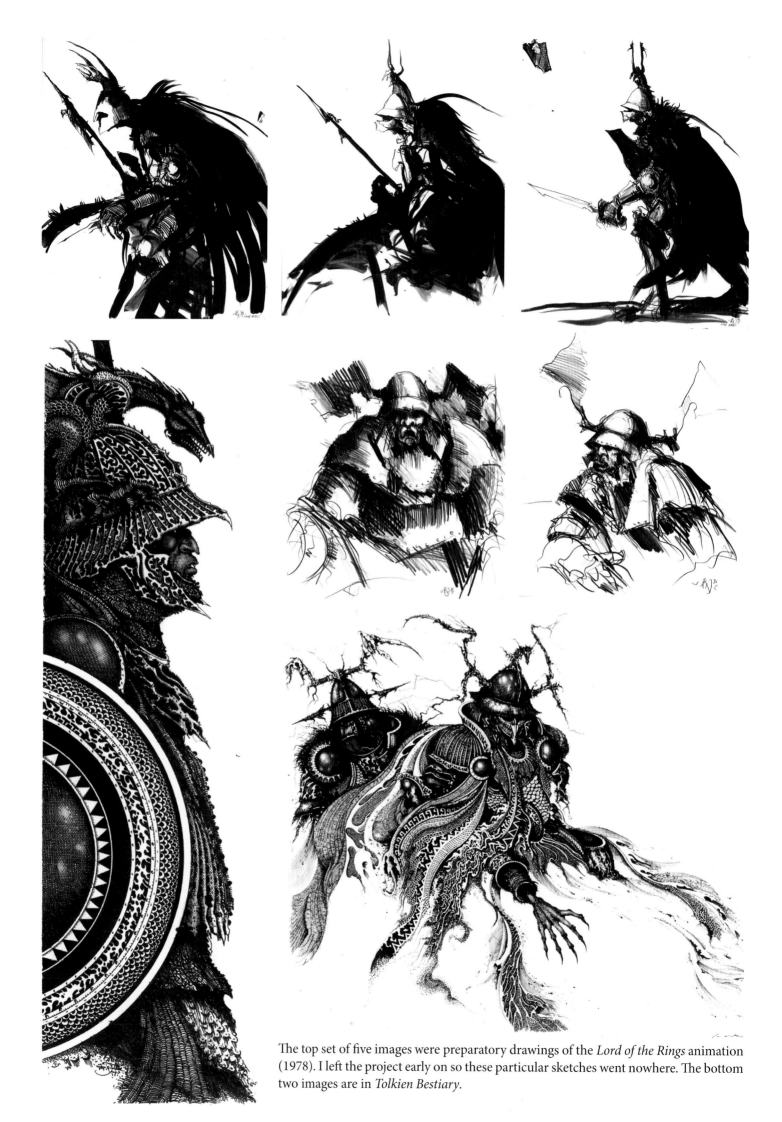

The top set of five images were preparatory drawings of the *Lord of the Rings* animation (1978). I left the project early on so these particular sketches went nowhere. The bottom two images are in *Tolkien Bestiary*.

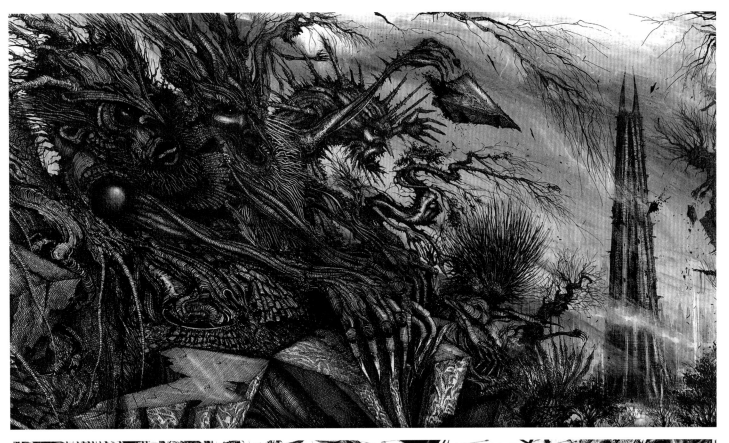

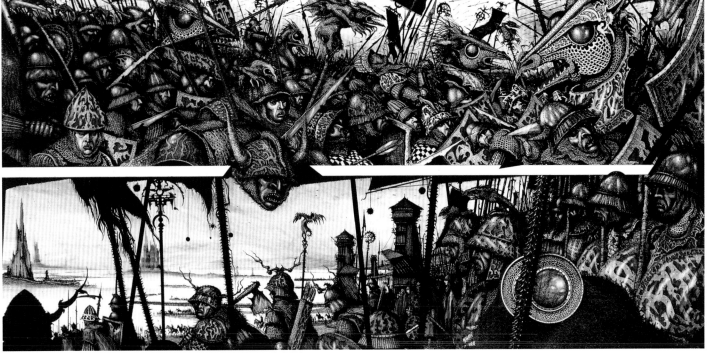

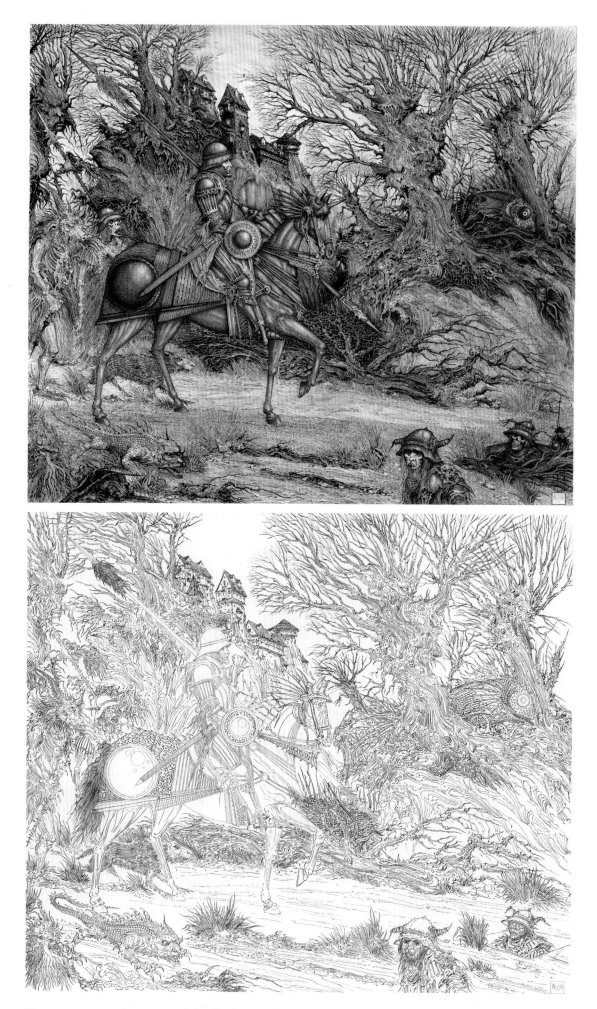

The preparatory drawing and finished piece for a private commission. The image has a deliberate Düreresque quality; Dürer was part of the brief.

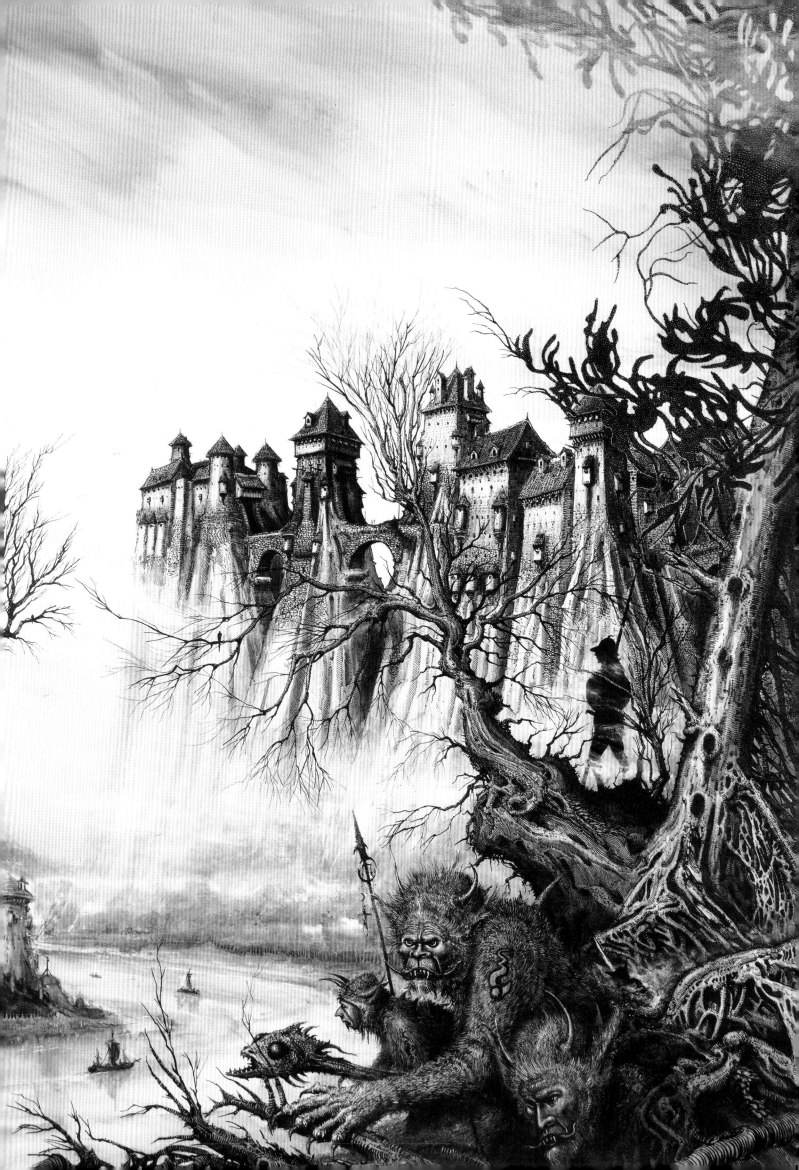

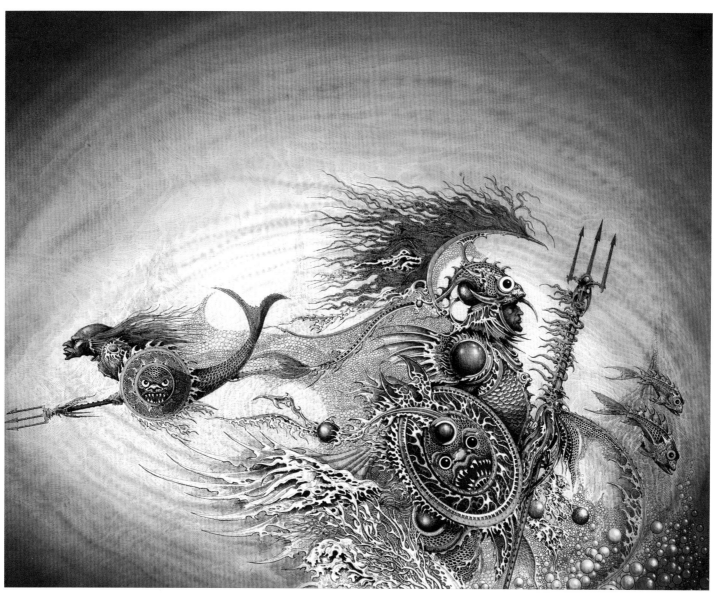

I always try to do very detailed roughs for covers and internal illustrations. This allows me to iron out any shortfalls early on in the process and clear the way for a straight run at the finished piece. I sometimes find the preparatory studies possess a freshness and vitality that is lost in the finished image. This, of course, is not always the case. One treads a very fine balance throughout the creative process and I'm always a little amazed when everything turns out well. The two images on this page demonstrate how I progressed from the rough stage (right) to the finished cover (above).

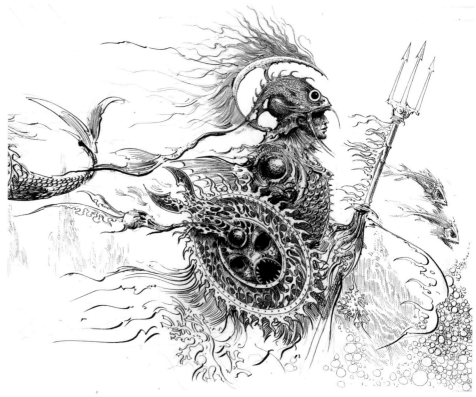

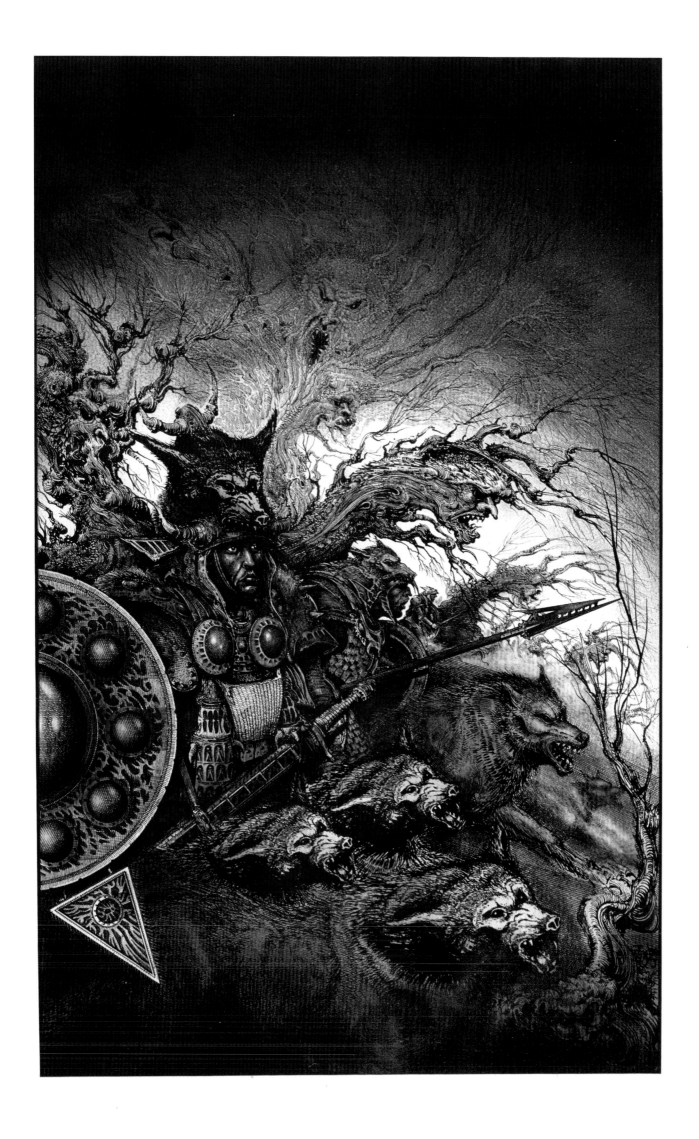

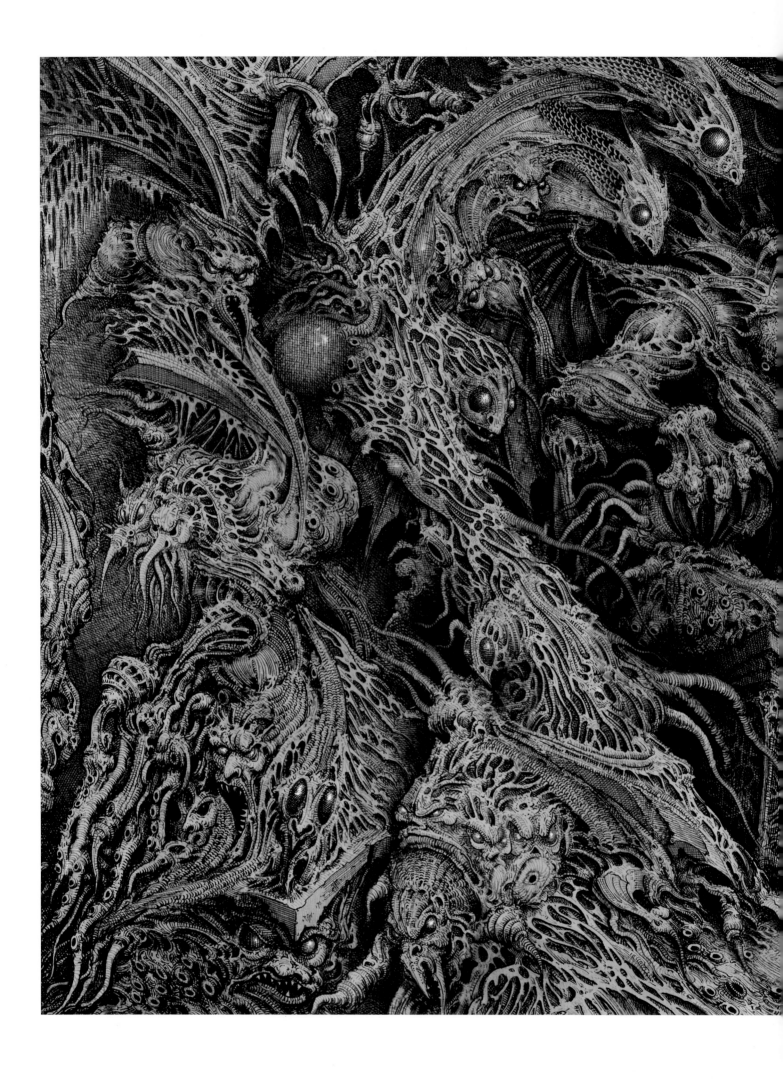

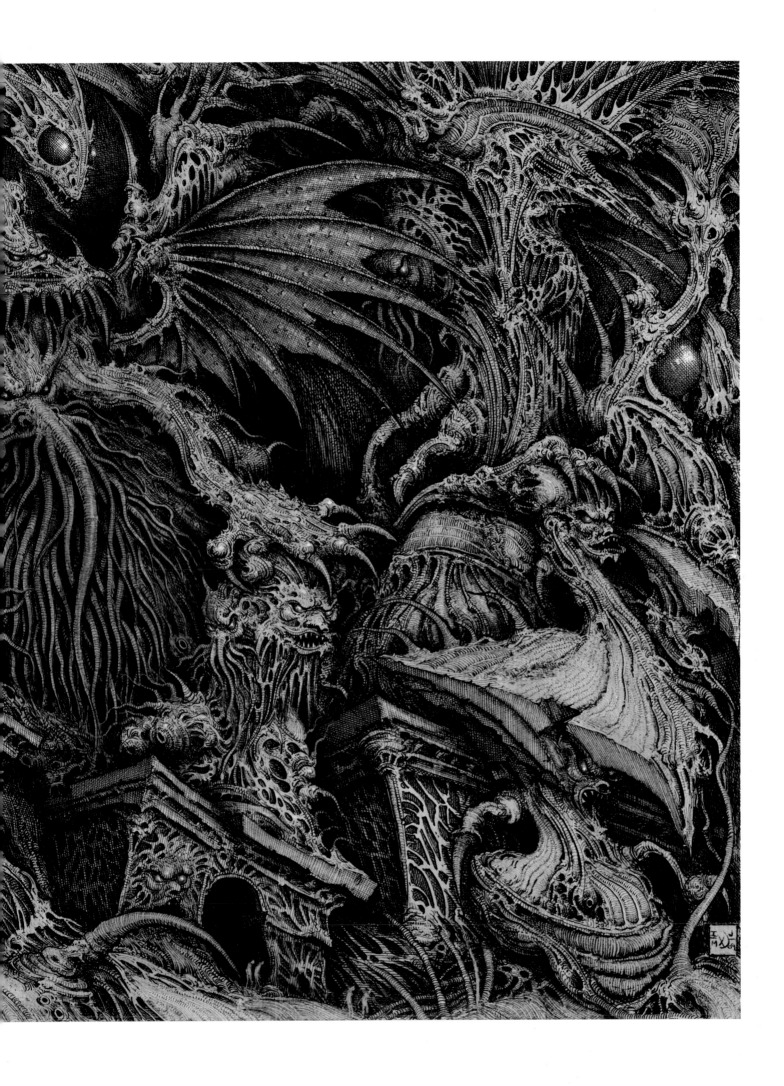

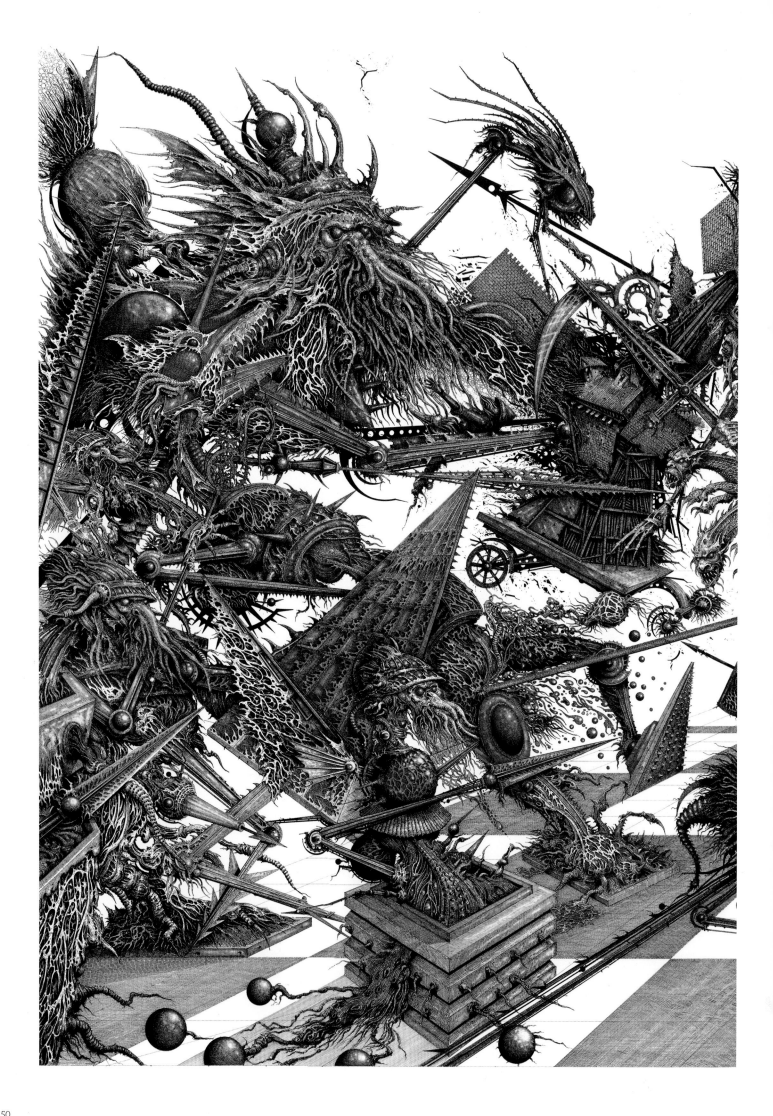

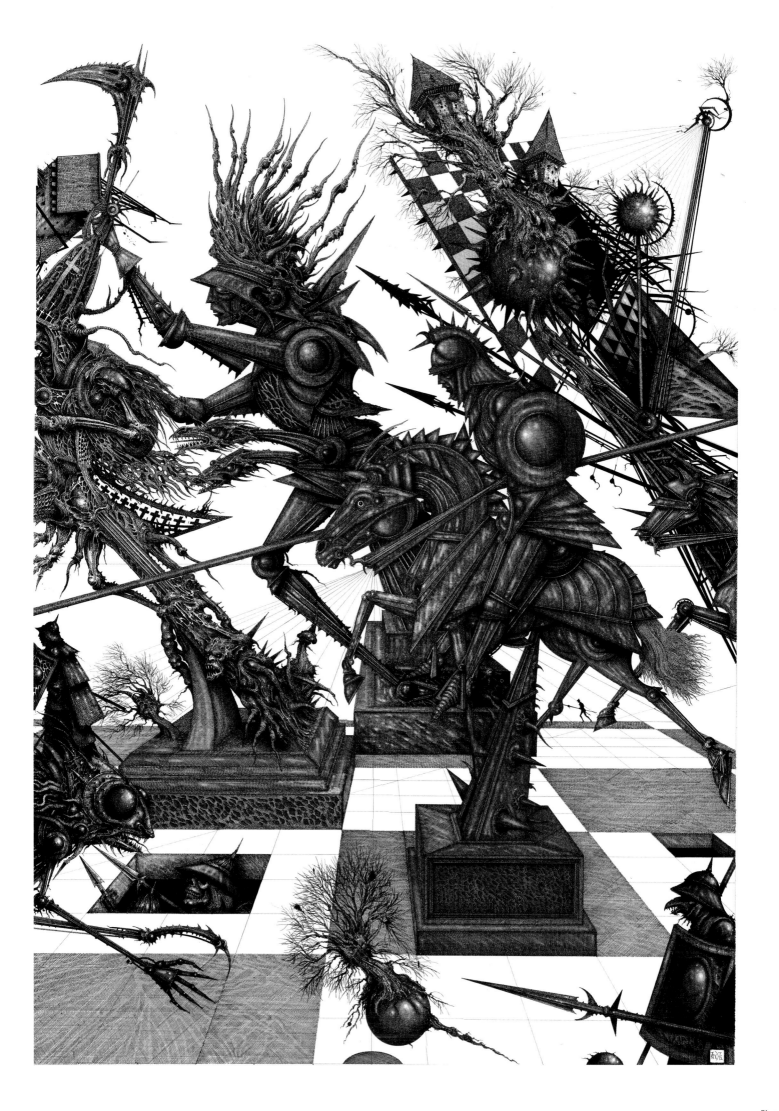

51

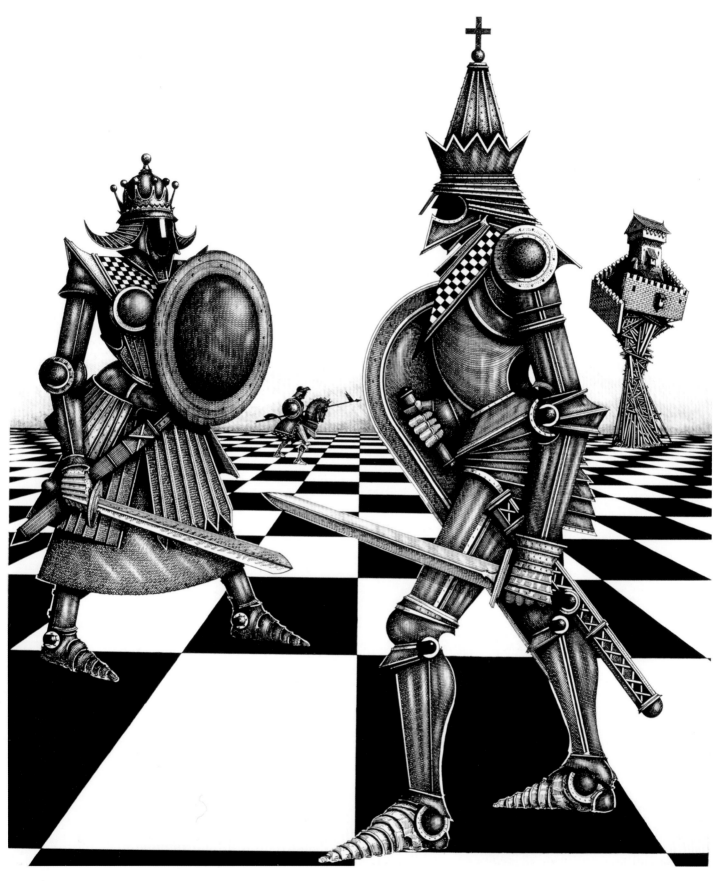

PREVIOUS SPREAD: Chess is the only game I play; it never bores me. I tend to play emotionally rather than very methodically. As an artist, I would love to design a chess set. These two large panels are part of an installation in Baltimore. They sit behind a chess set upon a table both made by different artists. Rather than choosing white versus black, this set is organic versus robotic.

THIS PAGE: A keen chess player recently looked at the two opposing kings on this drawing (for a book cover on a book teaching chess) and commented that this depicts an impossible position because in the rules of chess the two kings are not allowed to occupy adjacent squares. I feel he was missing the aim of the drawing, which was to show the movement and conflict inherent in the game itself rather than to communicate an actual endgame. As with so much of my work there is artistic license at play here.

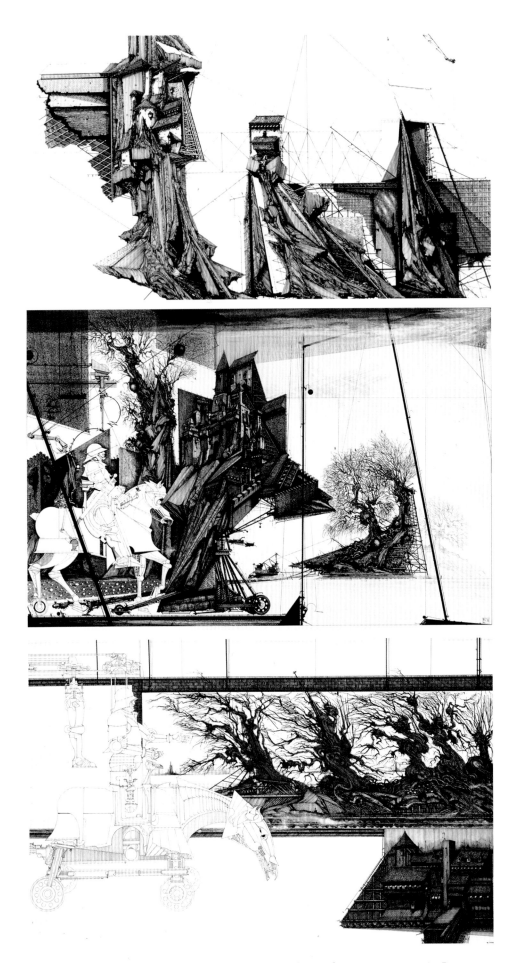

I created these images to convey the visual look alongside a movie synopsis. In a post-apocalyptic world our main character morphs into a strange beast whilst trapped in a basement. He builds a gothic kingdom and creates mechanical knights who must in turn rescue a piano-playing damsel.

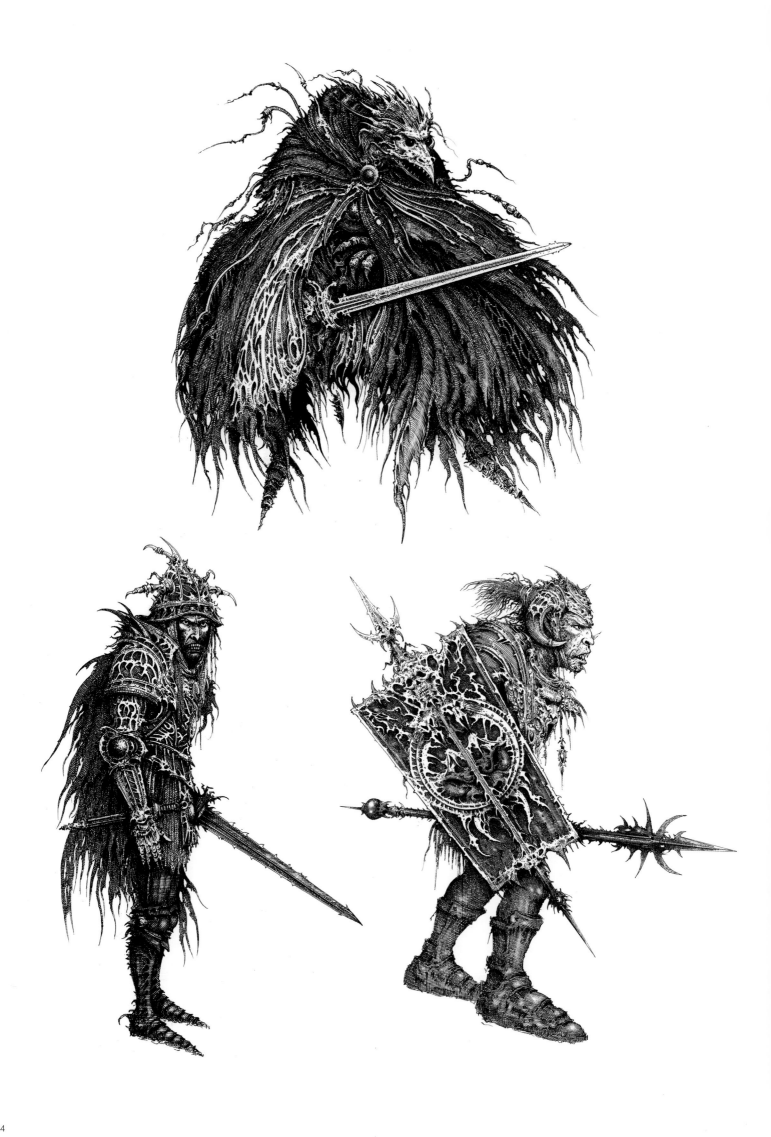

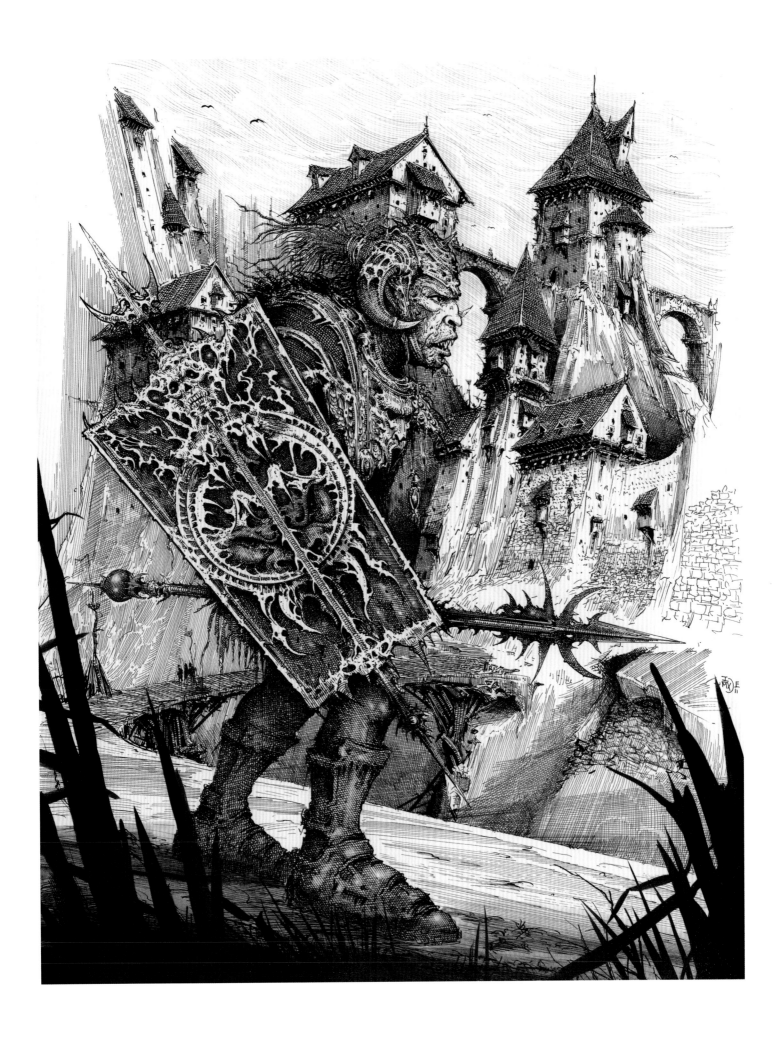

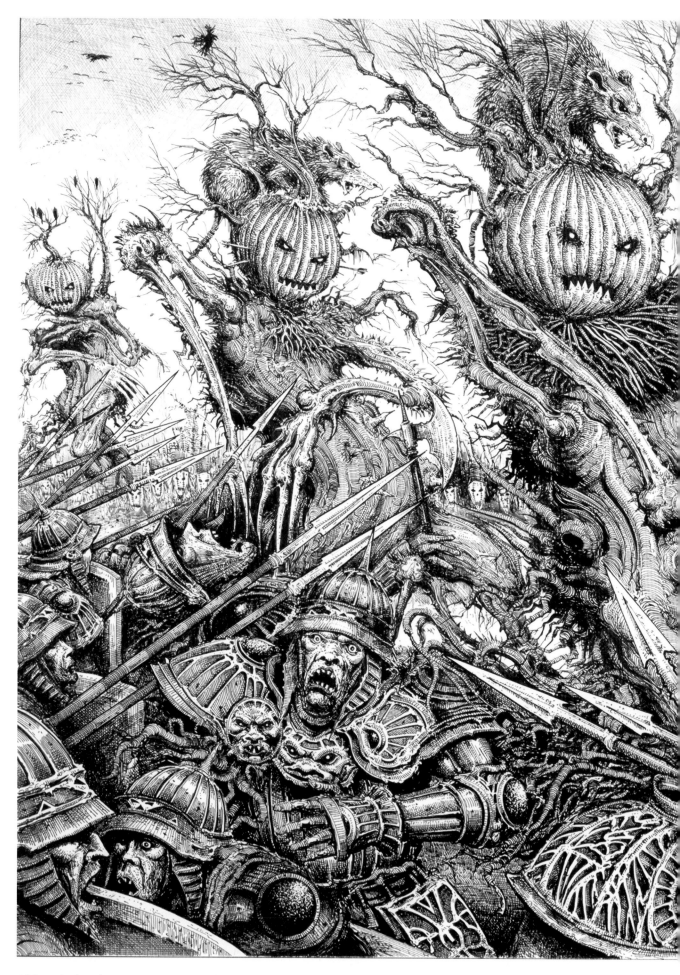

Although this drawing was very well received (and went on to win the ASFA Award for Best Gaming Illustration) I cannot warm to it for some reason. I feel it should have been far more dramatic and far less contained. I like the rats though. The image captures a particular moment in the storyline in which soldiers are forced back by an enemy they can not control.

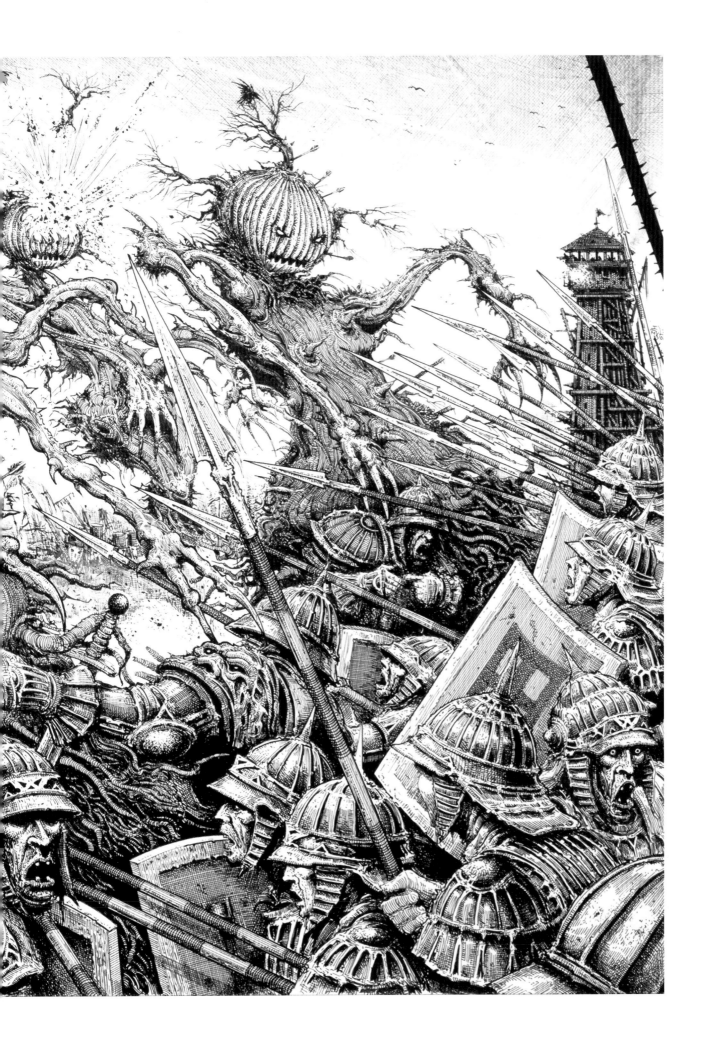

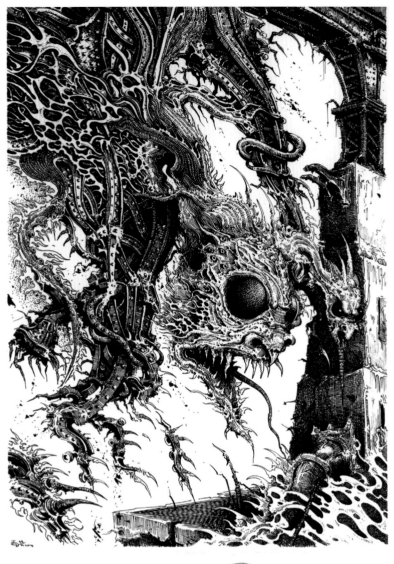

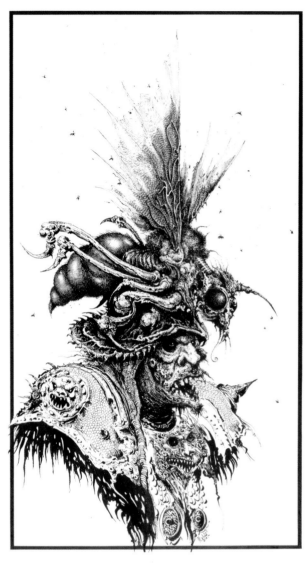

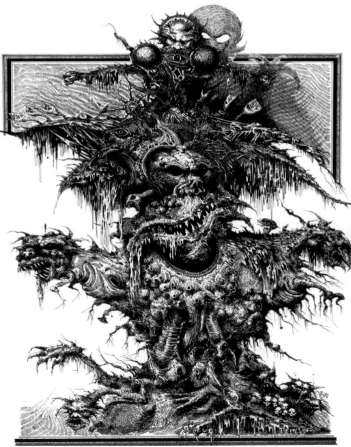

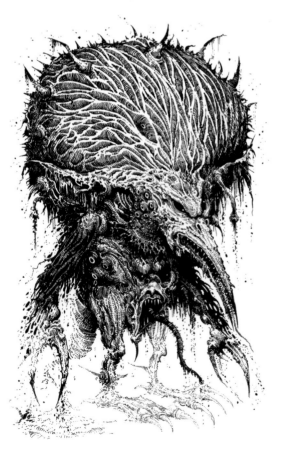

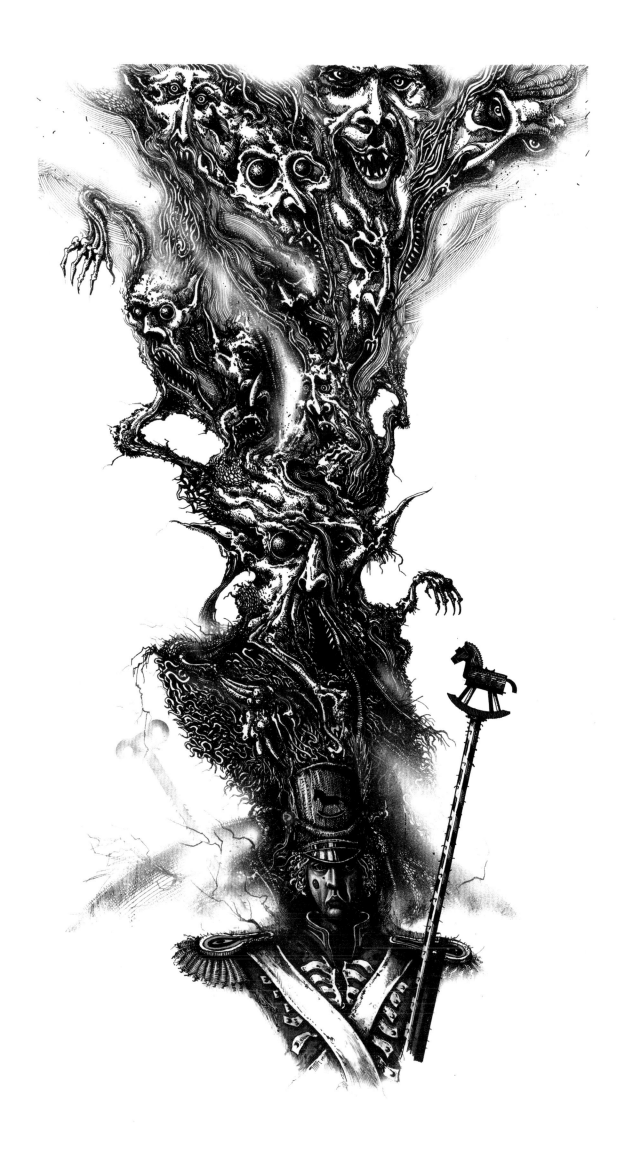

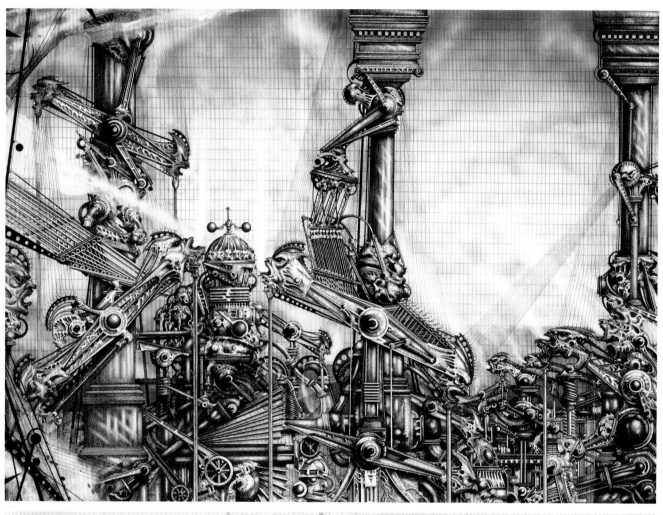

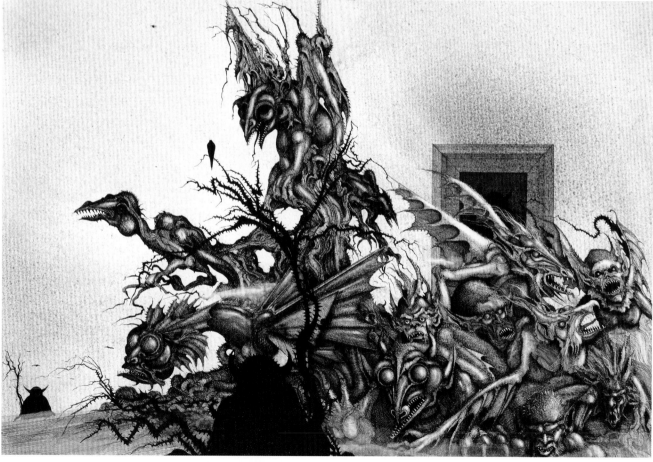

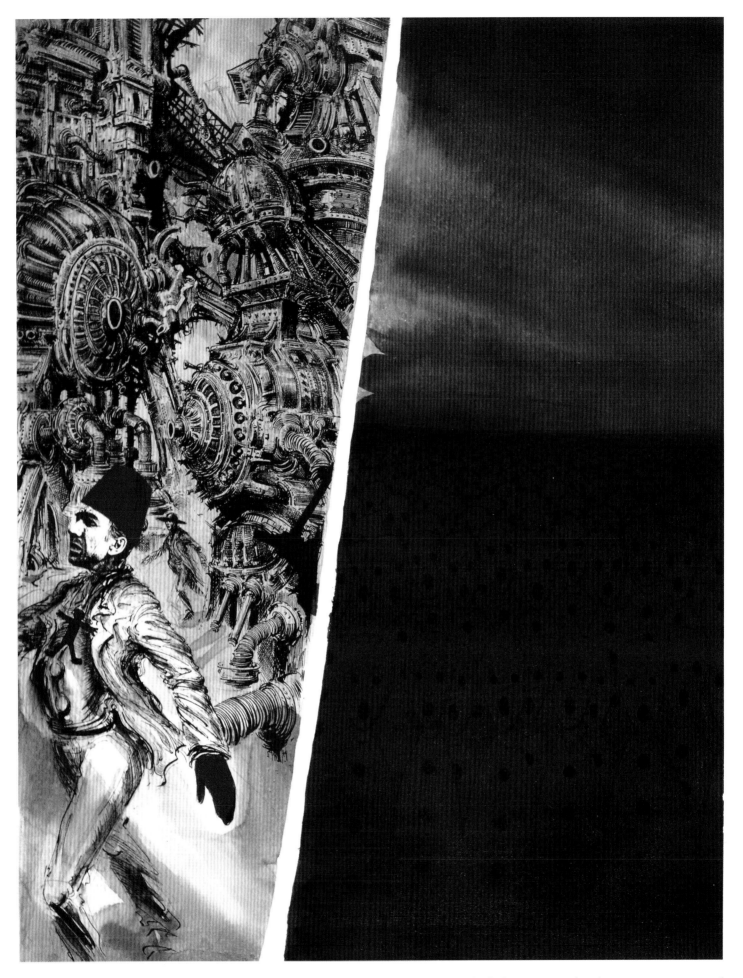

The Luck in the Head remains the most rewarding project I have ever worked on and I feel very exposed within its pages, warts and all. On this page of M. John Harrison's graphic novel, based on his novel *Viriccoium*, the screaming souls provide the background noise of a strange city whilst the central character, Ardwick Crome, goes about his business in a strange industrial post–Gothic world. He is wearing a fez because a fez simply seemed right.

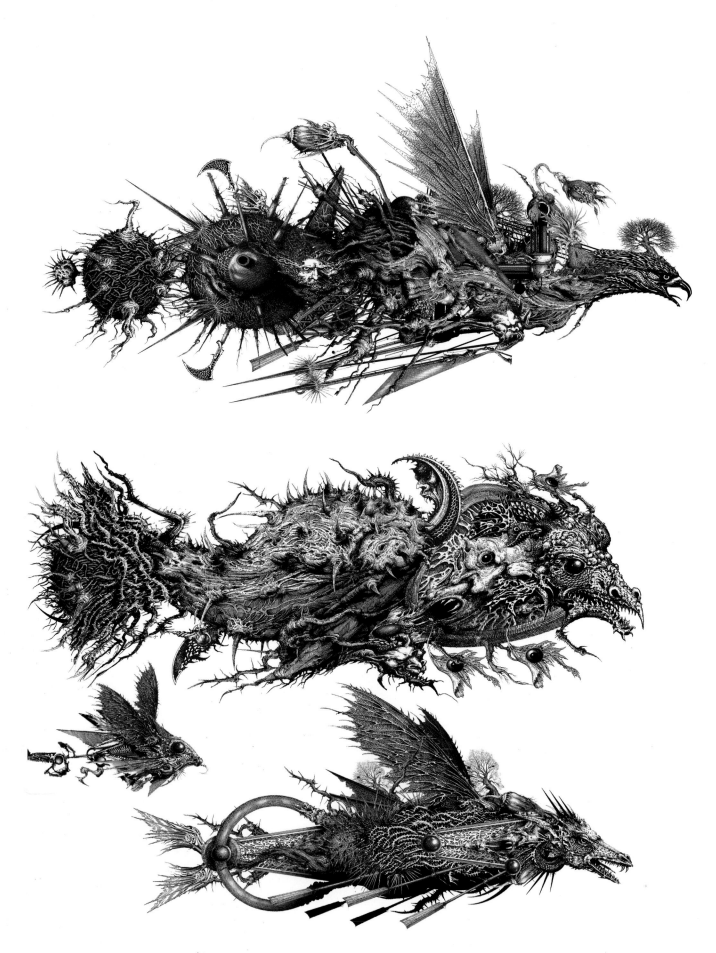

OPPOSITE: A circular design I called Portal. This was yet another pattern-making exercise. If I have an idea that seems interesting then I do try to follow it through. It is important, I feel, to push at the boundaries of ones practice continually; standing still creatively is not an option I readily subscribe to. This drawing could well have taken a more abstracted form but I was thinking about clocks and electricity at the time and so it evolved into this. I don't remember at what point I placed the Sisyphus figure who is walking the wheel. It just seemed appropriate and also right to help establish a sense of scale.

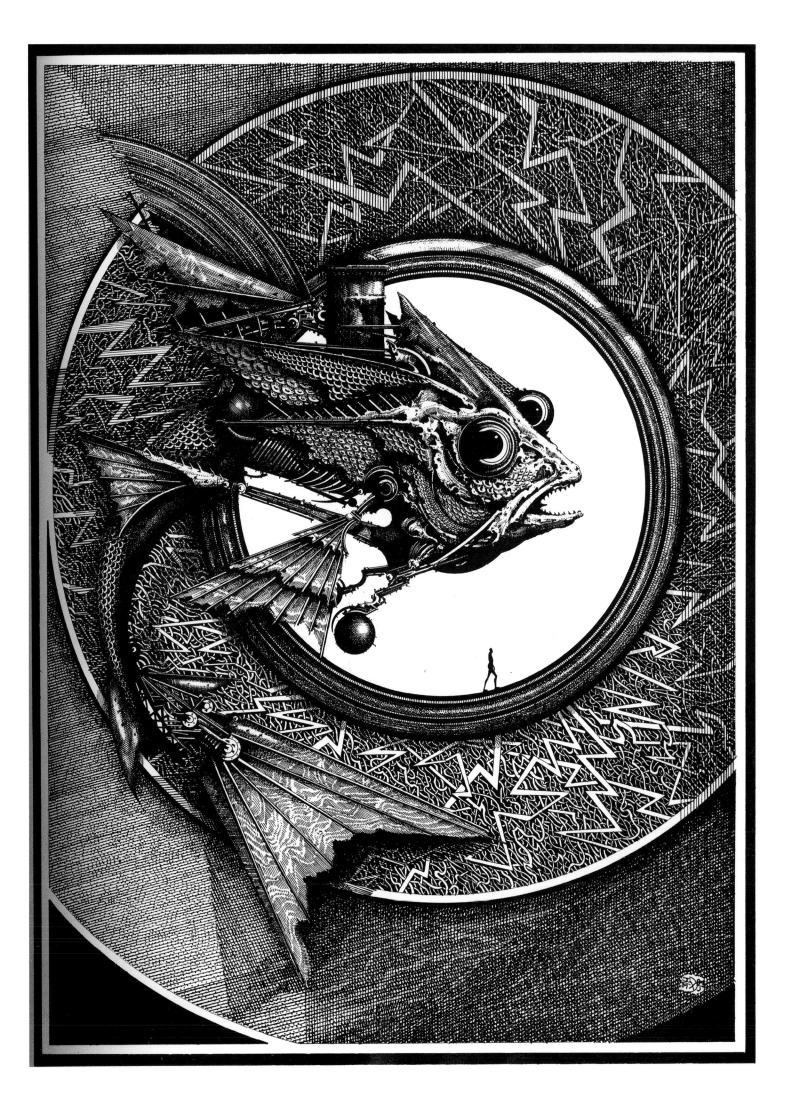

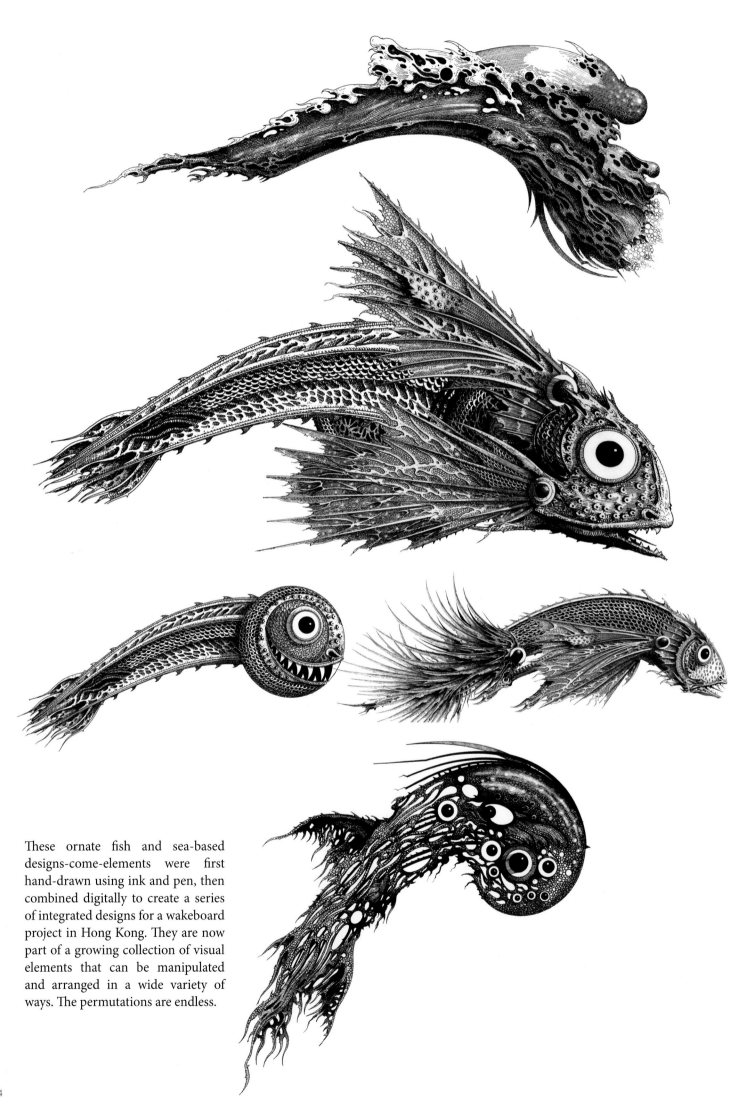

These ornate fish and sea-based designs-come-elements were first hand-drawn using ink and pen, then combined digitally to create a series of integrated designs for a wakeboard project in Hong Kong. They are now part of a growing collection of visual elements that can be manipulated and arranged in a wide variety of ways. The permutations are endless.

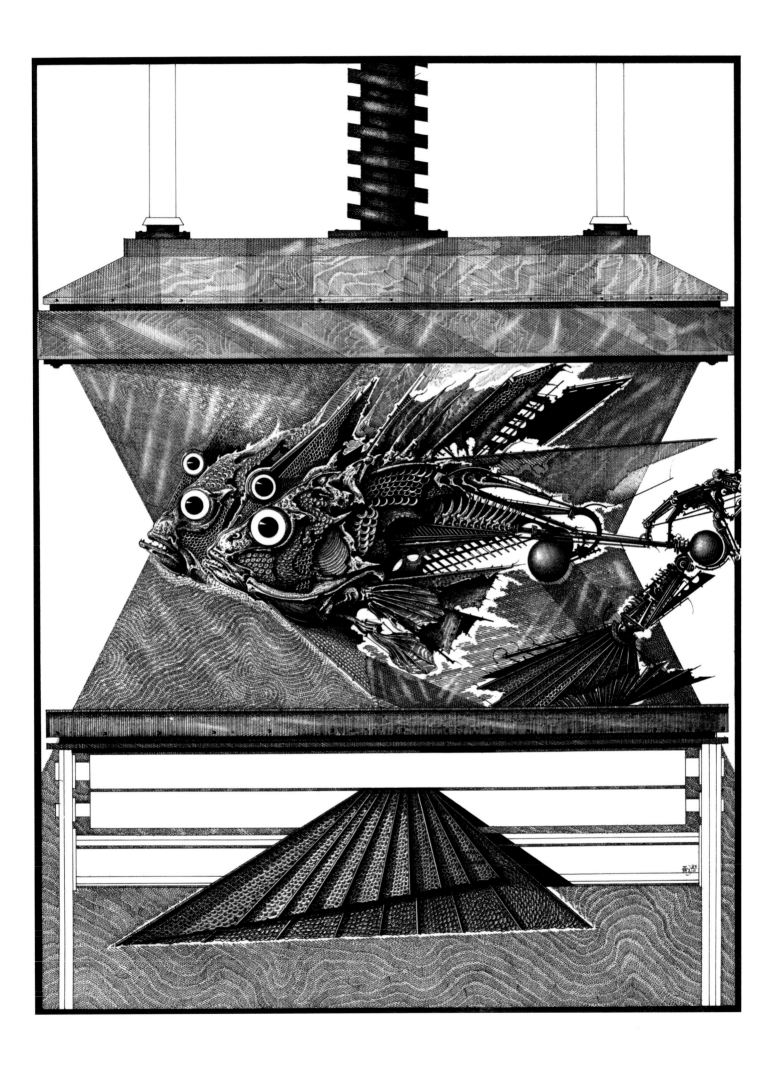

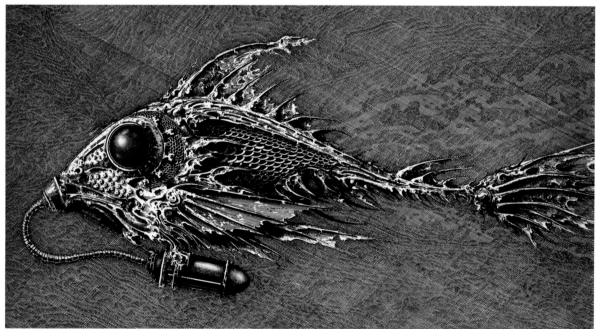

This fish was used by Greenpeace in the late 1980's as part of its continuing campaign against the pollution of our oceans. If the water had been cleaner, this particular fish would have been healthier and able to breathe oxygen without the aid of a filter.

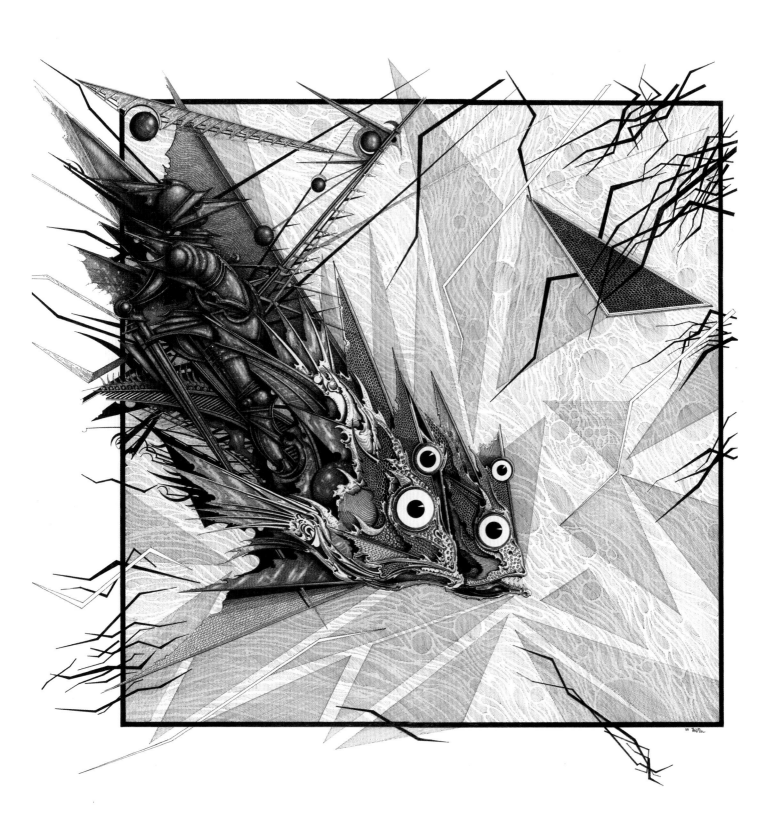

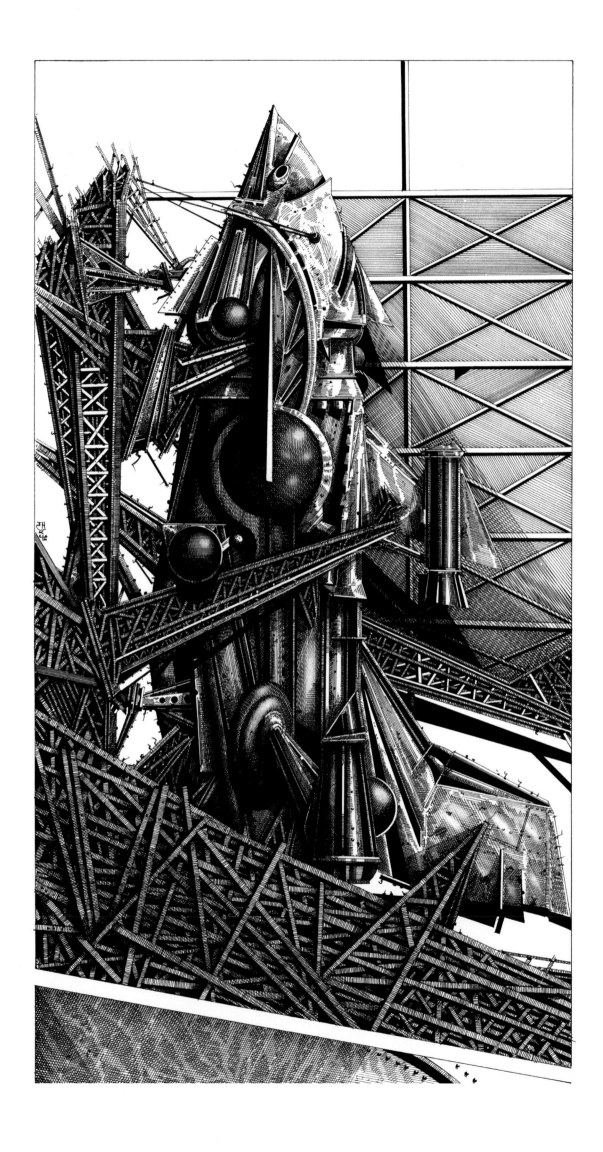

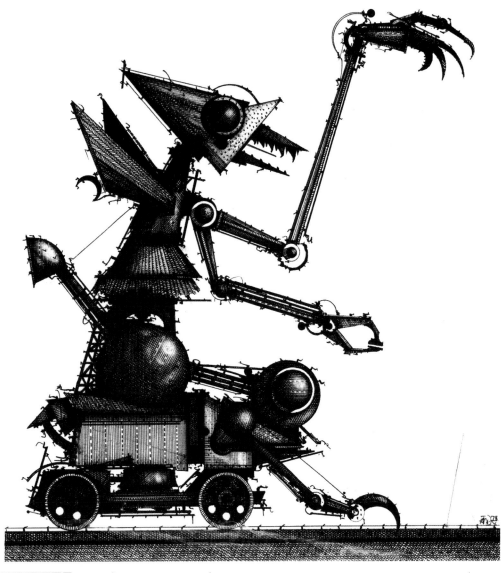

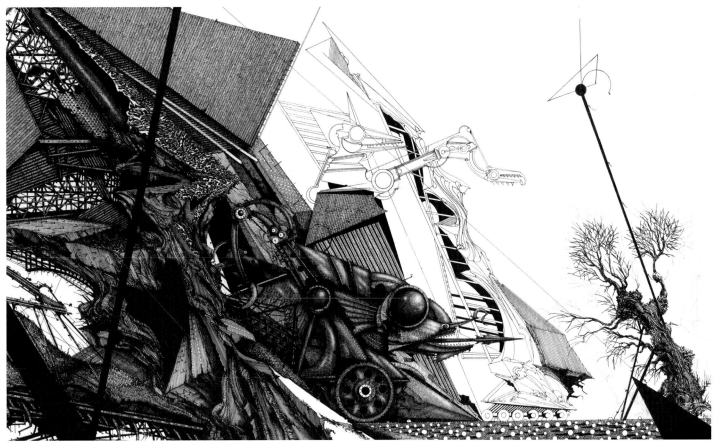

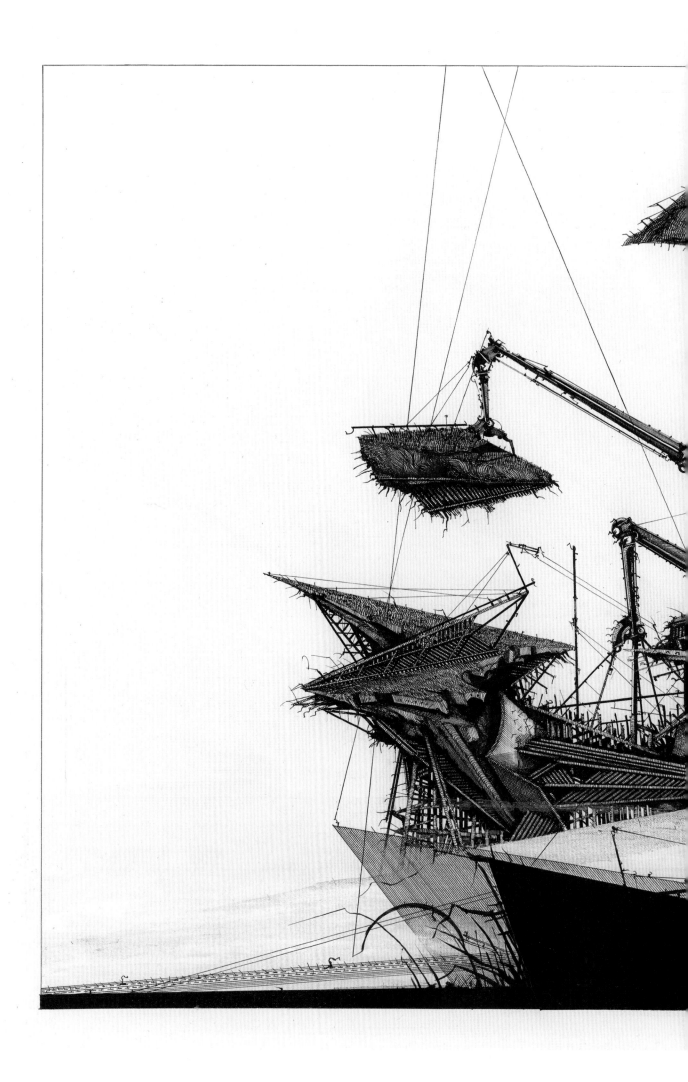

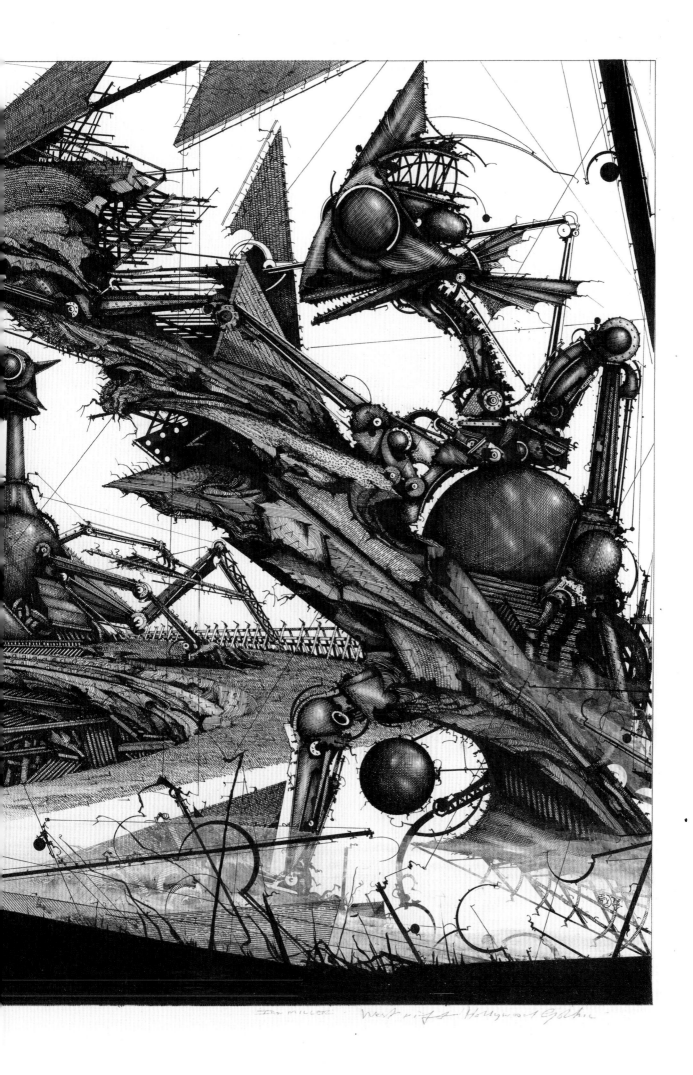

JOHN MILLER West wing: Hollywood Gothic

CASTLES & KINGDOMS

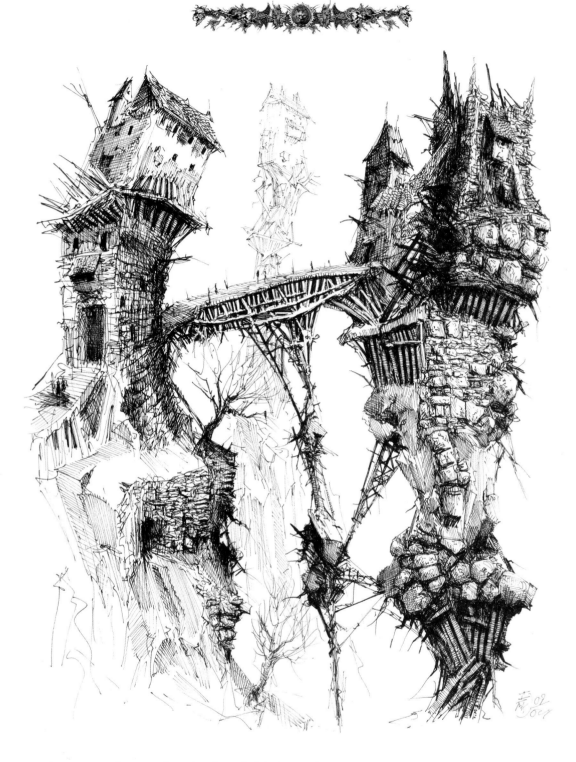

I love drawing castles…you might say with a schoolboyish delight. Strange to say, I felt more vulnerable and uncertain on the battlements of Alcázar of Segovia looking out and down than I did standing on the bridge outside its gates. Maybe I'm a creature born for siege and tunnel digging. I always imagined being inside an armoured tank was safe but after reading about them 'brewing up' (exploding rather a lot) I thought again. I came to the conclusion, erroneous or not, that being inside a castle might not be so wonderful either when it was under attack. In short I think castles might well be a metaphor for vulnerability rather than strength. You may well disagree.

I like the word: transmogrification, the idea of transforming objects in a surprising or magical way. Here I wanted to challenge the certainties of hard stone, architectural structures, and gravity, by twisting and softening the facades to imbue the inanimate rock with life. In a fantasy context this is the perfect fillip and it fitted well with the kind of reality that Games Workshop wanted.

I must have been six years old when I discovered castles painted on glass. They had been created by a film company for superimposition on a real landscape; and how real it all looked. I realized Illusion was king after that and anything was possible. Secret doors in wardrobes, worlds unseen were common coinage. Phantasmagorical is another of my favourite words.

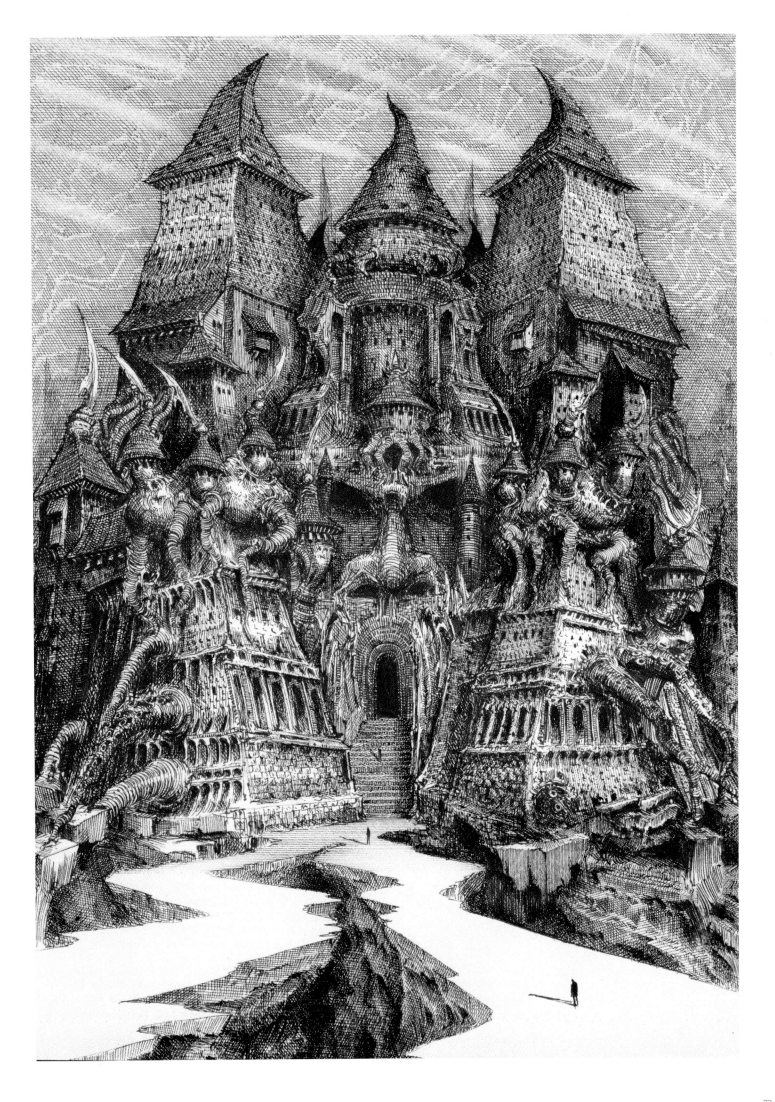

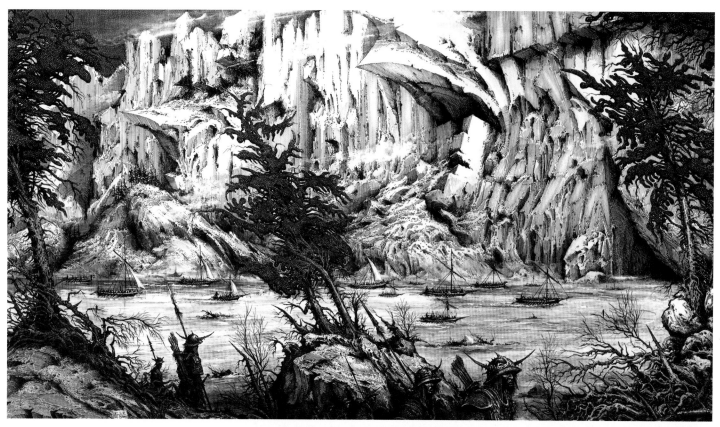

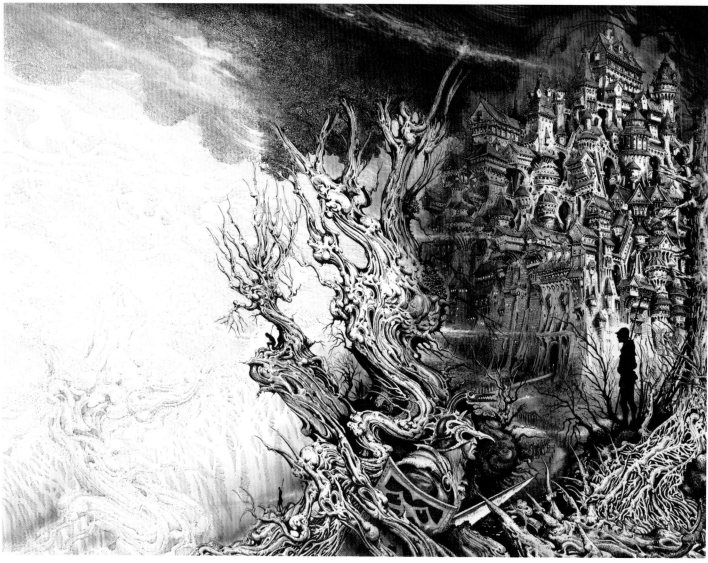

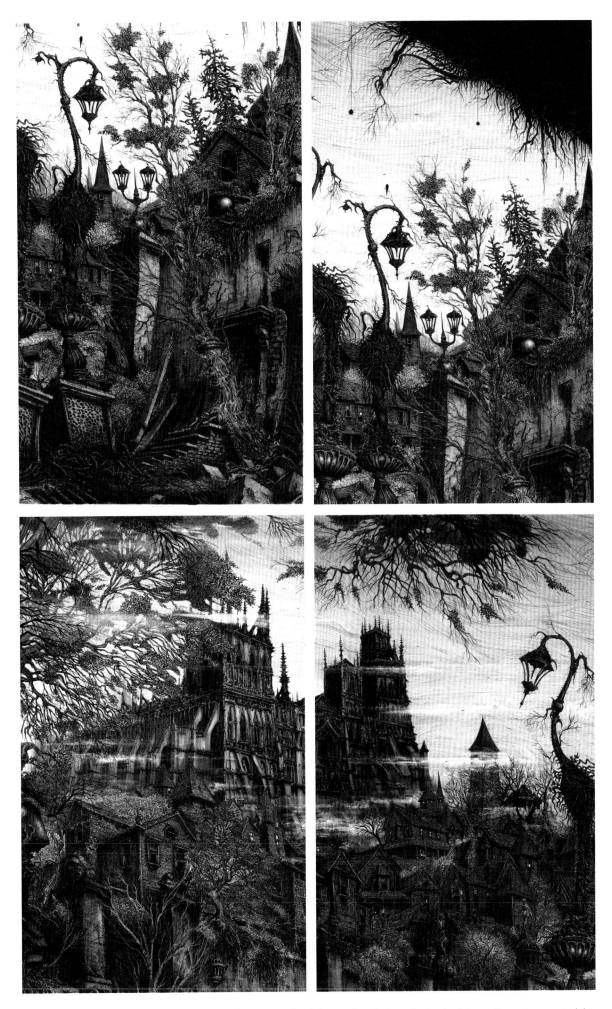

These are four sections from a larger drawing of Arkham, the fictional city in Massachusetts created by H. P. Lovecraft. The drawing was a private commission.

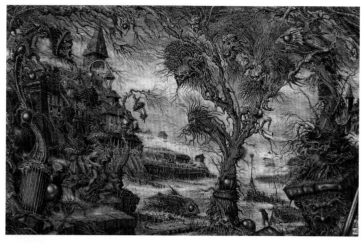

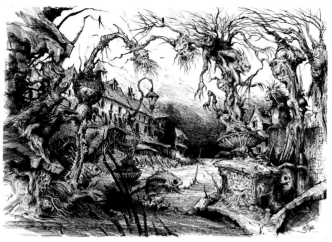

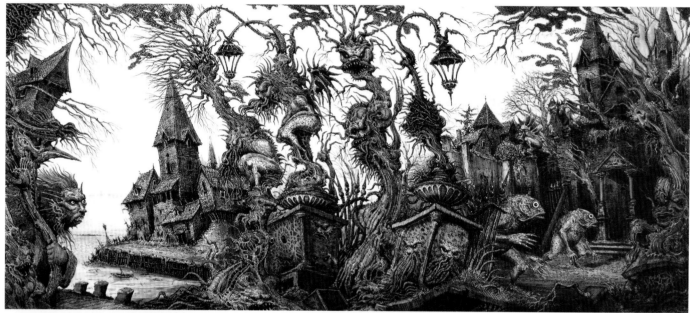

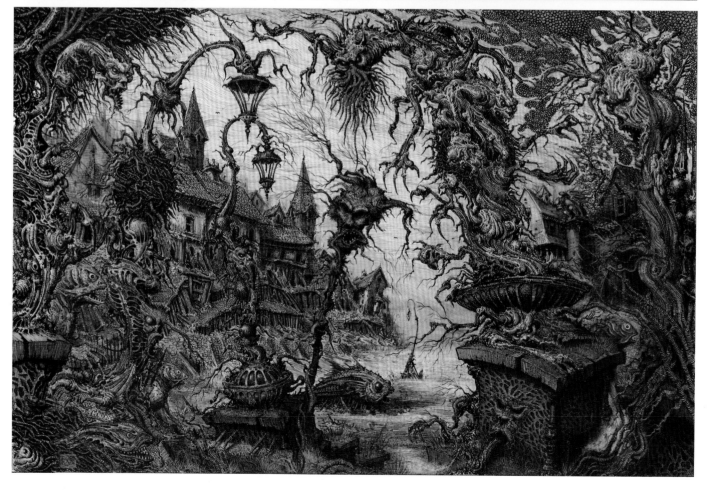

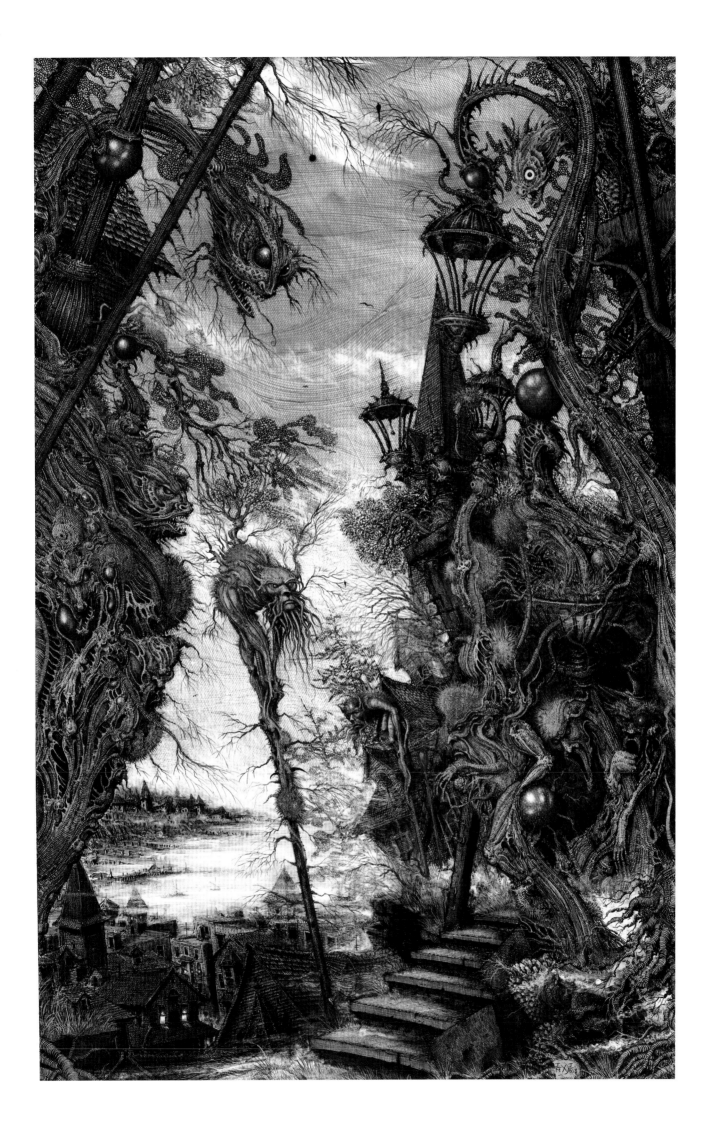

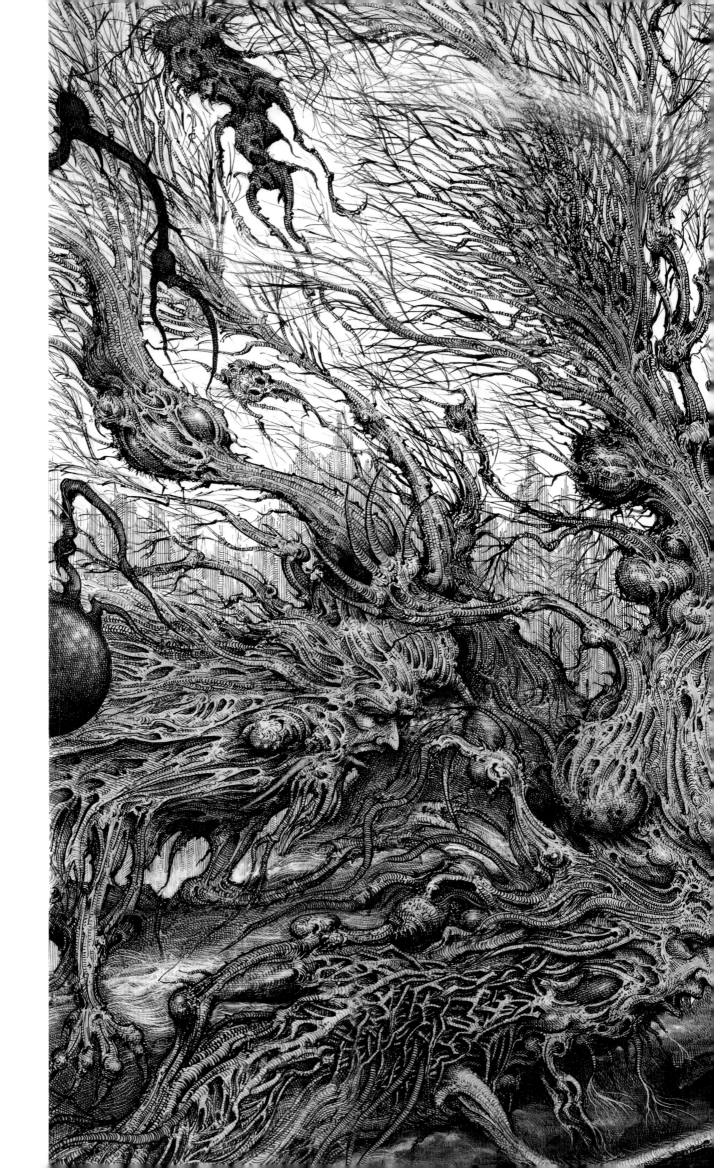

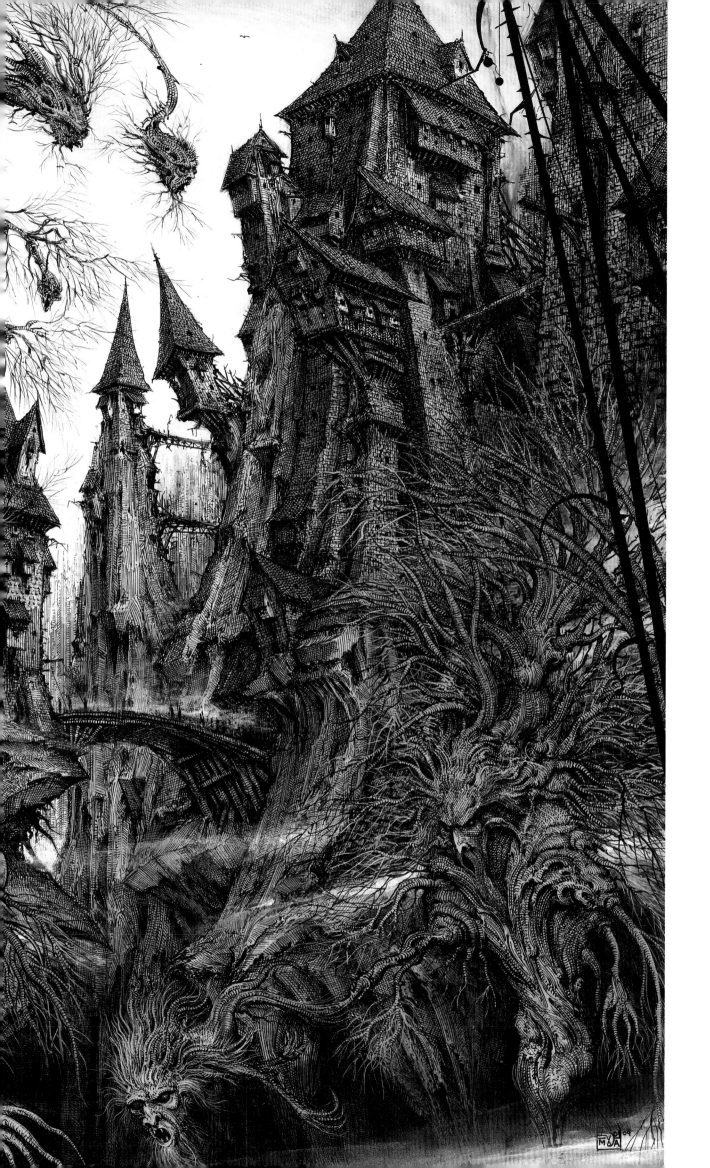

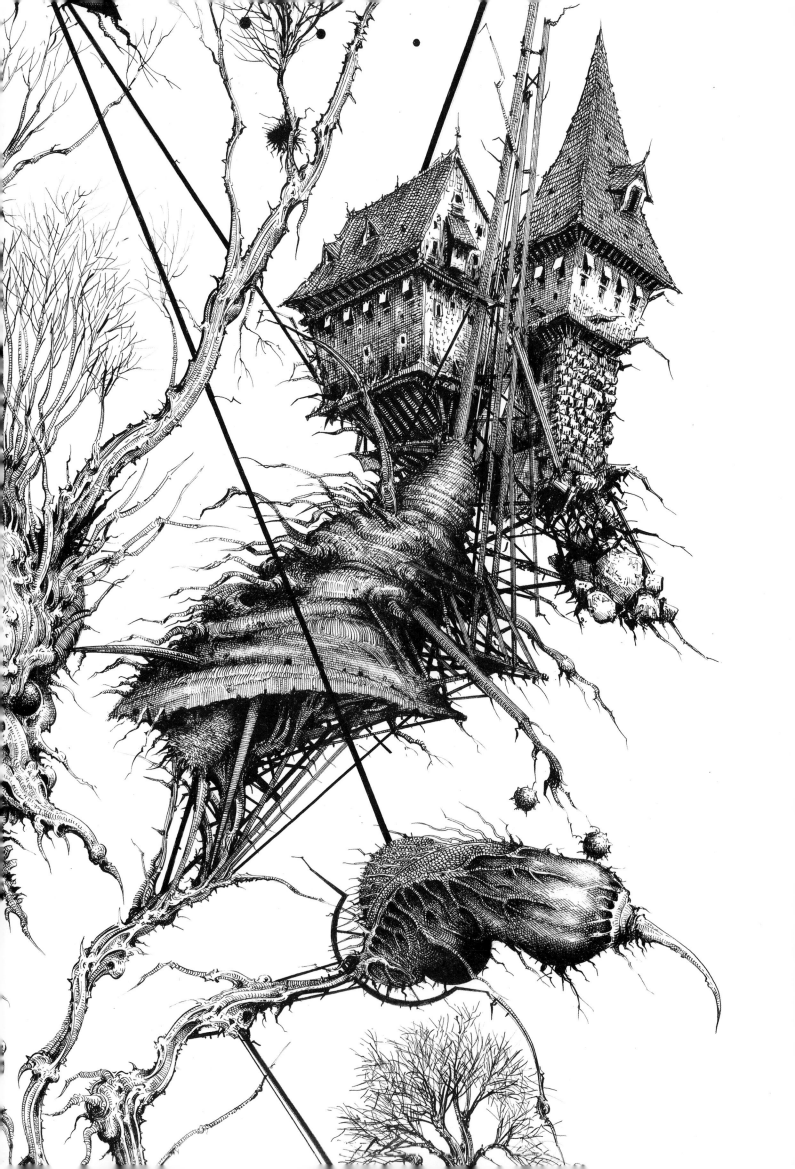

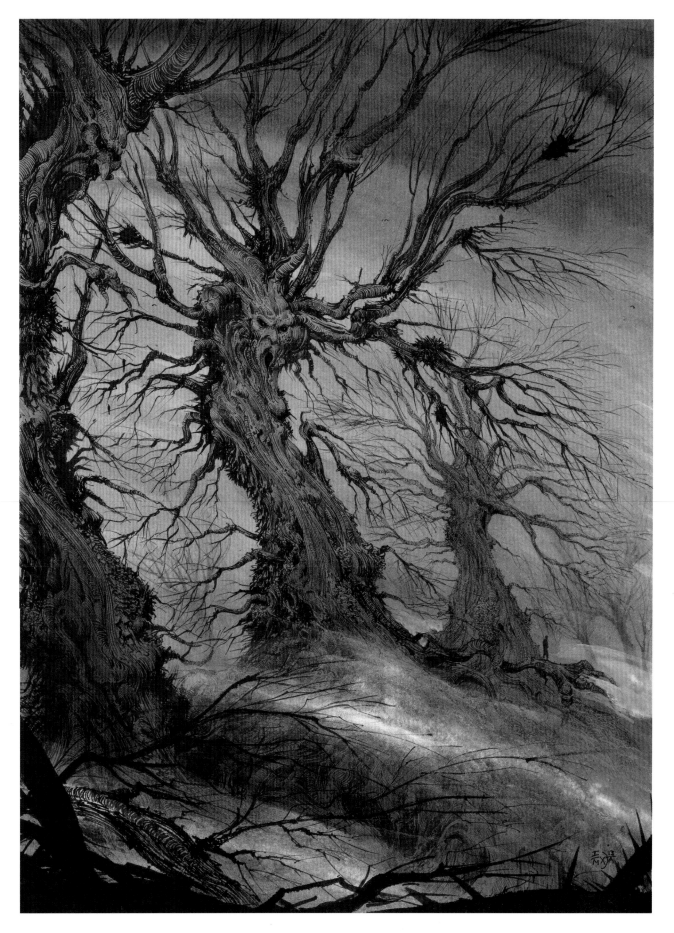

Trees. I can't stop drawing trees. I don't know why and I don't think I really need to know. I don't draw any particular type of tree but rather an amalgam of what I think a tree is. Ents are an easy next step. Wintry ones without the growth of leaves offer stronger, starker lines which can be used to powerful effect, bleak landscapes also. Perhaps it is the underlying sense of hostility in these wintry scenes that disturbs some viewers?

As a point of interest: I've always loved Arthur Rackham's tree drawings and am sure their influence can be readily identified in my own.

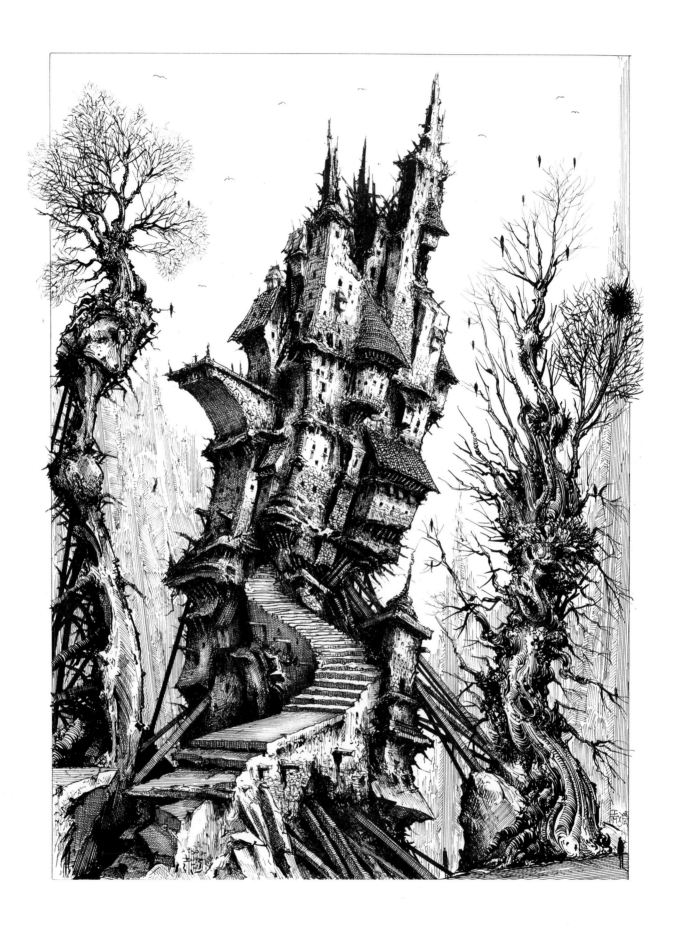

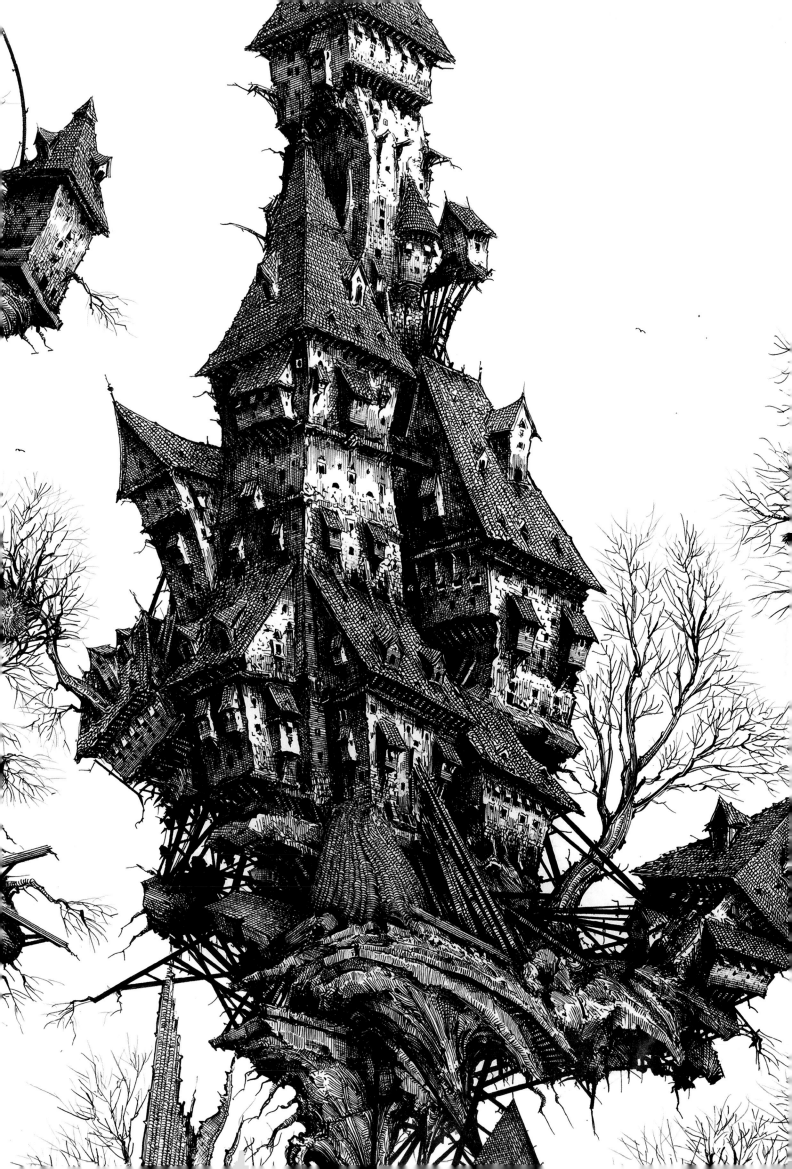

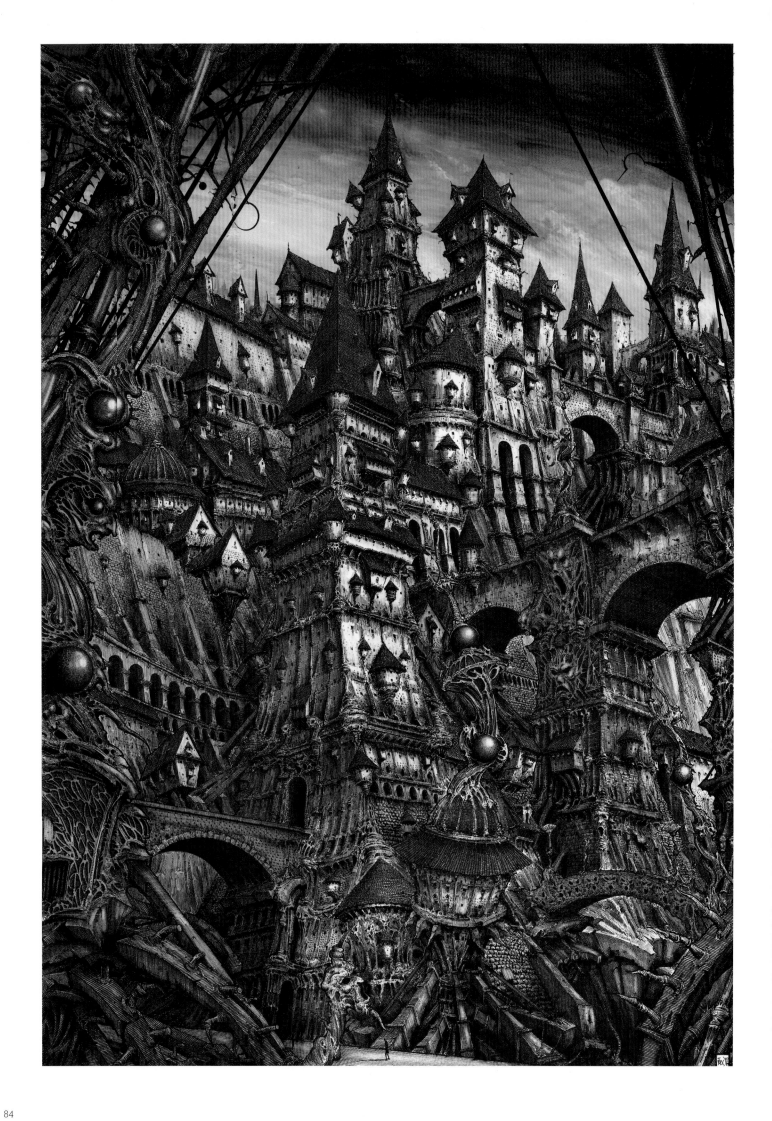

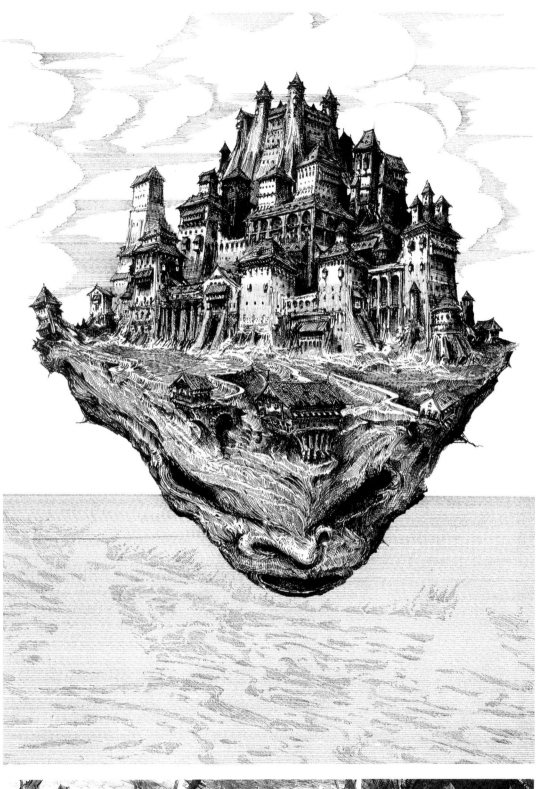

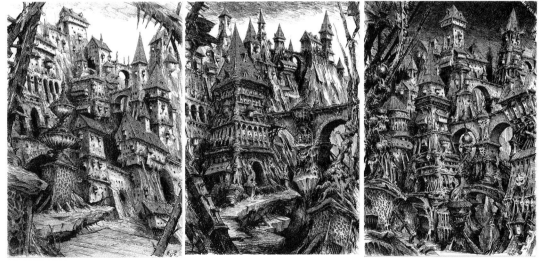

This was a recent redraw of a wrap-around paperback cover I did for Lovecraft's *Haunter's of the Dark* for Panther in the 70's. I wanted to see how I would handle the drawing all these years on. I have a strange affinity for Lovecraft. Maybe it's my preoccupations with dark cupboards and fish heads that does it, who knows? In any event, the brooding interplay between light and dark in his stories had always intrigued me. Once read, the stories nestle down in a dusty corner of your mind, arcane twitches and all, and never, ever go aways again. Some say they haunt you.

Over the years a lot of people have said how much they liked the original cover image, so drawing it again came easily. Whether I did any better the second time around is a moot point but I did enjoy the adventure.

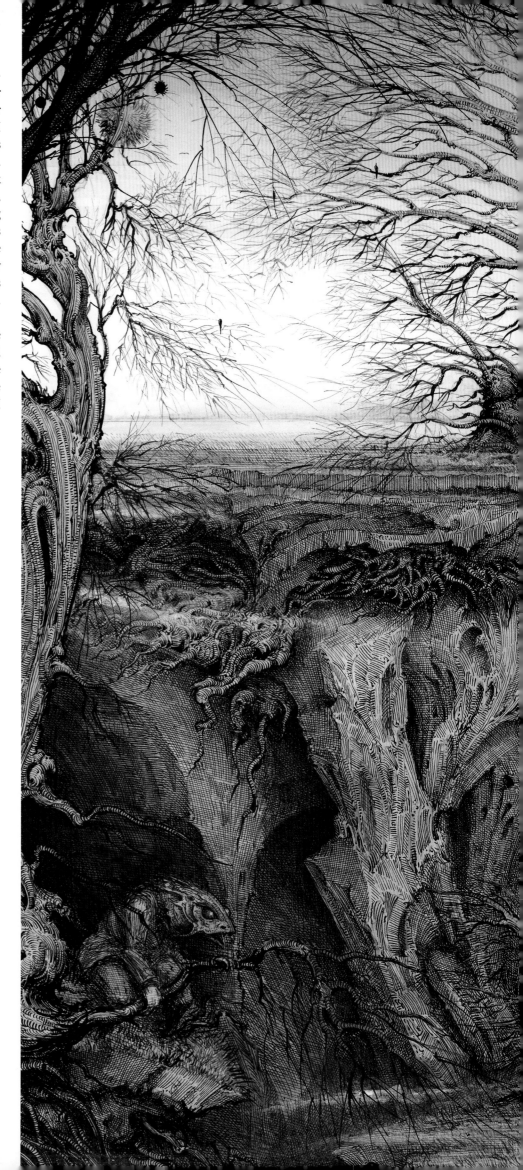

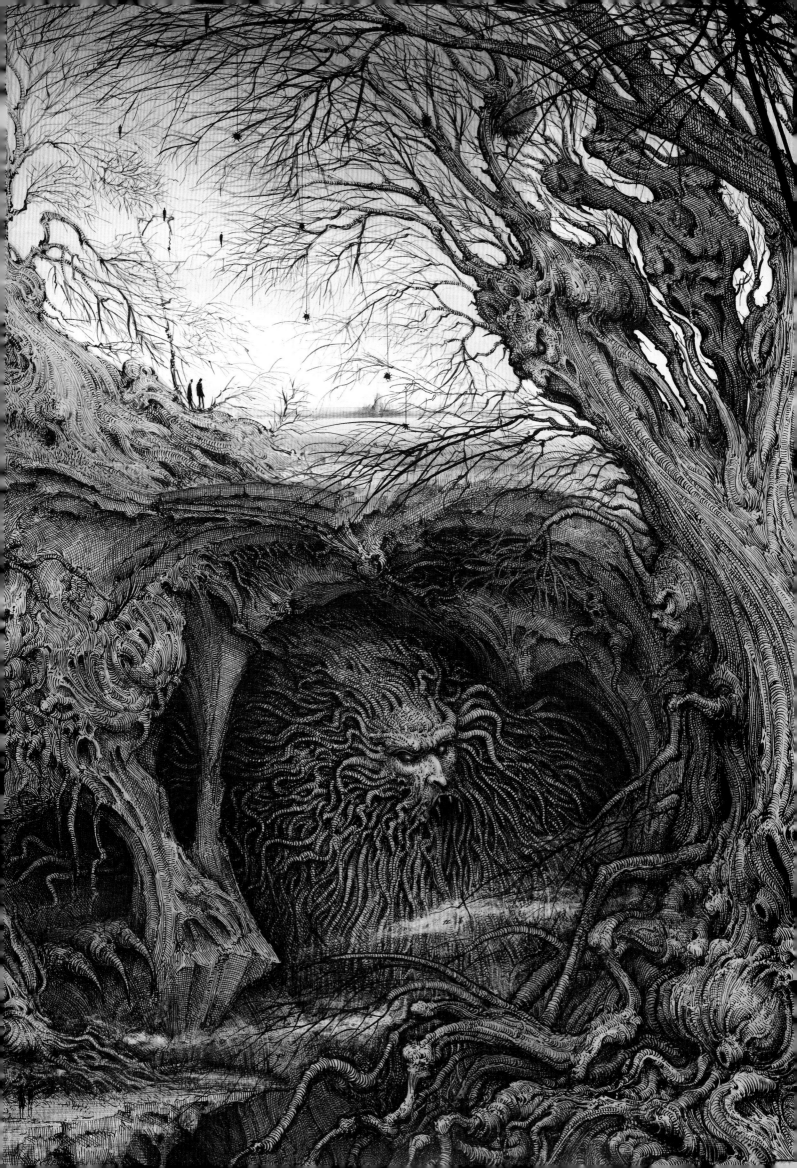

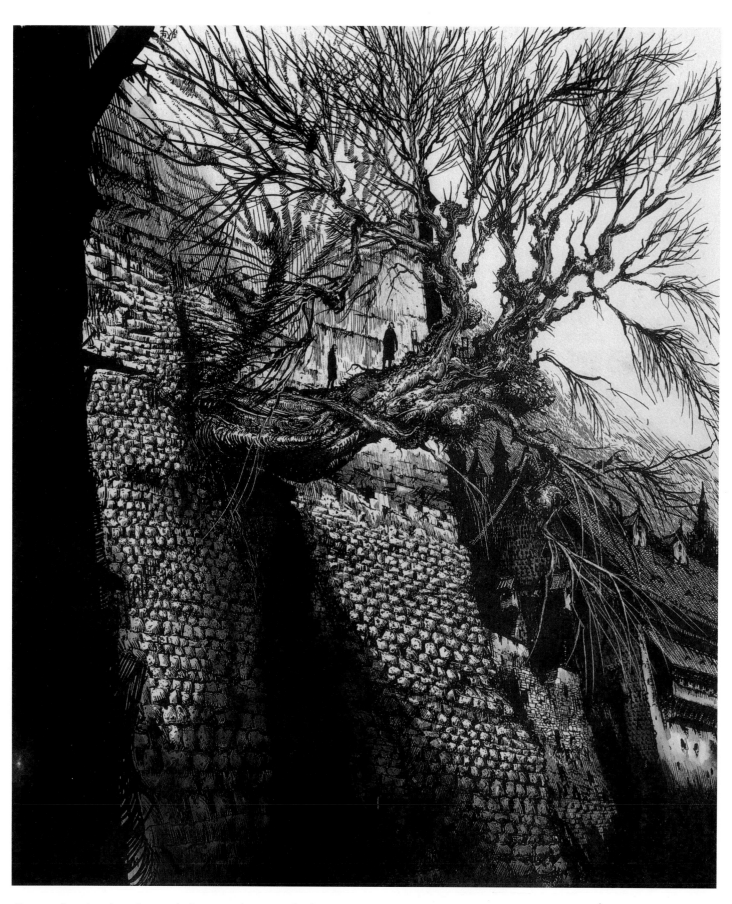

Gormenghast is a draughtsman's dream and a painter's obsession. Mervyn Peake's castle stands as fixed stone in a drama of complex characters and movement. Darkness vies with light, the beautiful with the grotesque, in a pageantry of grey stone and colour. The sheer scale of Mervyn Peake's imagination makes it impossible to do full justice to Gormenghast; I drew my first Gormenghast image in 1974 and can always imagine another way forwards. This drawing is as close as I have ever got to date… I'm still trying.

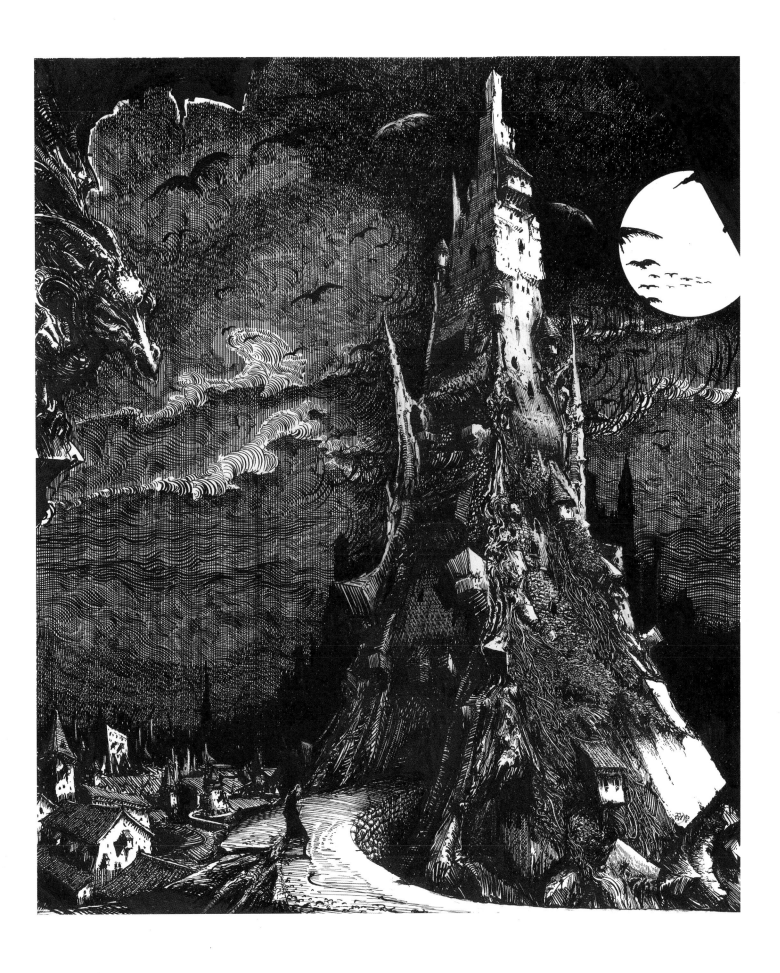

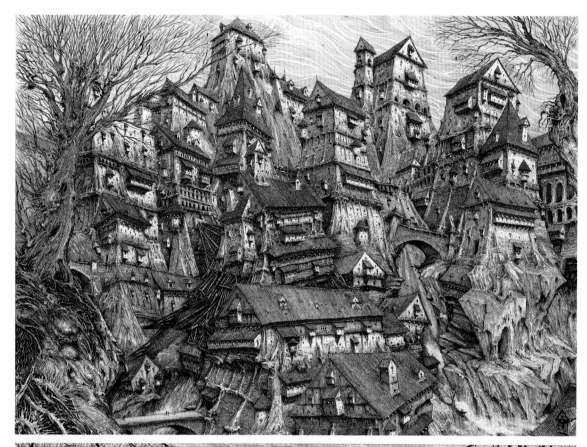

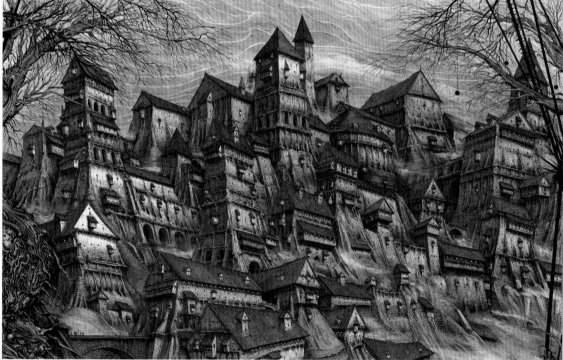

I keep returning to *Gormenghast* in an attempt to grab the essence of its spirit. As a child, I was given unforgettable advice by the art master Mr. Beck about the minute gap between success and failure: "Twitch once, Miller, and you're king of the heap. Twitch twice and you're inconsolably lost. Carry on and remember the twitch." It was under Mr. Beck's influence that I determined to become an artist.

My own artistic process goes like this: I think about and around the image, make sketches and refine them, then jump in and go for a finished piece. Most times this works out fine and everything flows sweetly; sometimes it is a struggle and nothing appears to work. When this happens it is necessary to step back, take a deep breath, revise the plan and approach the task from a different angle. This for me is the nature of the beast. What you never ever do is give up.

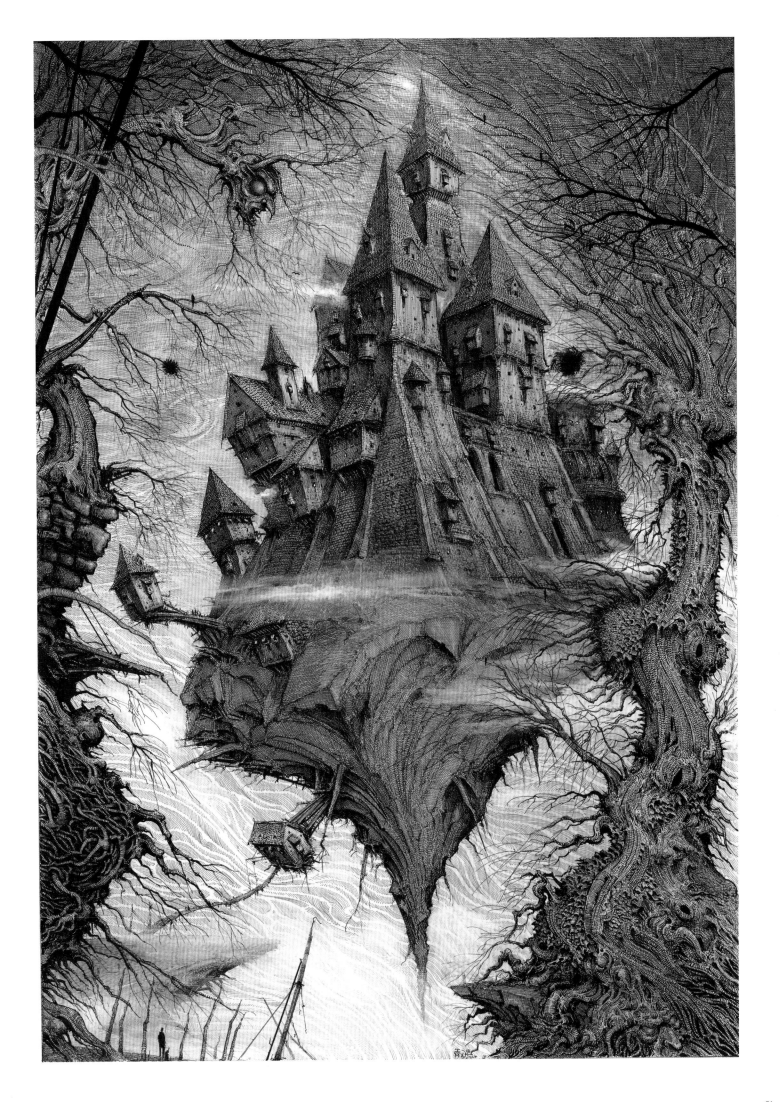

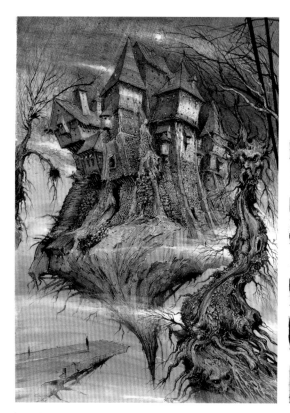

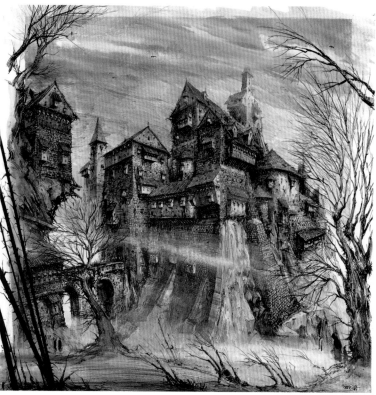

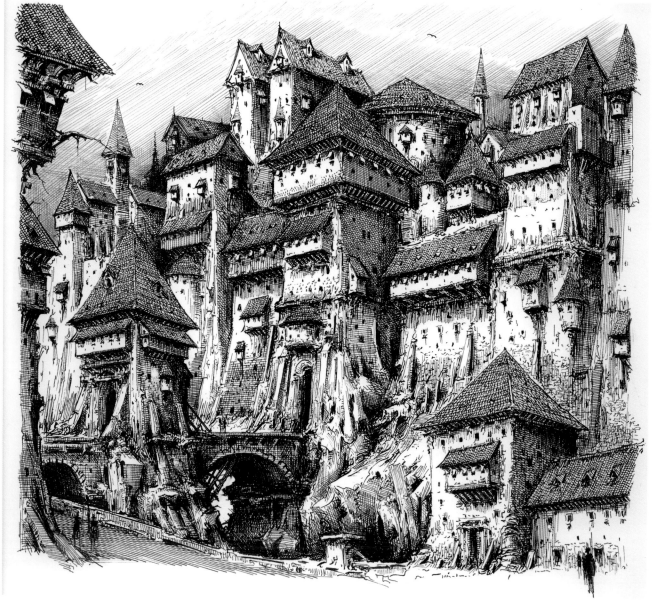

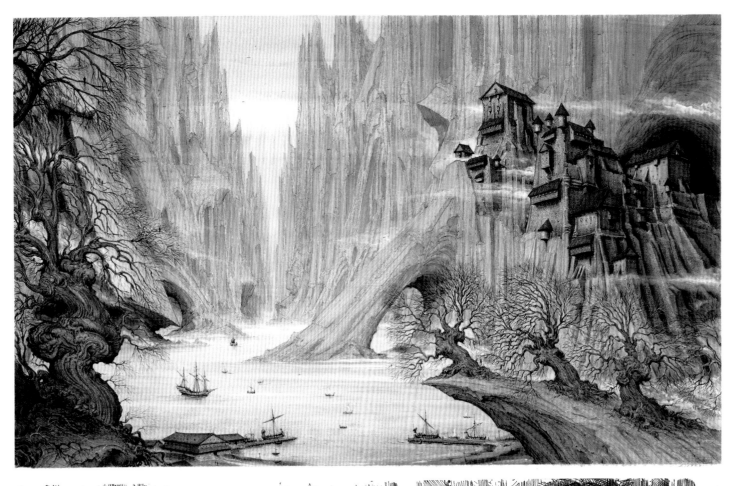

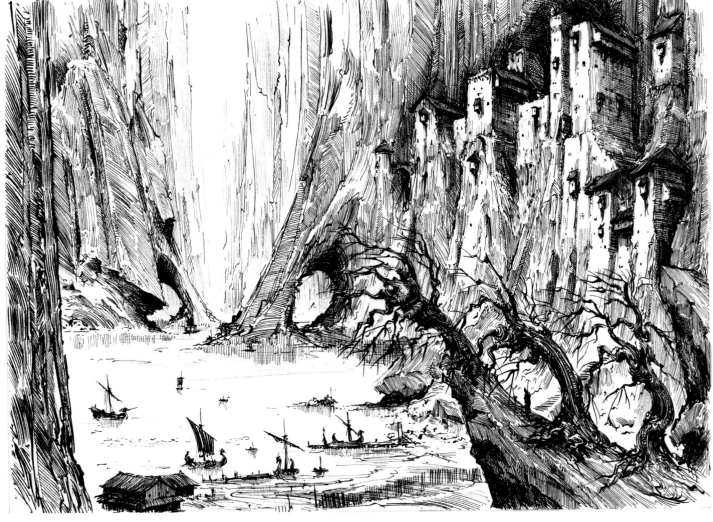

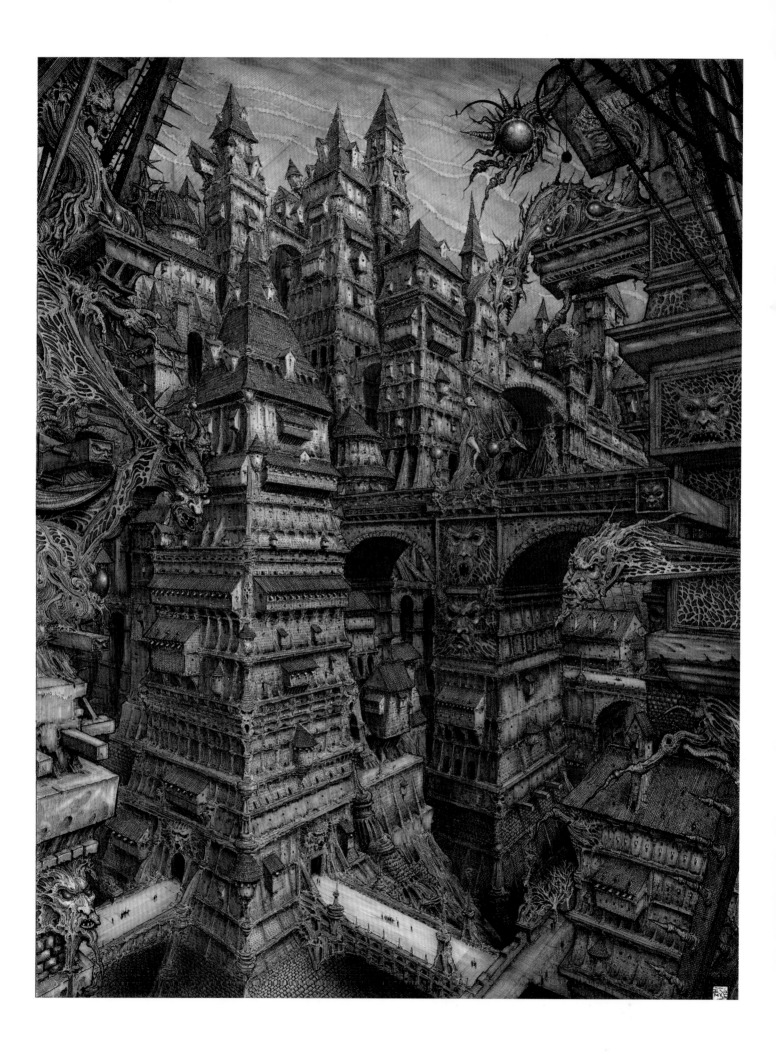

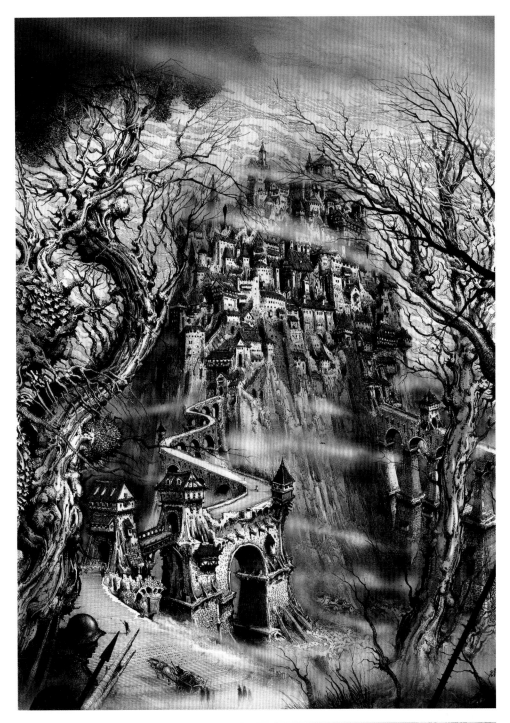

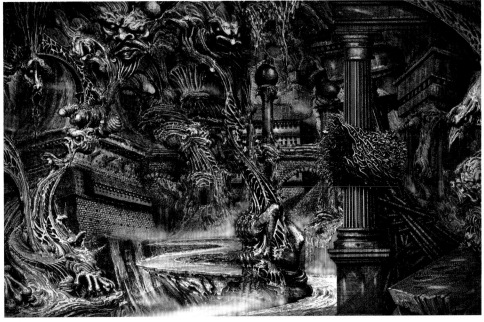

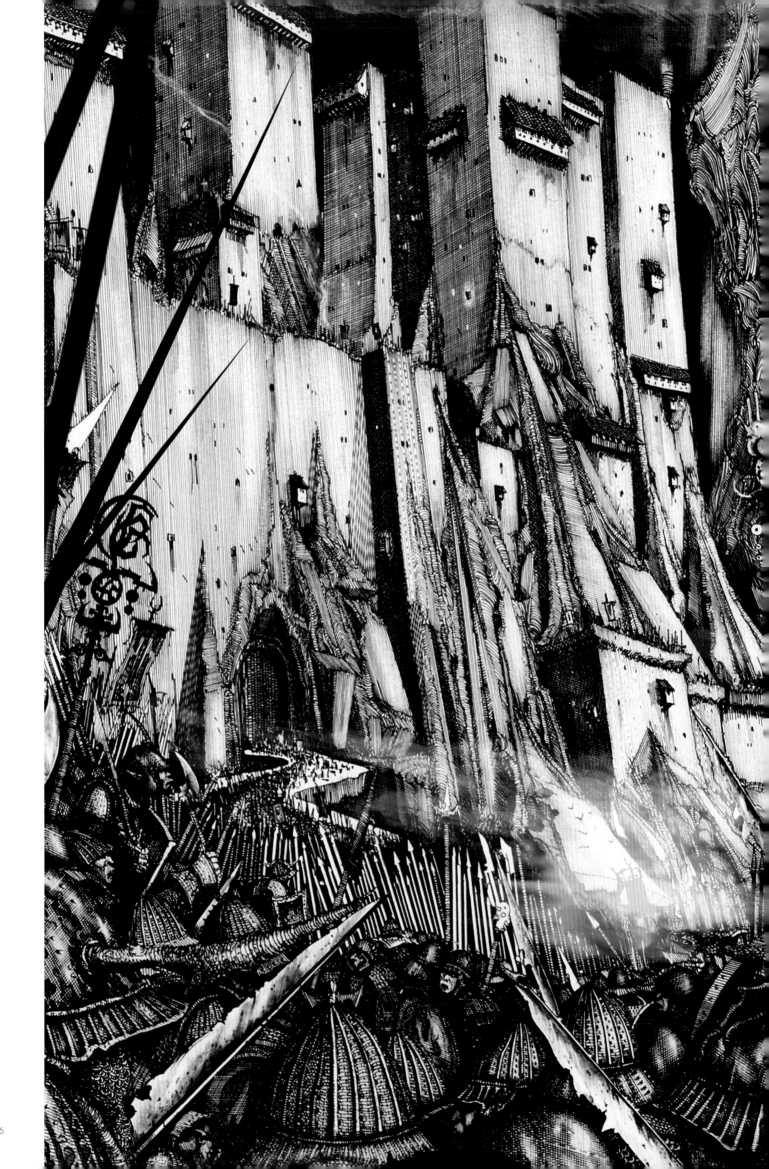

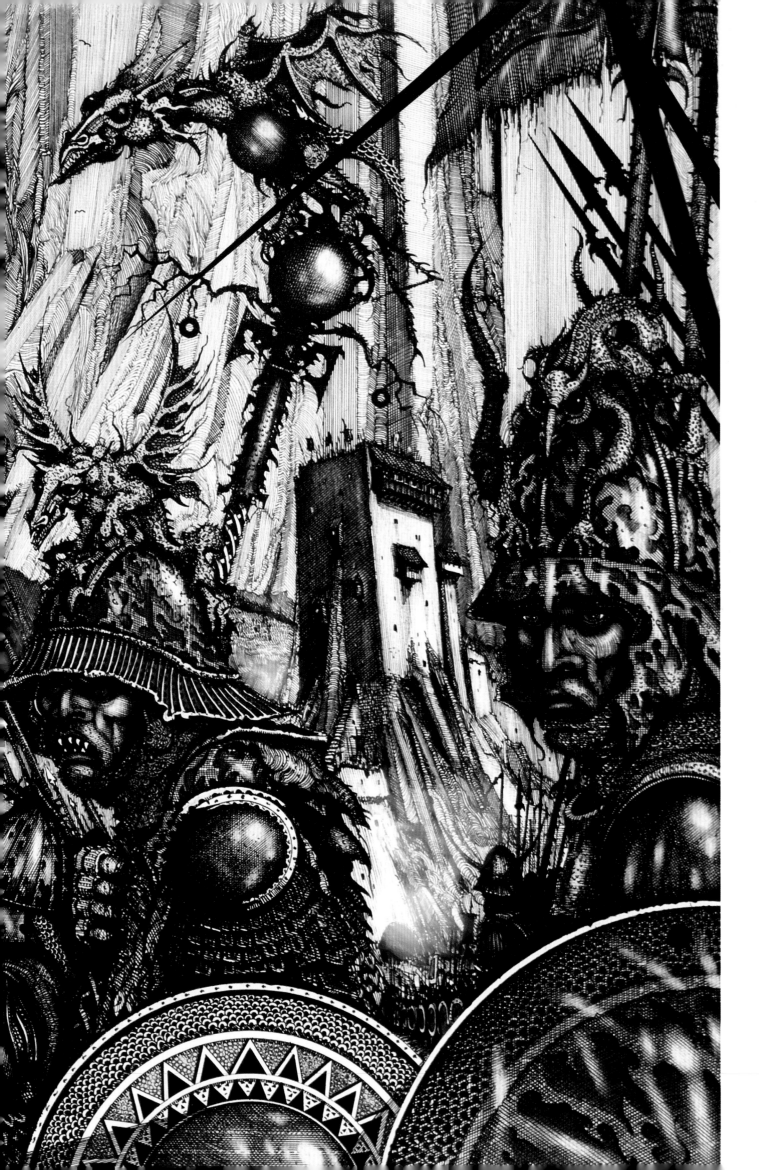

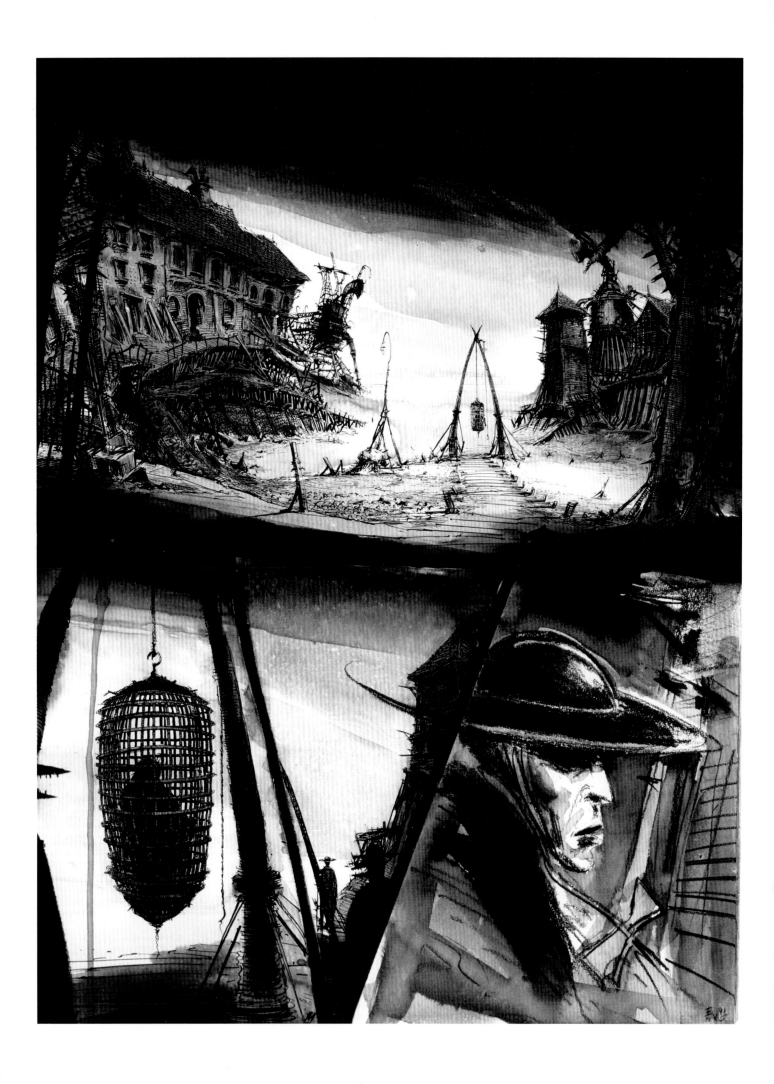

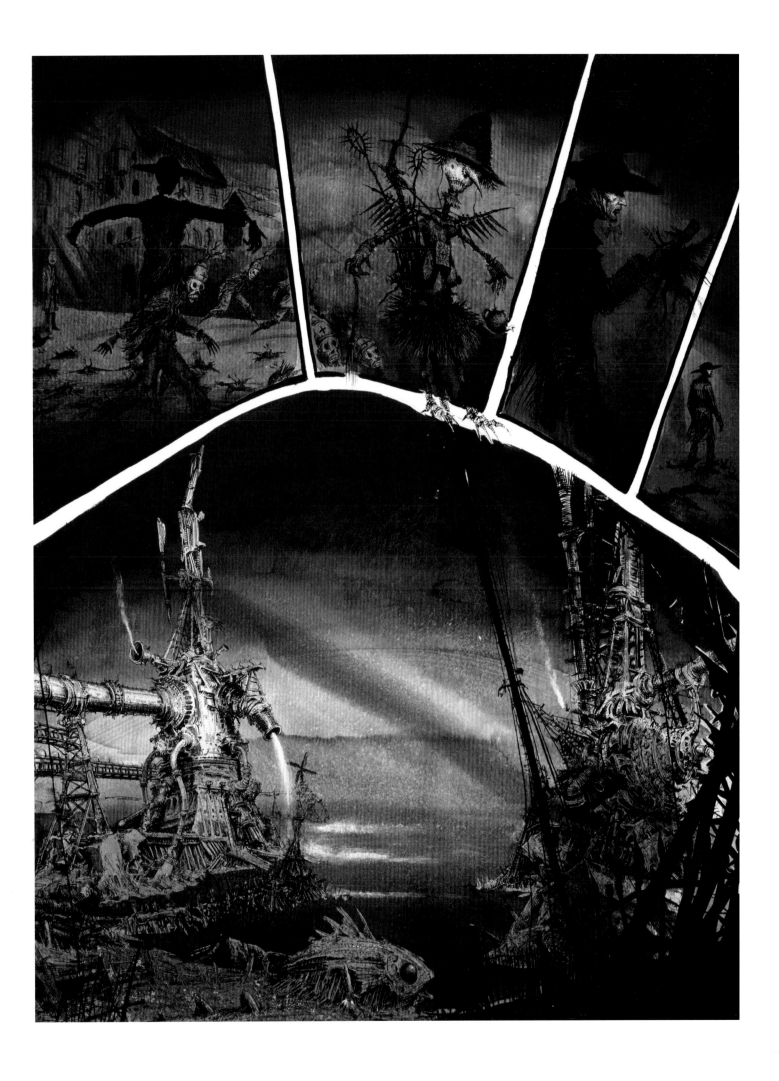

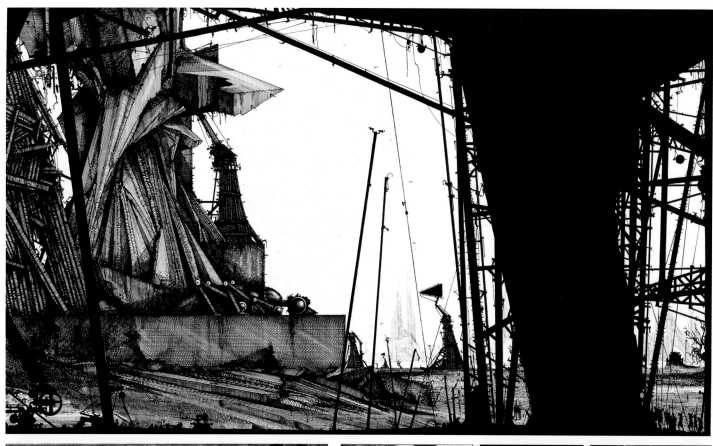

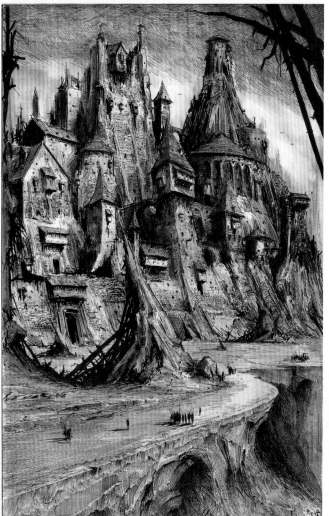

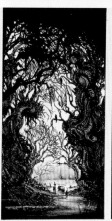
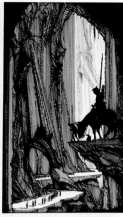

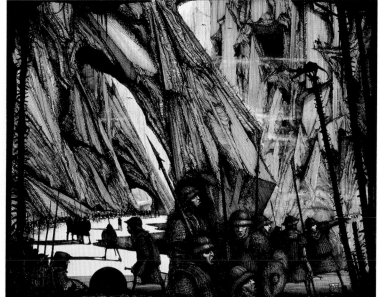

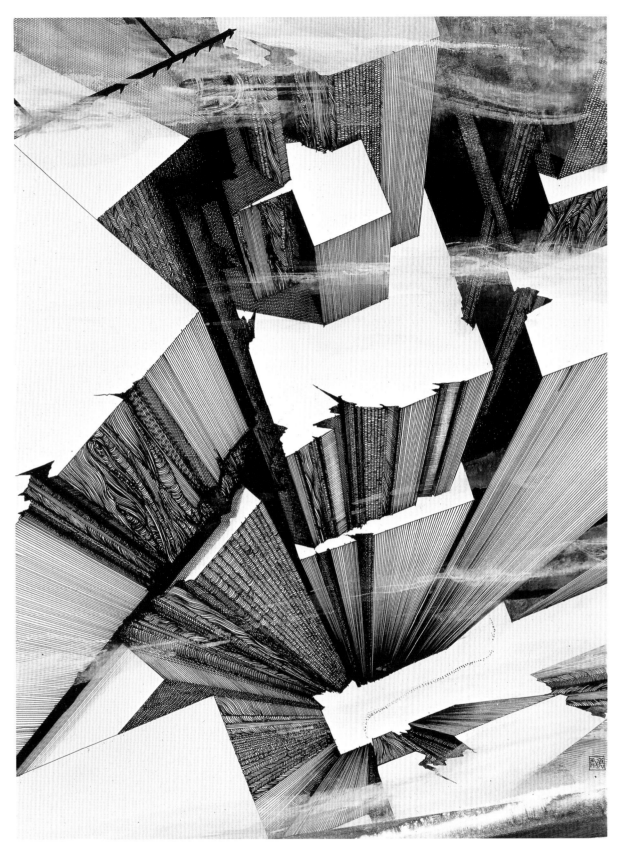

This was as much as an exercise in perspective as tale telling, executed with technical pens in what I often call my 'tight pen' style. The introduction of dip pens and bottled inks alongside the technical pens allowed a far more lively interplay in my images, a new harmonic. Nibs on a dip pen are far more responsive to mood and direction change. The flex and pressure introduces variations in the line, thickening on the turn perhaps, becoming much lighter on the straight - in short, a modulated line that allows the eye to traverse it at different speeds. Lines drawn in this fashion resonate actively on the eye. This interplay between eye and line is an essential factor in the success of my images. There is, of course, some undefinable element, magic if you will, in all creative processes that is perhaps harder to pin down and easily define. Knowing everything would be a little boring I think.

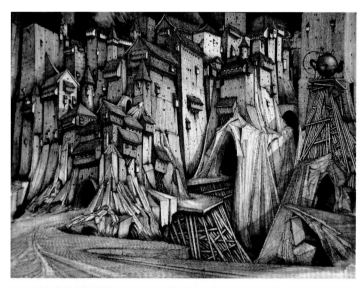

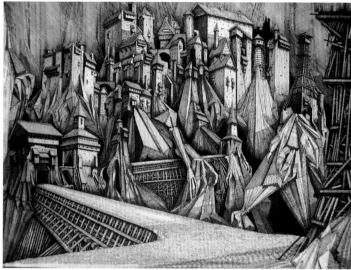

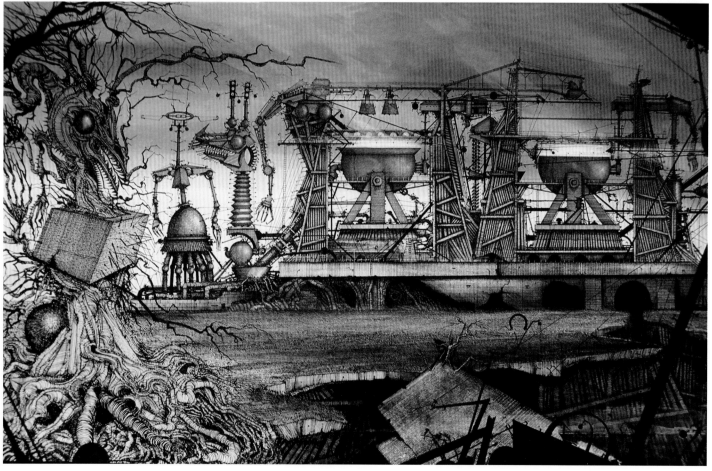

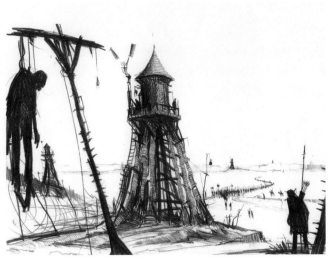
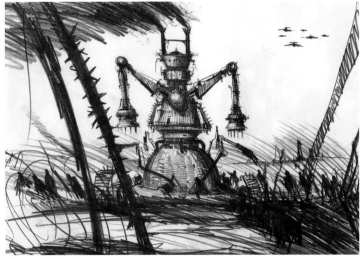
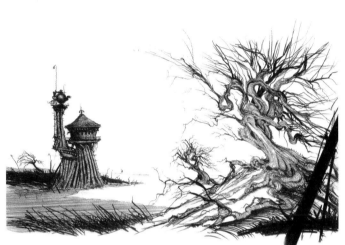
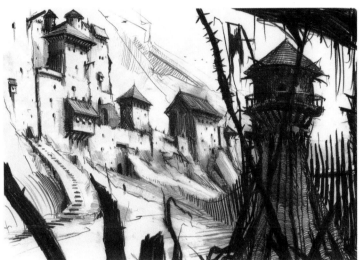
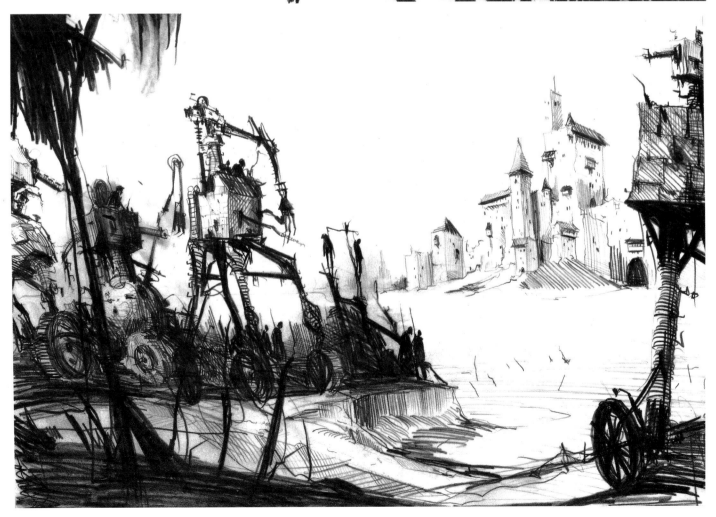

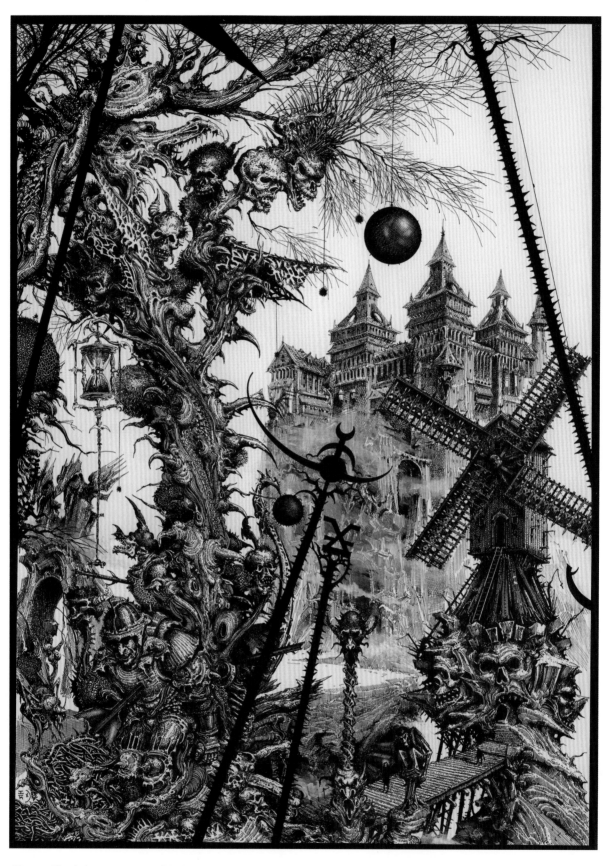

Chaos Citadel was executed using a mix of technical and dip pens, in sepia and black ink. The interplay between the pen lines and two hues was for me a very successful combination and exercise. A water colour wash was also applied in some areas of the drawing. Given my concern with the visual impact of line work, I think this image resonates on the eye rather well.

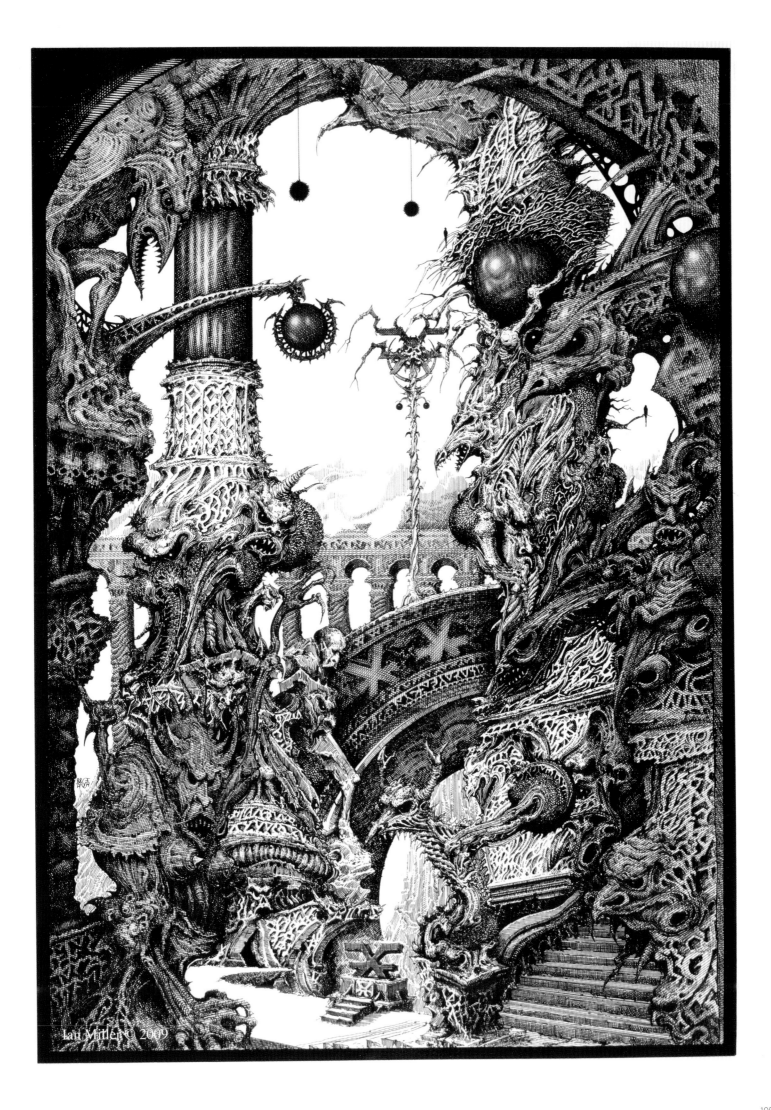

Ian Miller © 2009

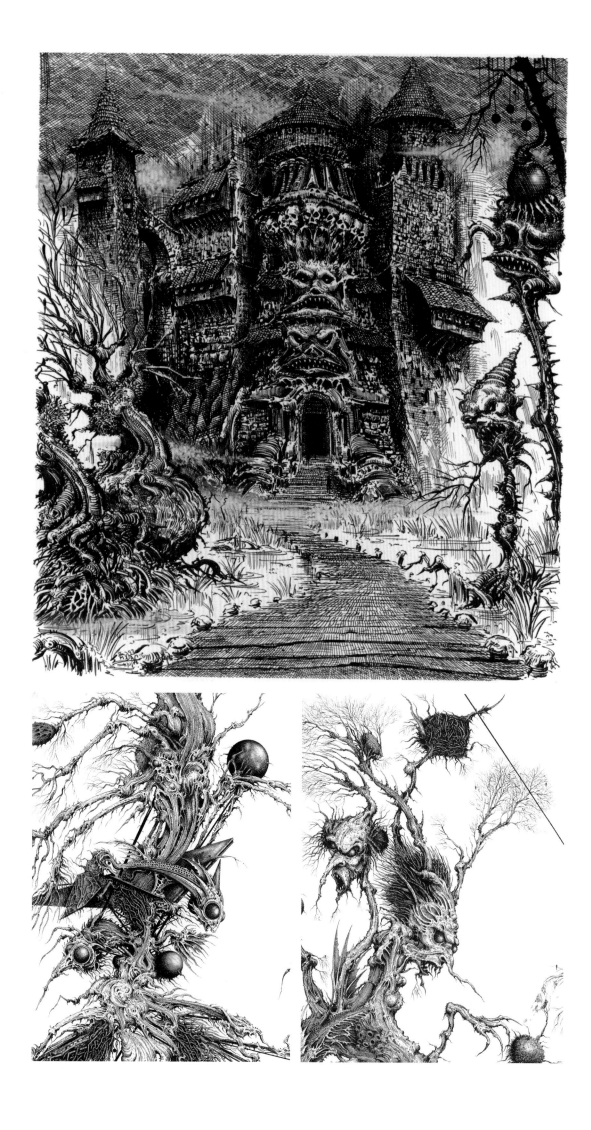

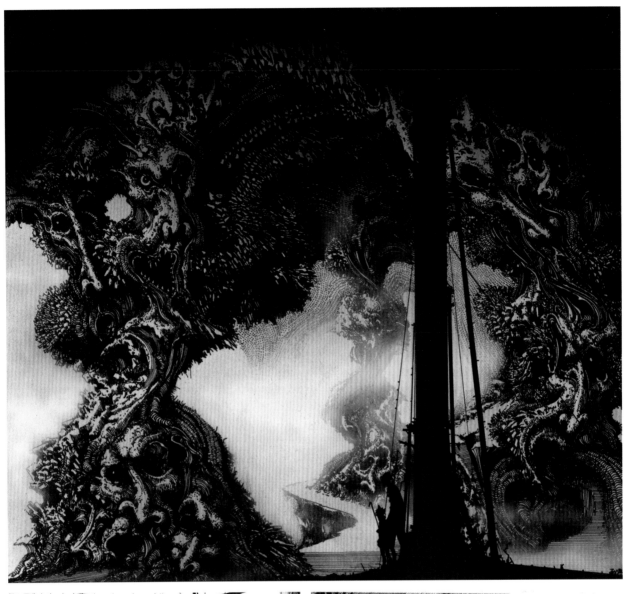

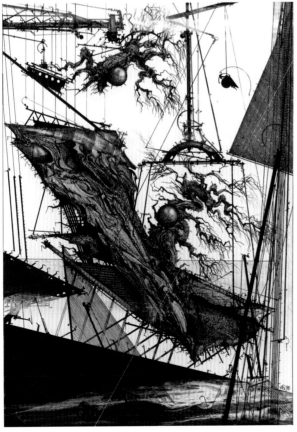

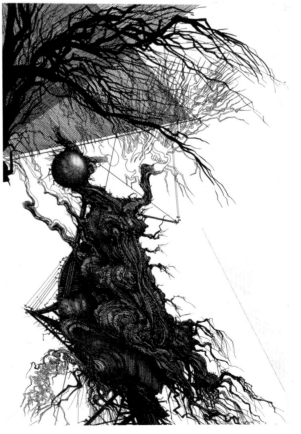

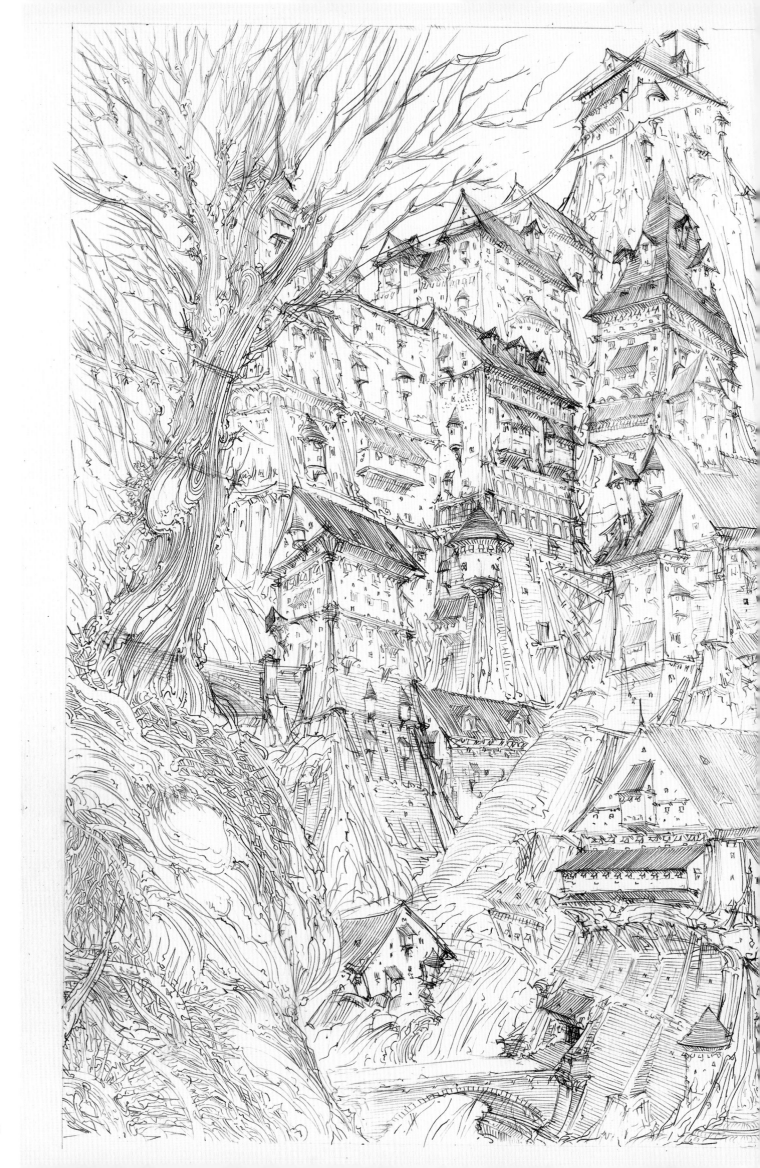

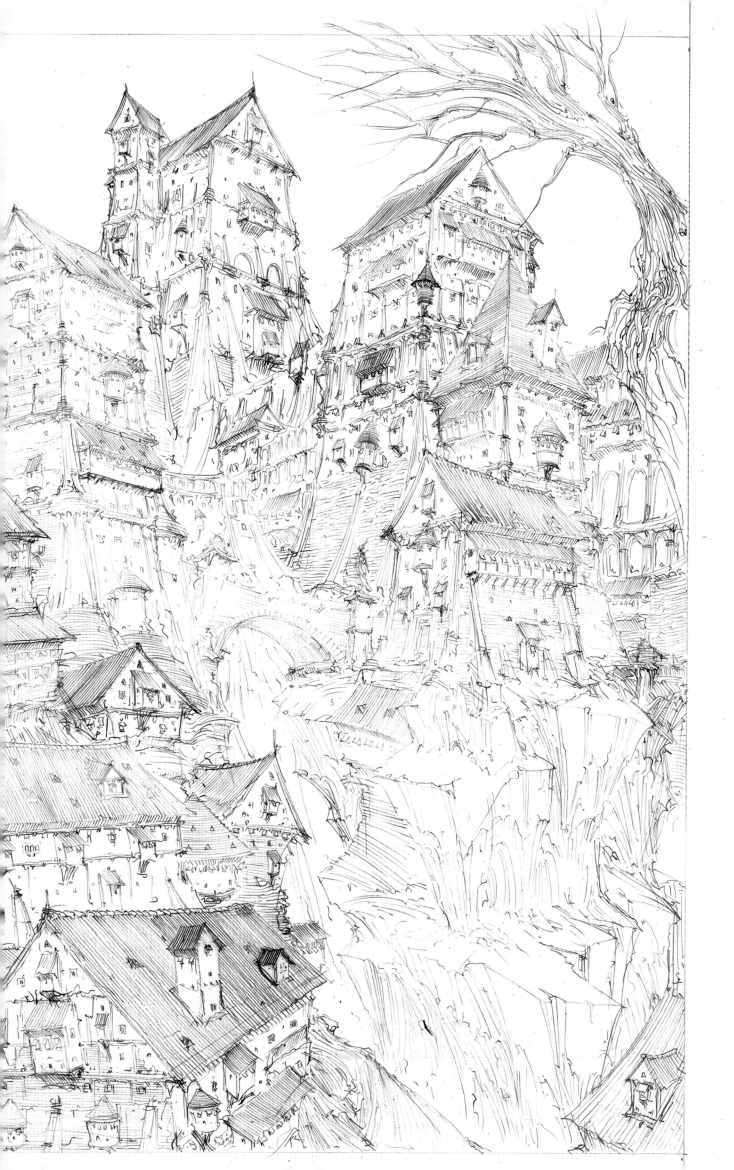

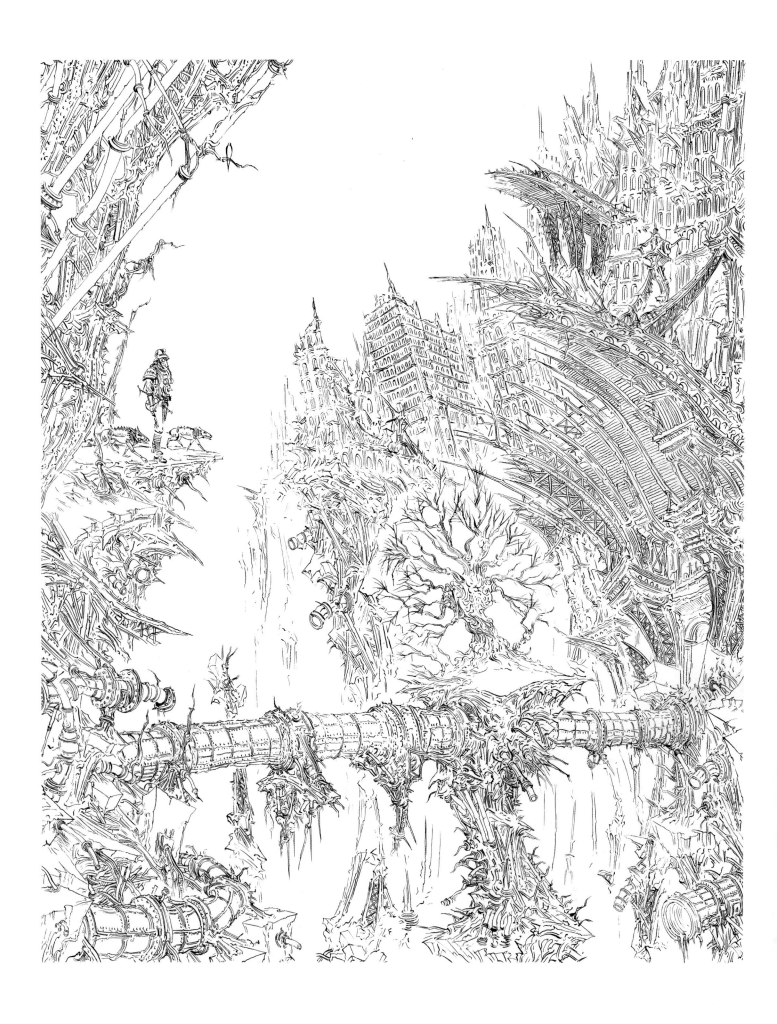

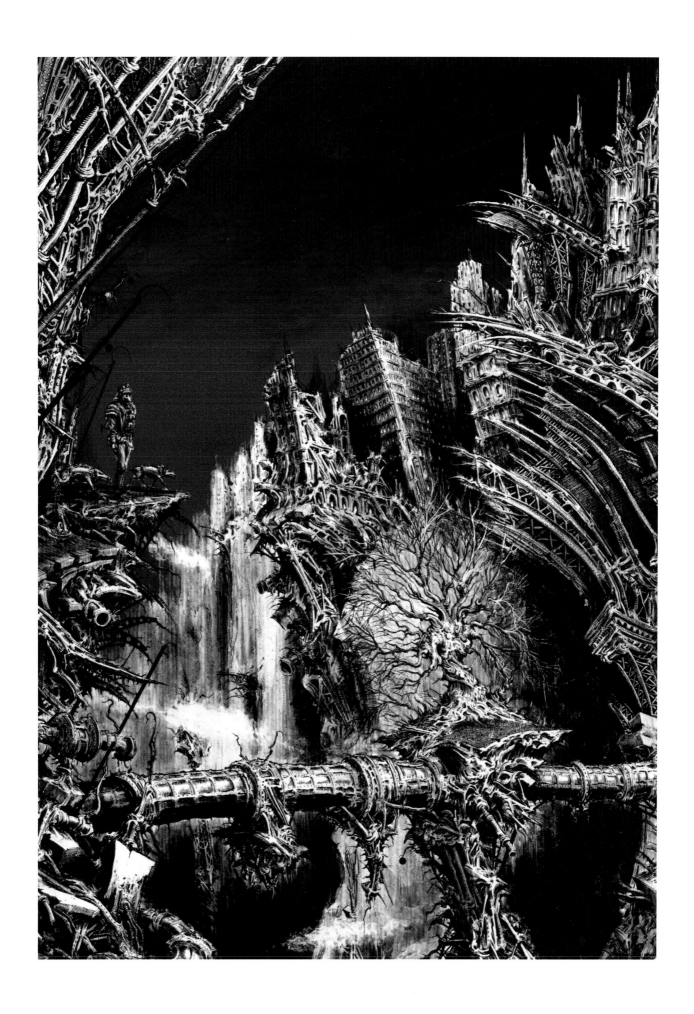

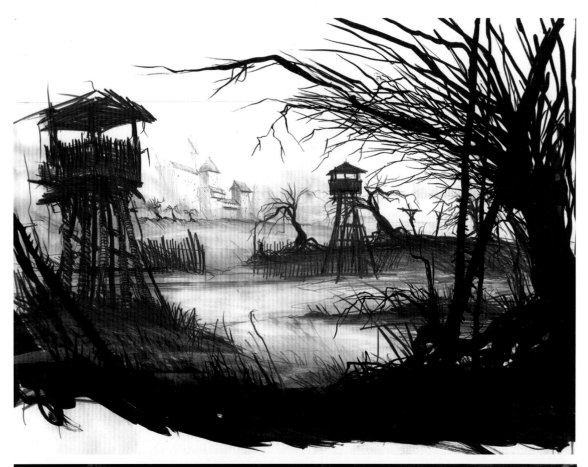

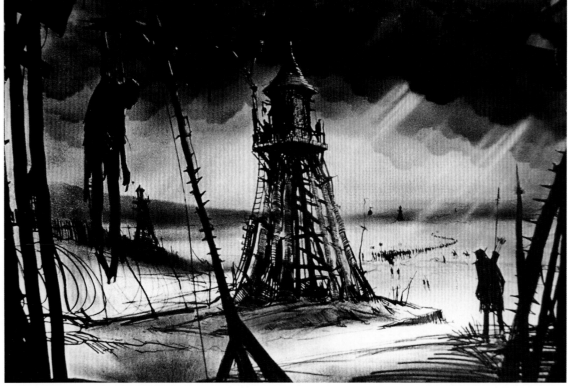

These are both backgrounds from *Wizards* by Ralph Bakshi.

It was whilst my wife and I were wandering penniless around San Francisco in the early 70's that Ralph Bakshi tracked me down via London and New York and offered me a job working on his forthcoming animated feature *Wizards* in Los Angeles. This was all on the strength of a Gormenghast castle scene I had drawn for a fantasy calendar back in the UK. After a frugal time at the Gaylord Hotel near Union Square, where the lift threatened to die every day and the highlight of the week was free donuts and coffee on Sunday, West Hollywood and Melrose avenue was something else. Although the scenery was not as good, we had a swimming pool, money to spend, and as many donuts as we could eat. It was a time of violent contrasts. One minute the world hardly moved then it was spinning fit to burst. The actual experience of working for Ralph was in every sense star shell bright, and overwhelming. He demanded a great deal of me but in turn gave me immense artistic freedom. More freedom than I'd ever had or had since, bar *Luck in the Head.* It doesn't get any better than that I will always be grateful.

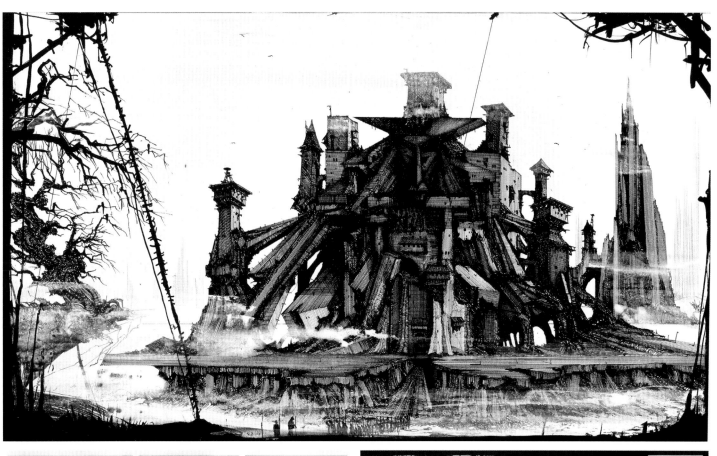

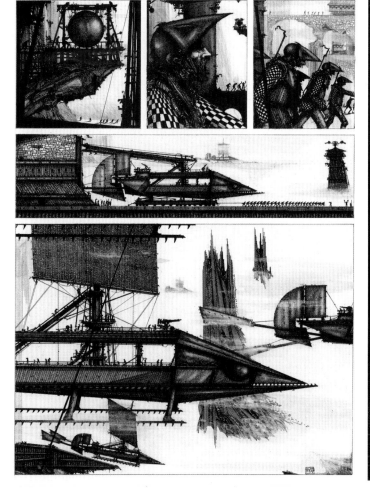

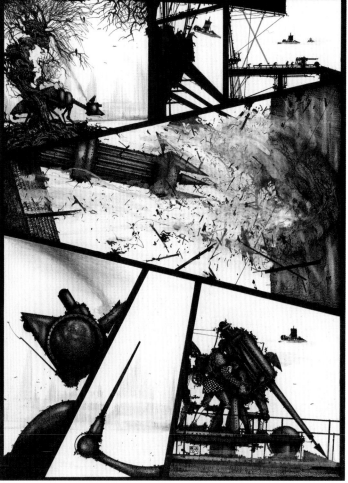

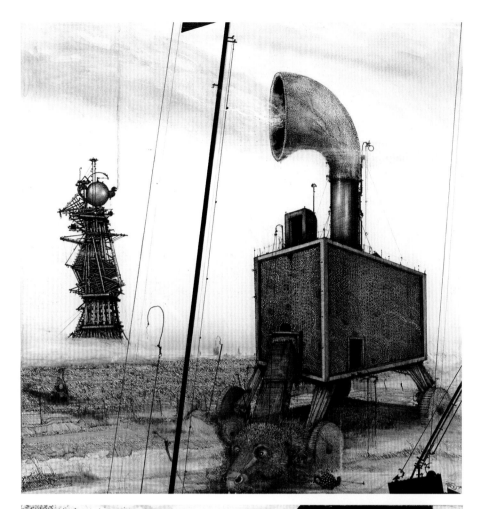

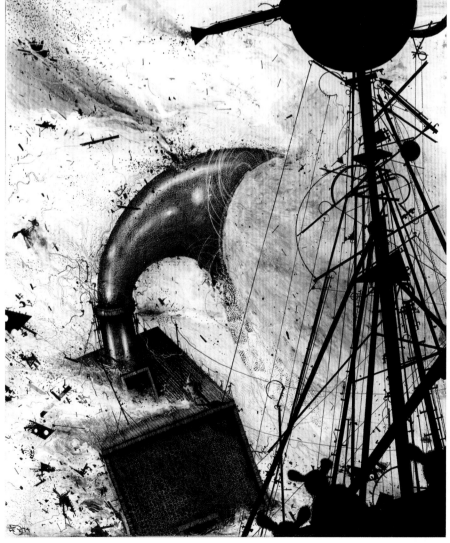

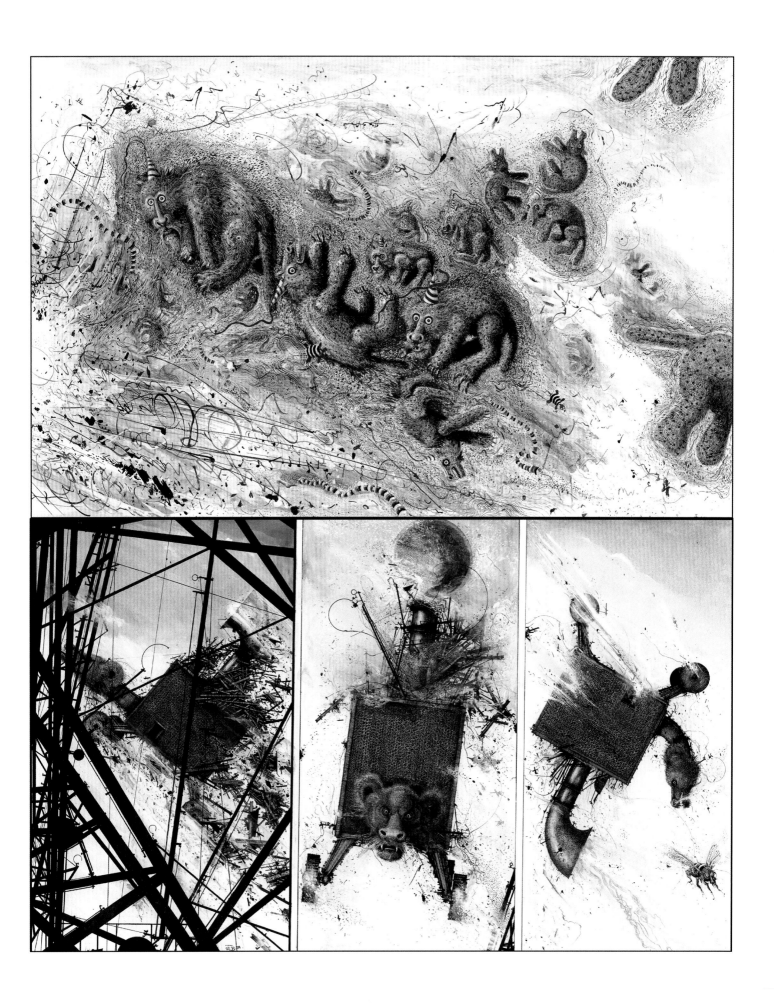

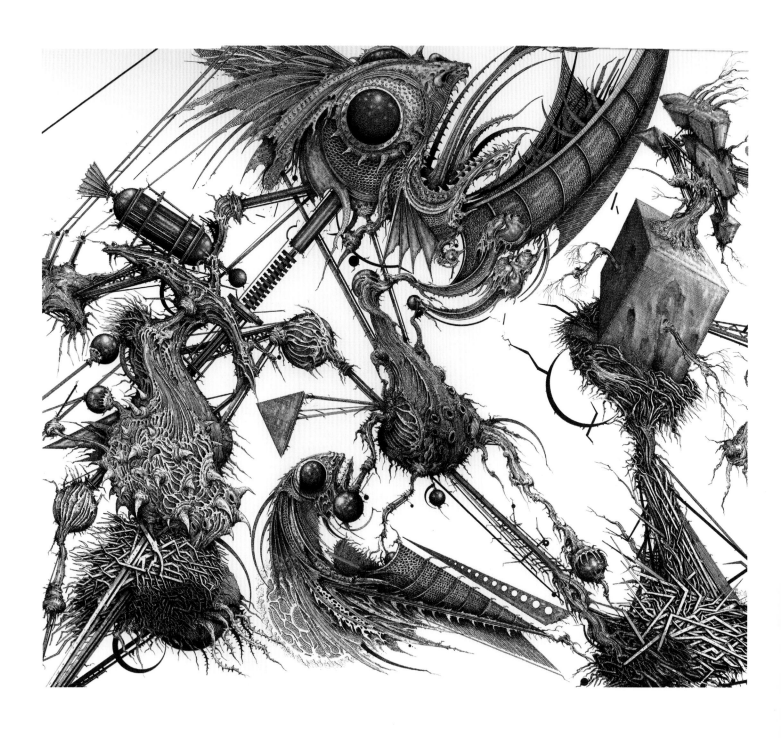

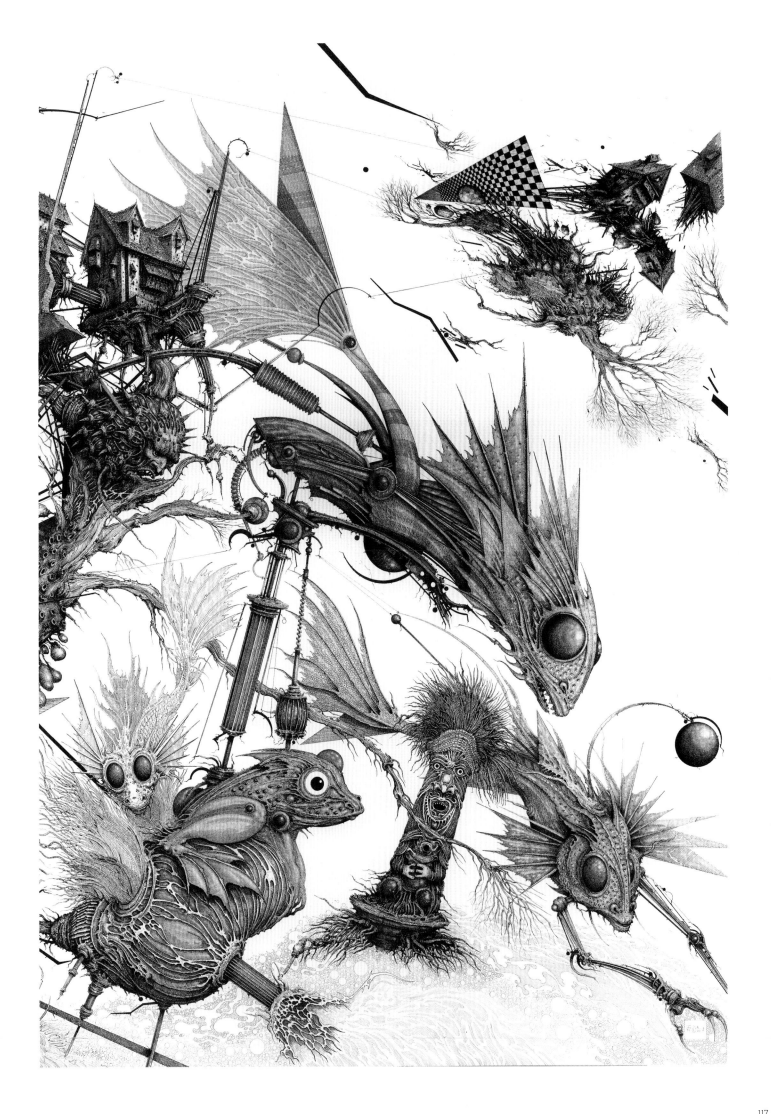

DREAMS & NIGHTMARES

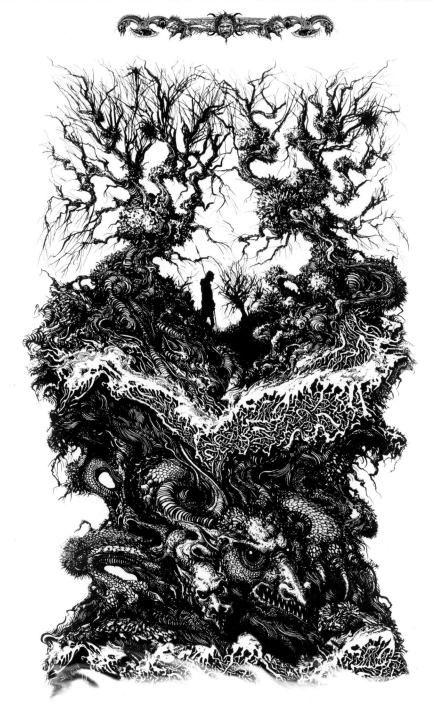

A t an exhibition of my work, I once overheard an onlooker comment: "look at that, he MUST be on something." I'm not.

I have never needed any mind-expanding substance to tap the subconscious: my childhood was a rich and whirligig world; I take from it freely.

My mother worked at a leading theatrical costumier's in the 50's and as a consequence of this my toy box was a veritable treasure trove of fantastic objects and cast offs from a gaggle of films and theater productions. I was steeped in the world of make-believe, and surrounded by the 'fantastic' most every day. Characters like the green-faced Wicked Witch of the West in *The Wonderful Wizard of Oz* and the genie from *Sinbad the Sailor*, who also had a green face, were etched into my psyche and still, even today, provoke both excitement and fear when I think of

them. These and all the other fantastic transports, the devices, from my toy box still frequently appear in my work.

Strange to say, the images I often think of as being gentle and playful, innocuous, are often the ones that disturb people the most. They inspire descriptions such as 'dark dream', 'disturbing', 'melancholically beautiful'. If it were me labelling the artwork, the term 'pathos' would be the key.

I have often heard film producers and publishers express a concern that my work will be too frightening for their audience. They see something in my work that I often do not see myself. It is not something I purposely set out to achieve, I just seem to manage it by default. That said, it is important to make images that grab the attention of the viewer. I am often surprised that two-dimensional graphic work still upsets people and is able to achieve similar effects as a ninety minute movie.

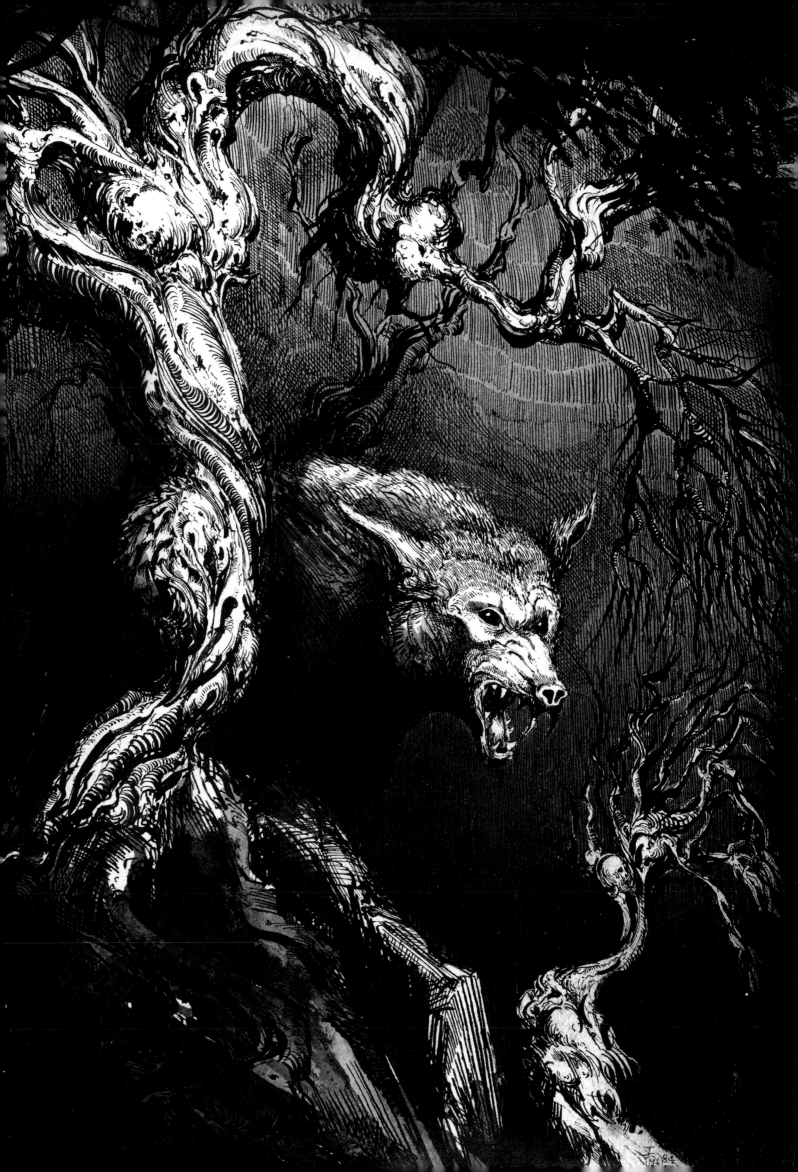

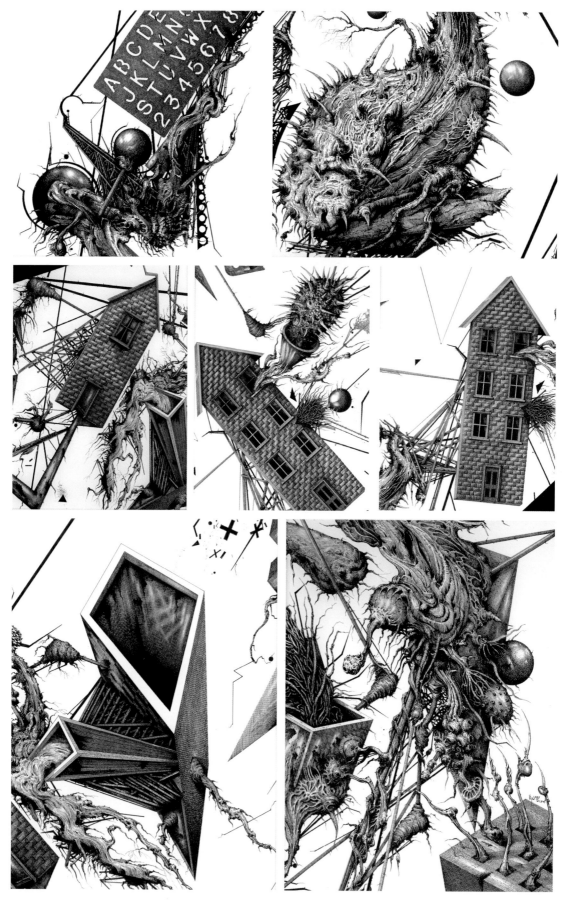

ABOVE: These are details from a project entitled Corpus Pandemonium, comprising four large interlocking panels. The images featured on this page are sections from those panels. It was an extemporized process. I had no preconceived idea about how it would look. I drew on and around the first panel then expanded out and into the other three. Each shape and form I created, whether it be organic or geometric, dictated where the next would fall. I realized I could have gone on expanding outwards in this fashion forever.

OPPOSITE: This is a section of a finished artwork that won the Chesley Award in 2010 for Best Monochrome Work, Unpublished.

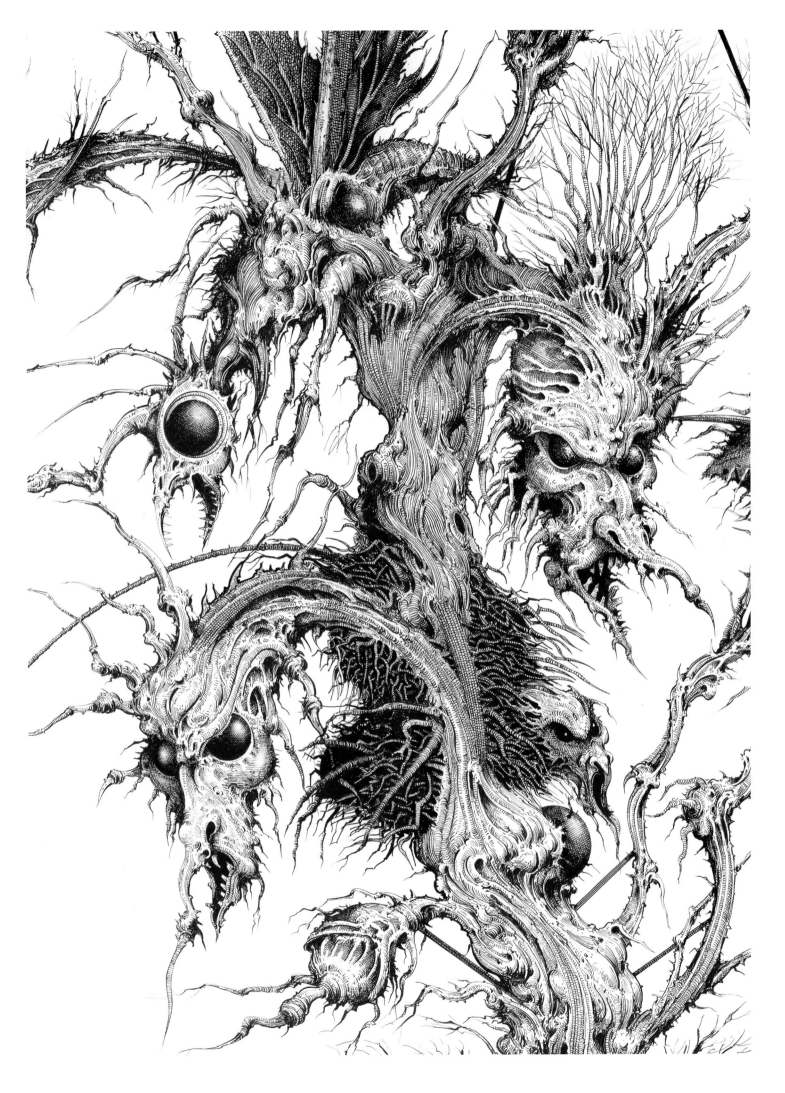

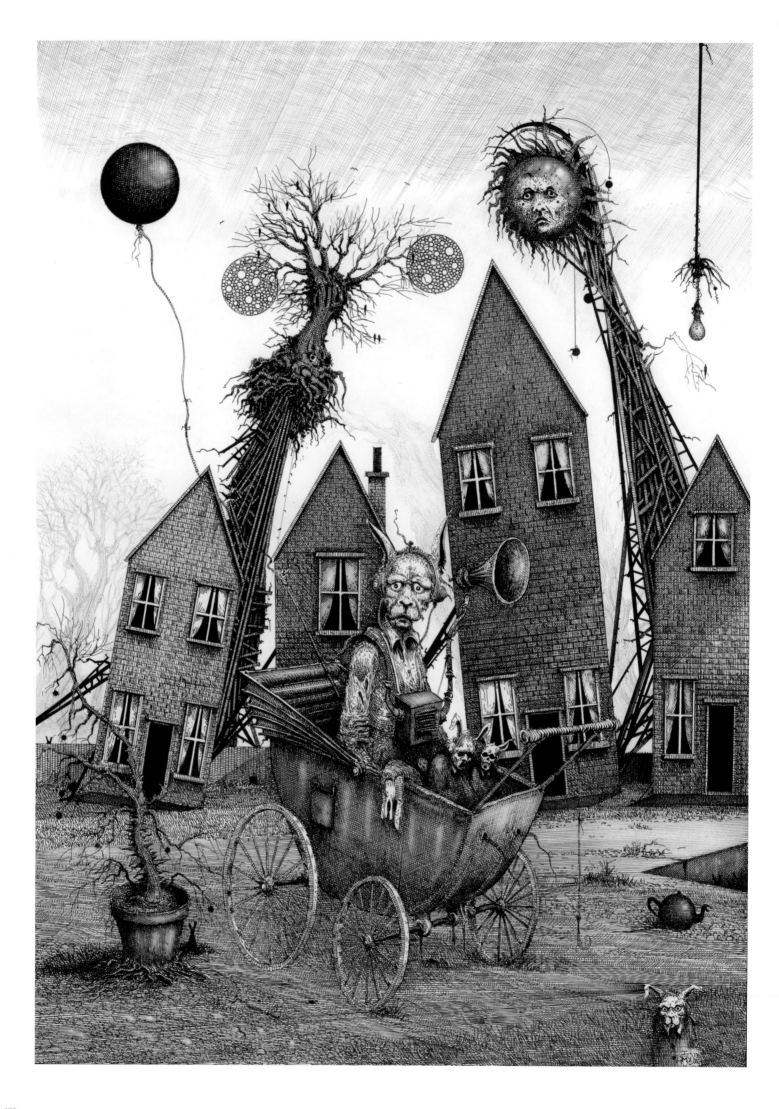

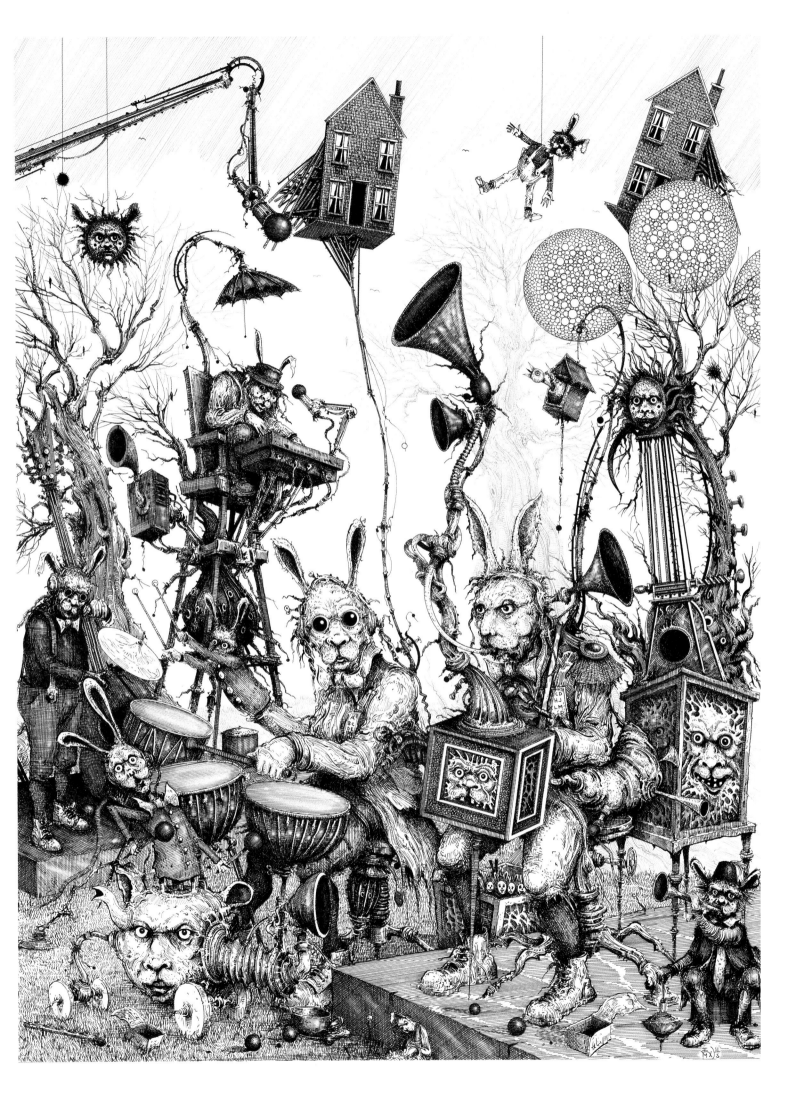

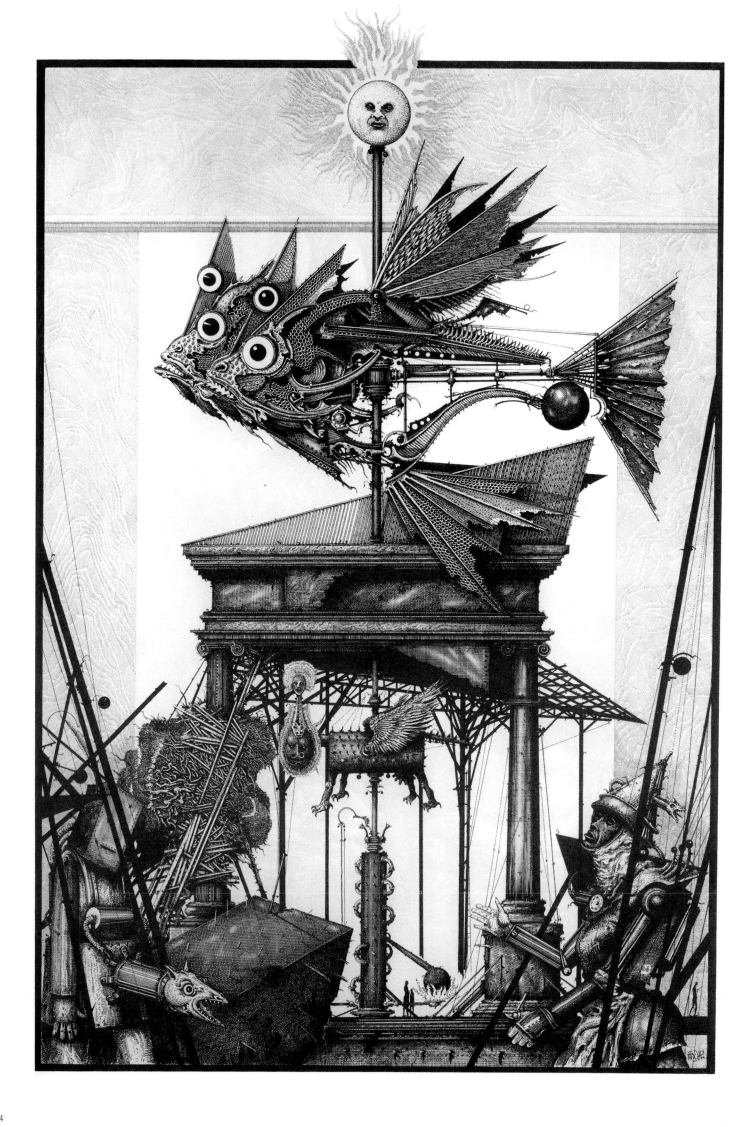

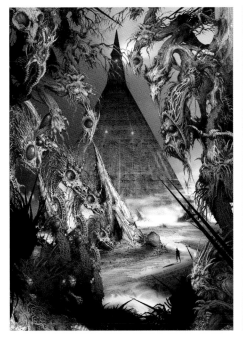
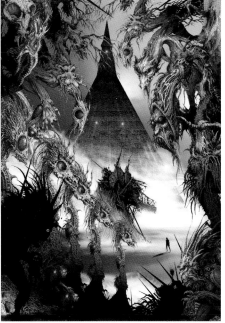
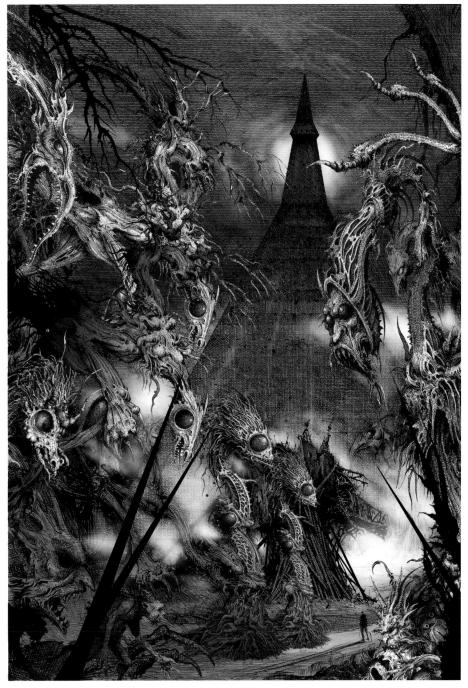

This is a re-draw of a Panther horror cover *Mountains of Madness* in the 1970's. The original has a stillness but this quickly took on a life of its own. I am thinking of drawing it a third time to break the components down even further and make it more abstract. I would like to stretch it to breaking point. As for the spheres at the bottom of this image, I often use them in a drawing.

They give solidity and provide a counterpoint to the movement of the metamorphosing tendrils. The trapdoor becomes part of the dialogue, suggesting different levels of reality, a further hellish world below.

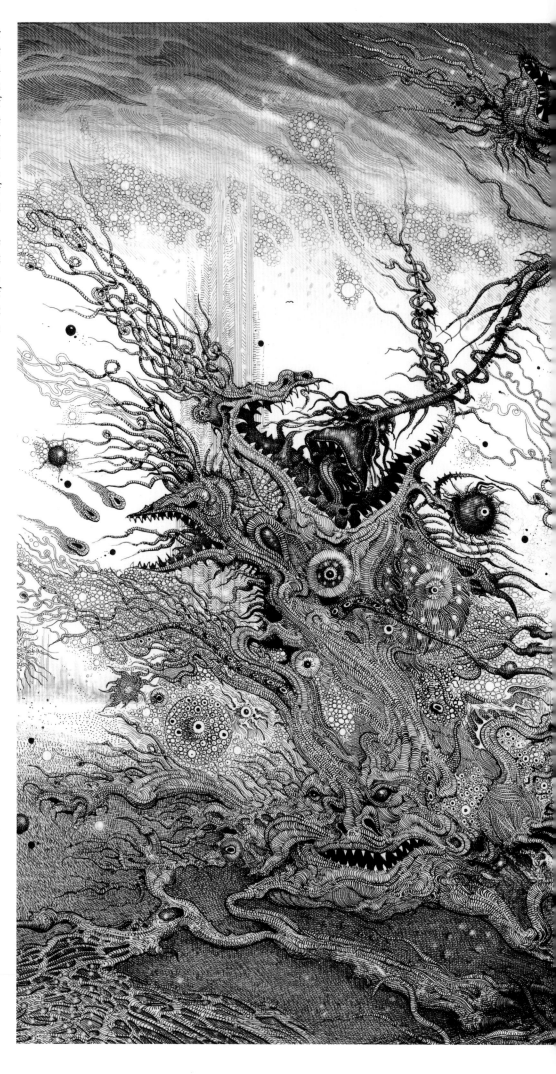

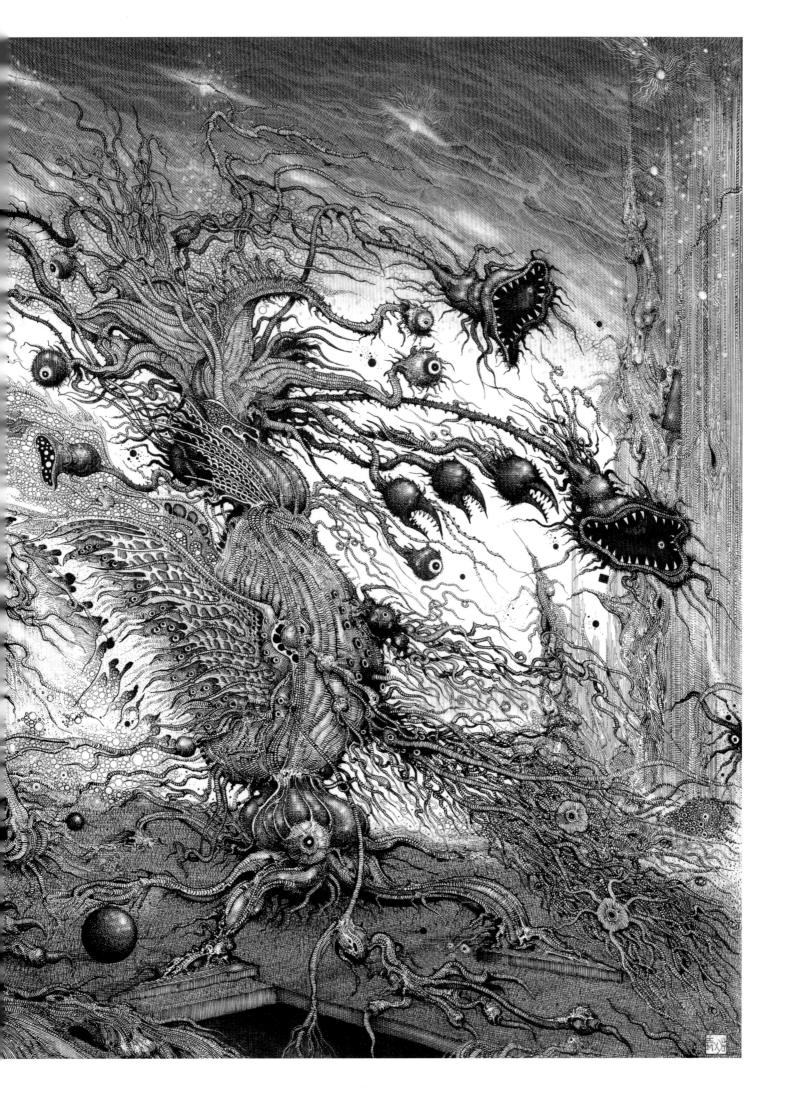

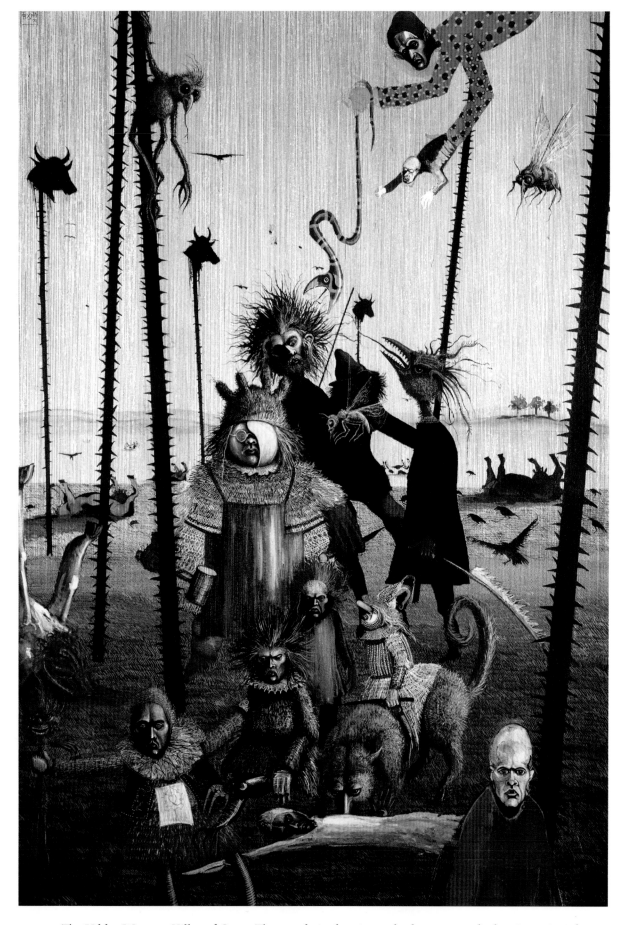

ABOVE: The Udder Woman, Killer of Cows. The people in the picture look out towards the viewer in a frozen moment of time.

OPPOSITE: The rocking horse factory (top left) was the cover for the *Secret Art* and contemporary with The Udder Woman, Killer of Cows. The other three images are from the series of drawings entitled Snake Woman.

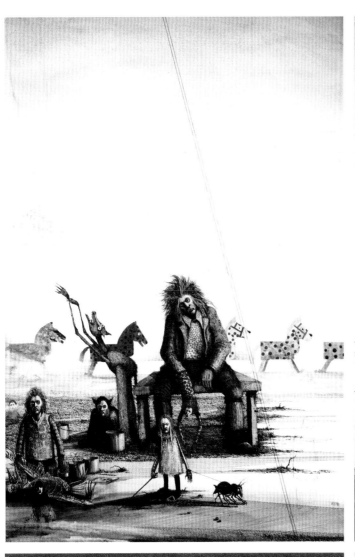
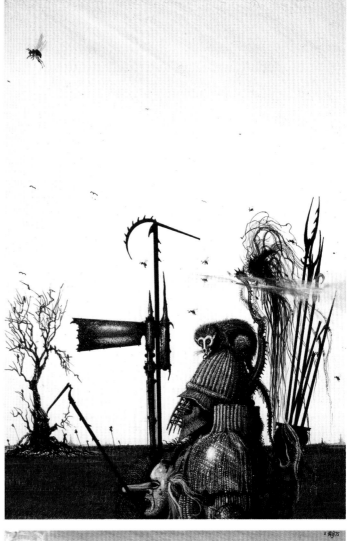
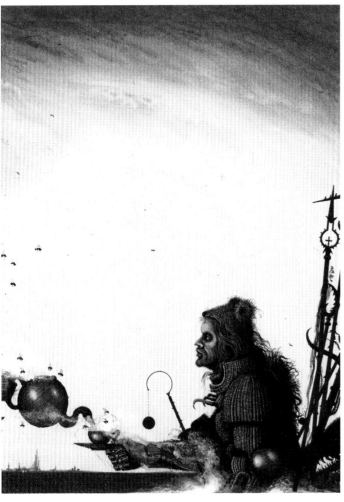
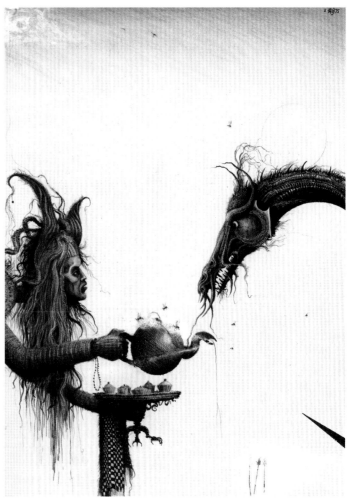

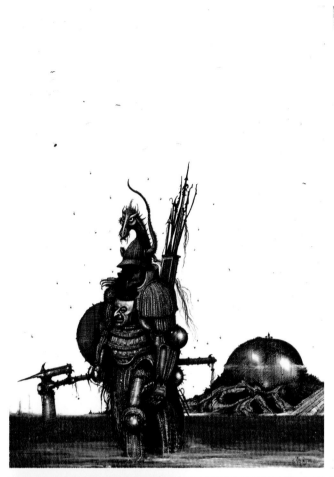
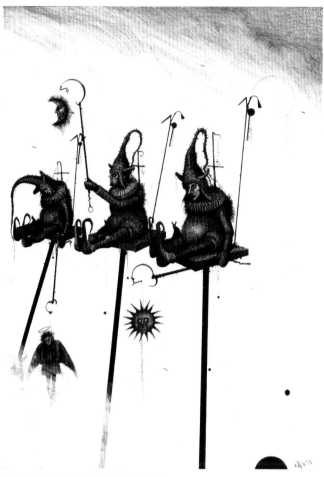
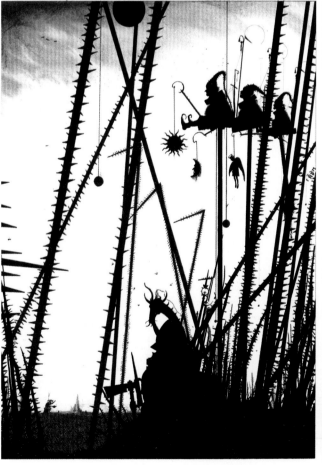
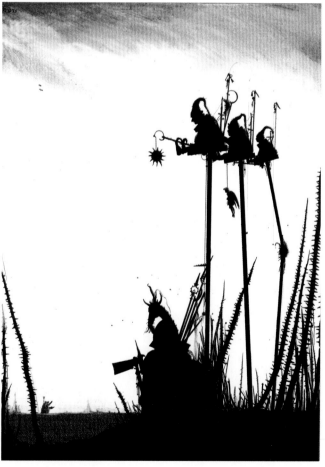

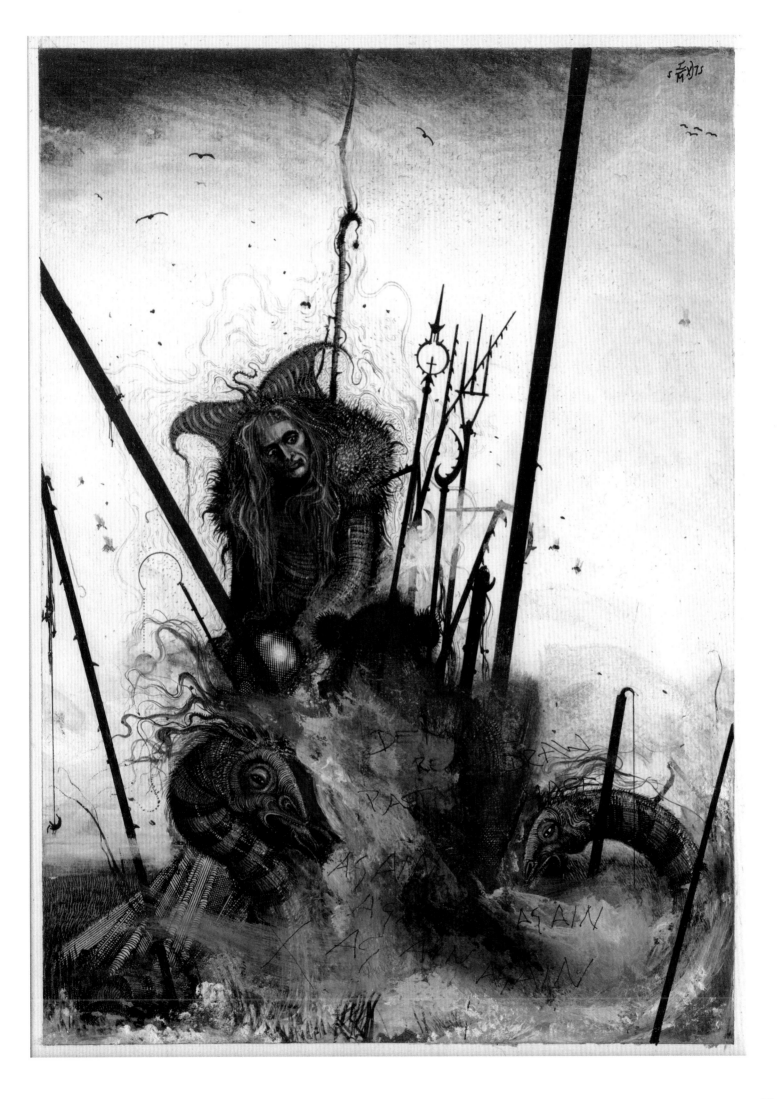

131

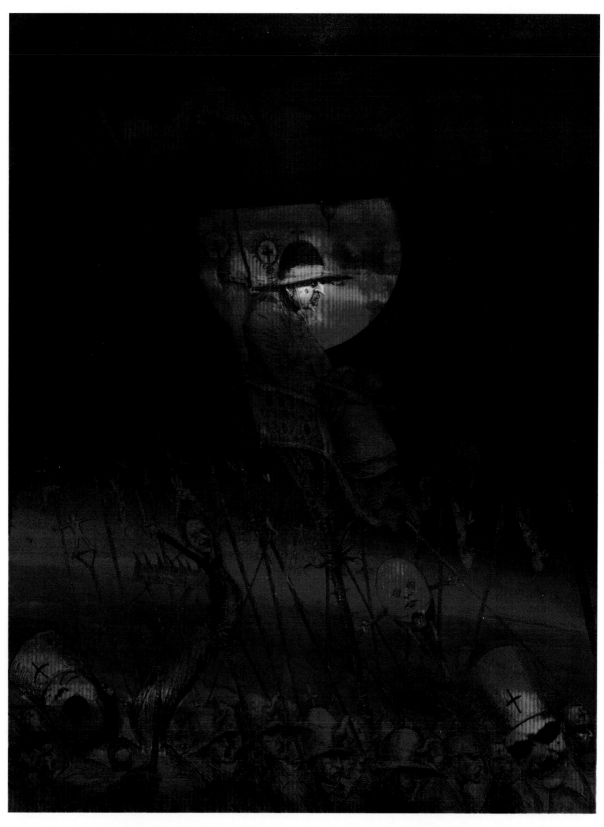

This image from Mike Harrison's graphic novel *Luck in the Head* shows the leader of the city in a procession. It was drawn during the Thatcher years and I used the profile of Margaret Thatcher. I am not a fan of her or her legacy.

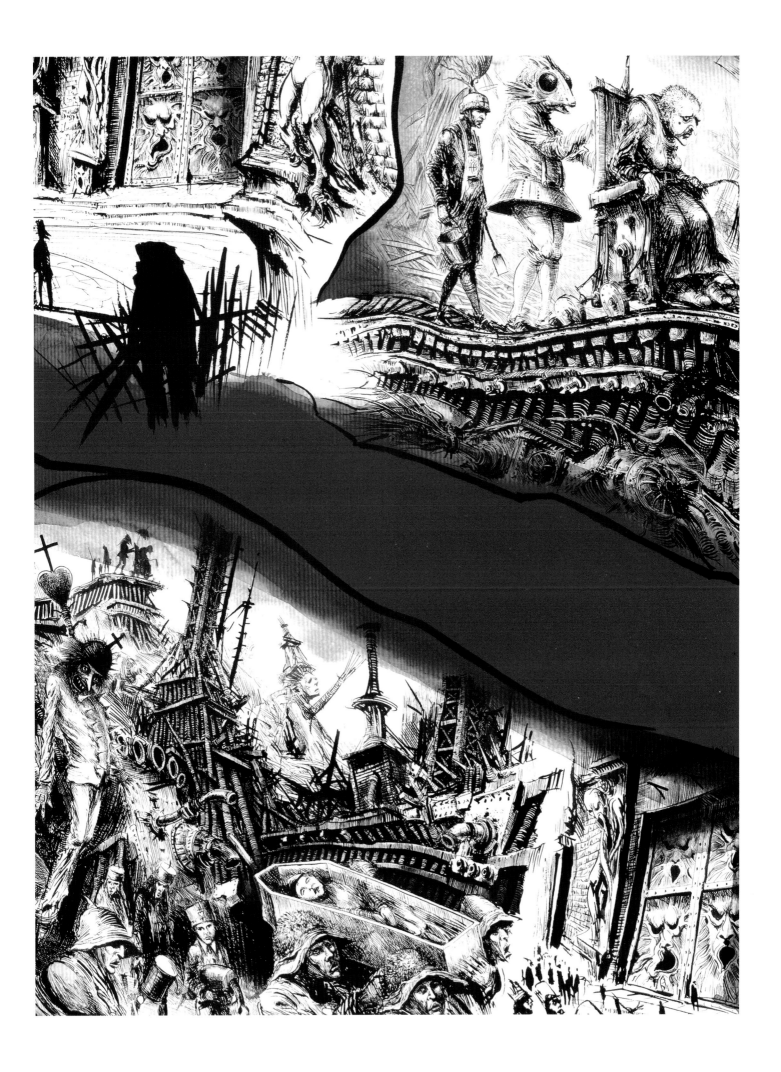

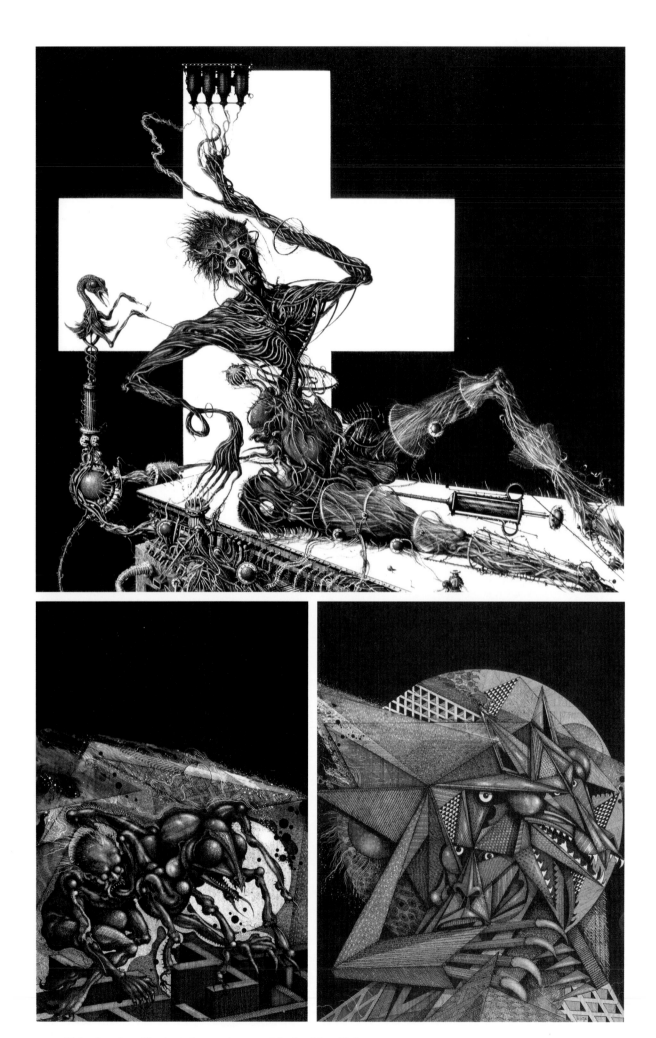

TOP: This drawing illustrated a serious article in *Men Only* magazine about the medical trials of drug companies.

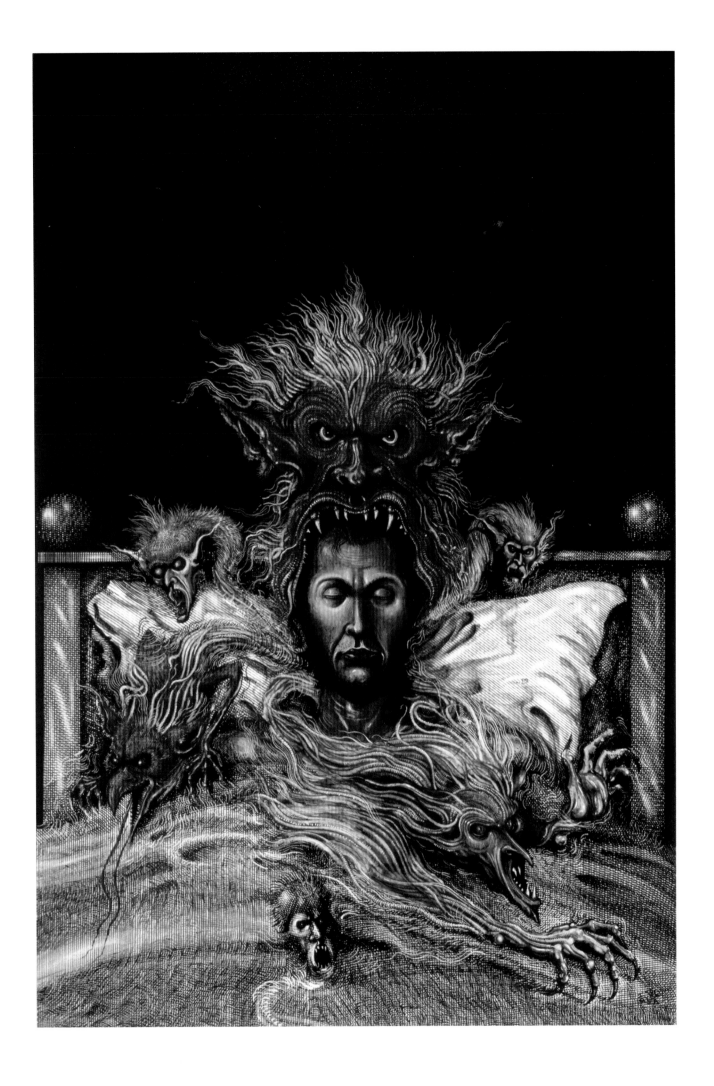

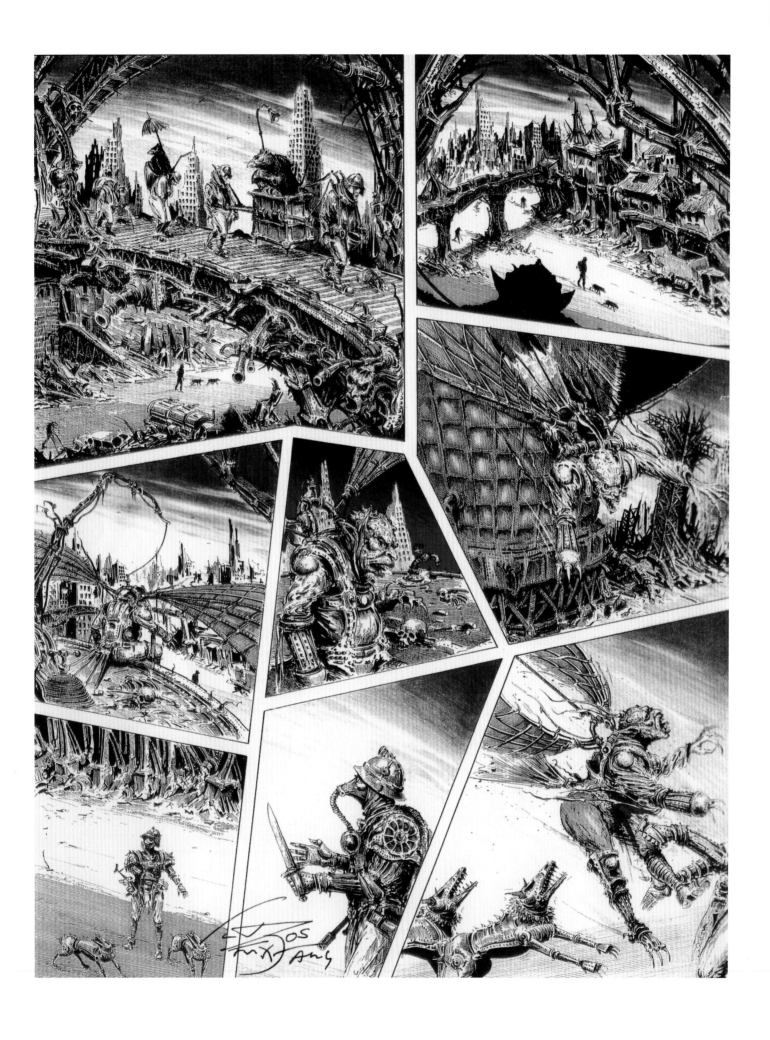

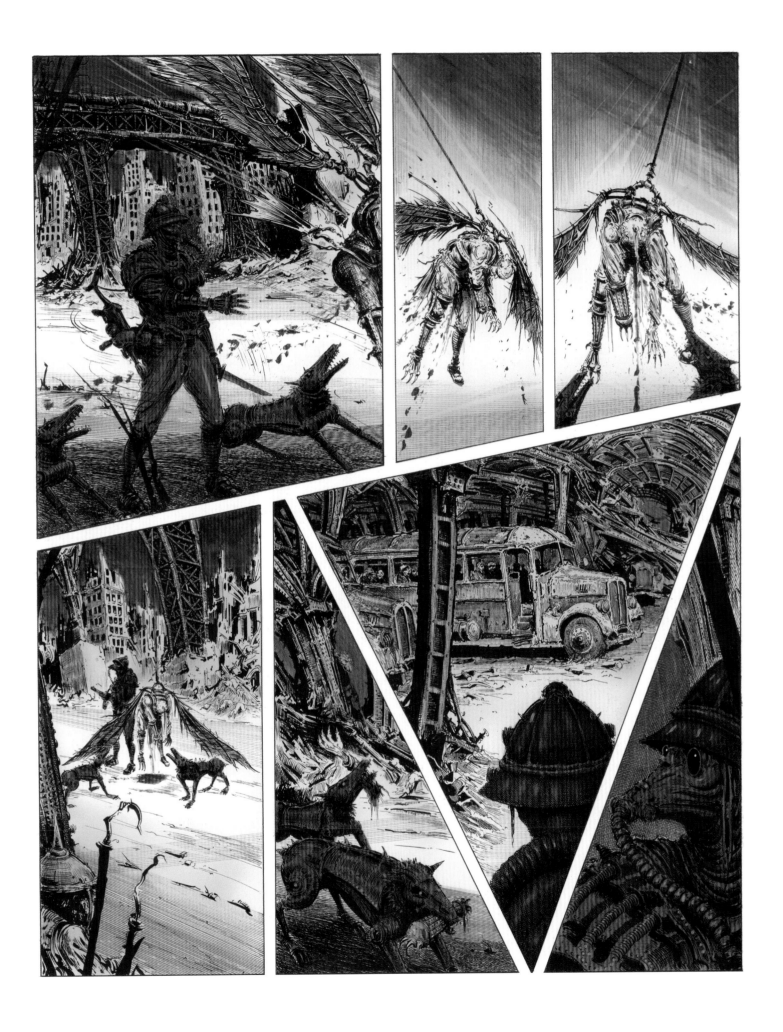

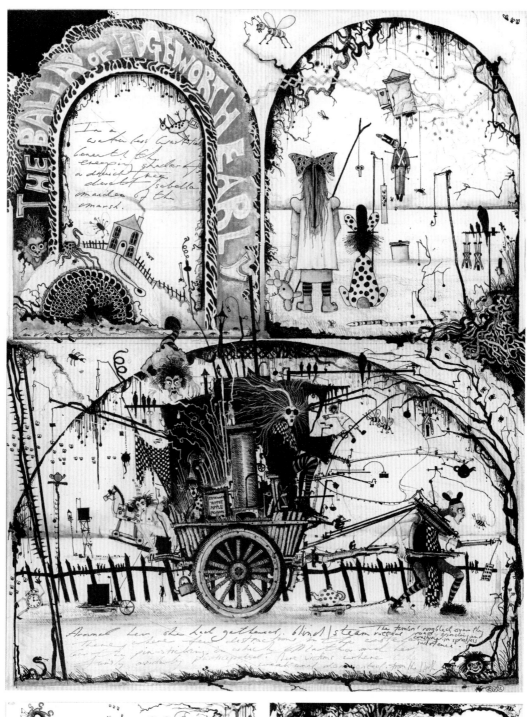

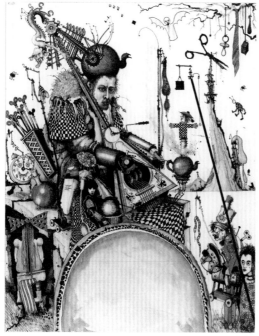

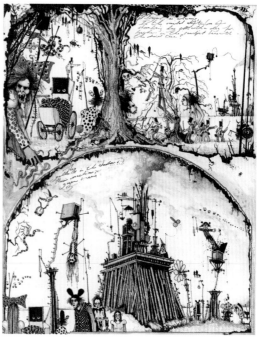

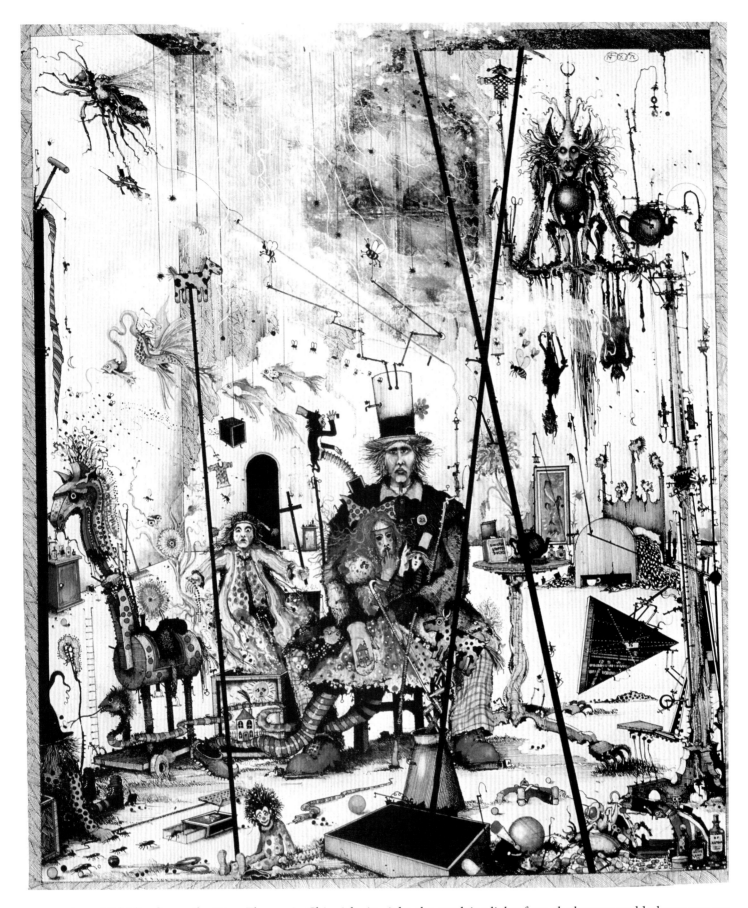

ABOVE: As a child I lived near the River Thames in Chiswick. At night, the revolving lights from the barges would play across my bedroom walls. I woke one night to find a cannibal staring at me through the illuminated window and screamed. I'd seen him the day before, standing in the display window of a furniture shop on Chiswick High Road. When my father rushed into my bedroom and I told him about the cannibal, he said he would sort it out in the morning. That was the last time I ever saw the cannibal but he was not the last creature to stare at me through a window.

OPPOSITE: This compendium of nursery night time images from 1969 plays with the ingredients of classic stories, such as Grimm. The image is very familiar; my mother had it on her wall for many years.

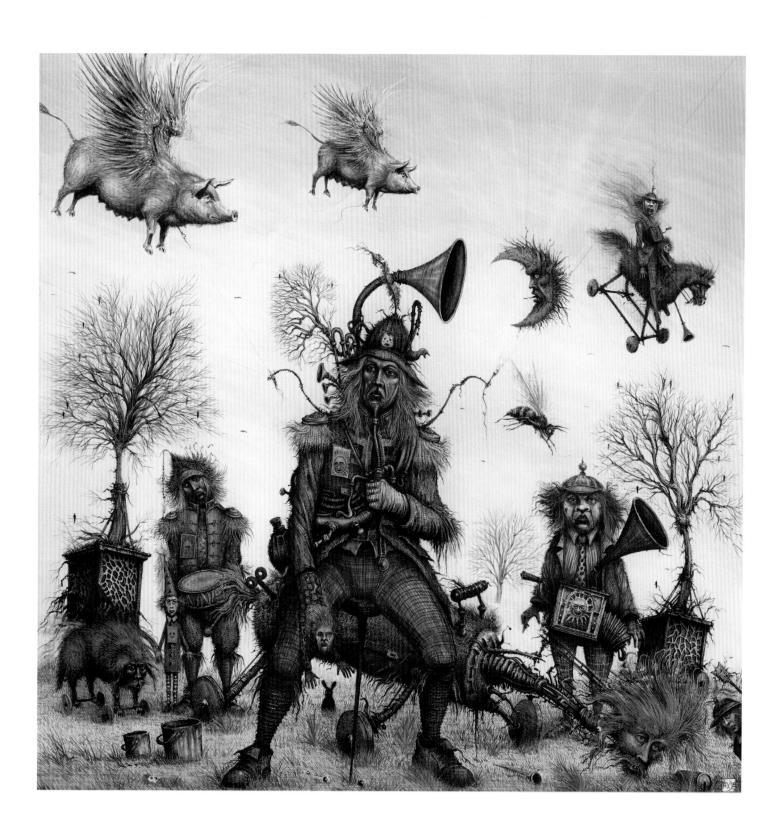

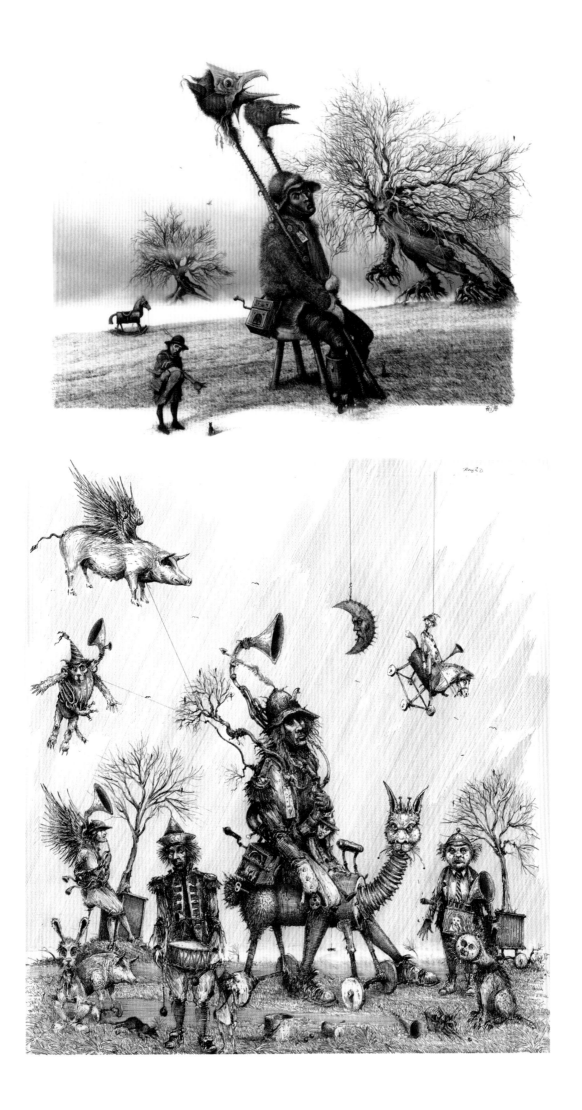

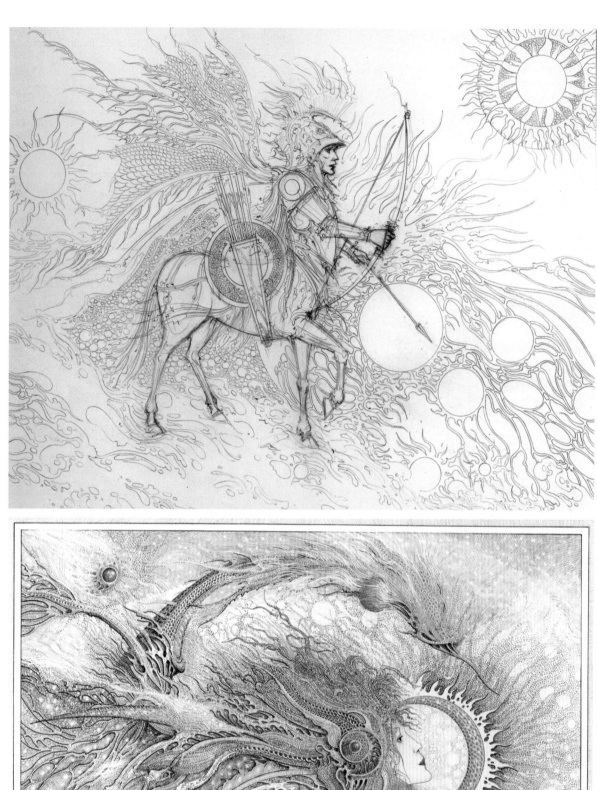

Years ago I did a series of zodiac signs that were later bought at auction, but incomplete. So I have recently returned to the zodiac to complete the series again for the private buyer.

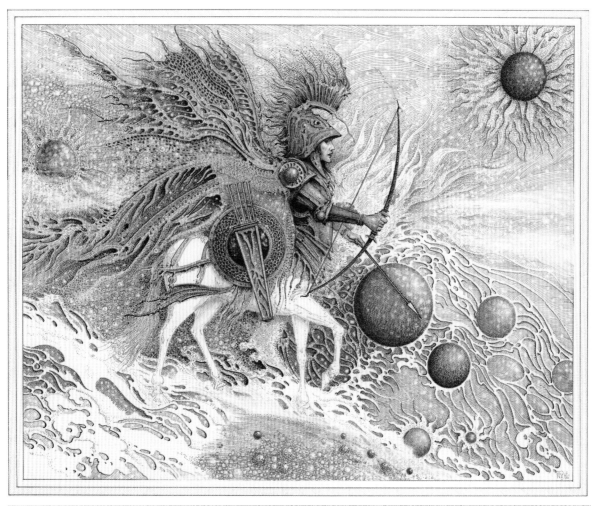

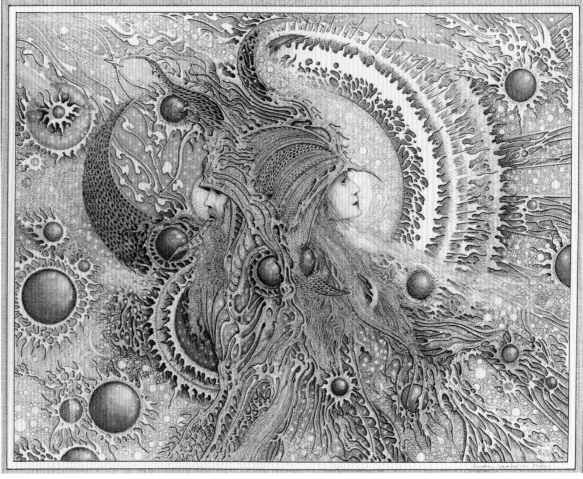

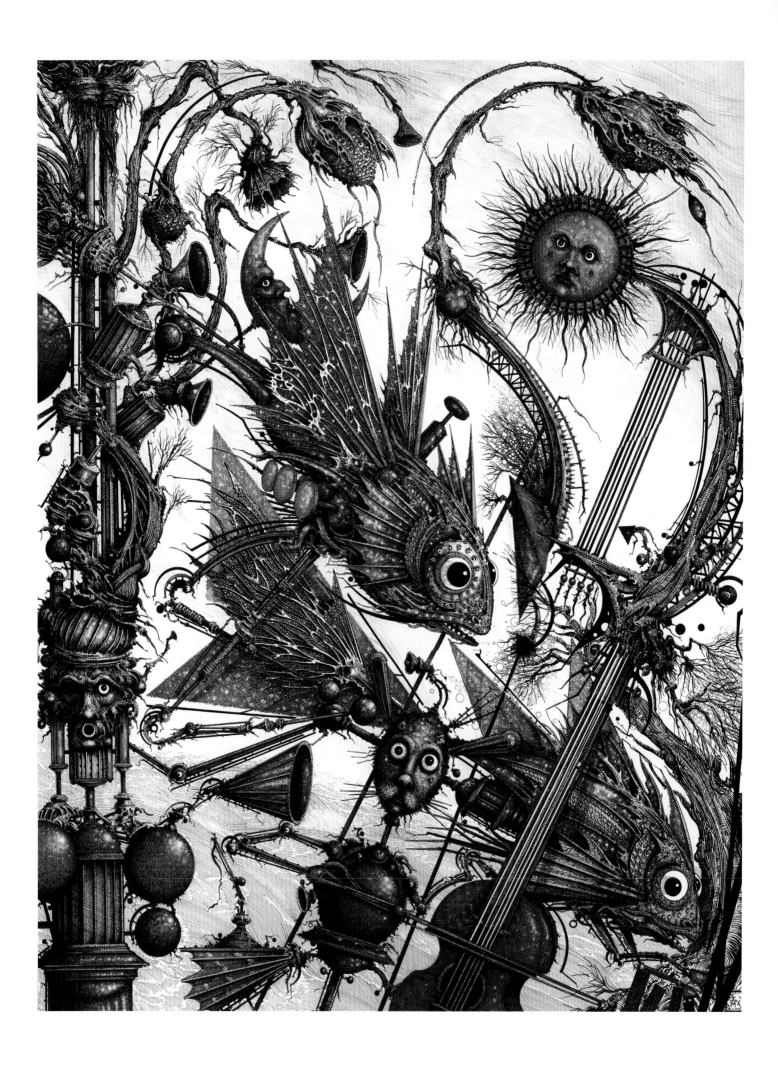

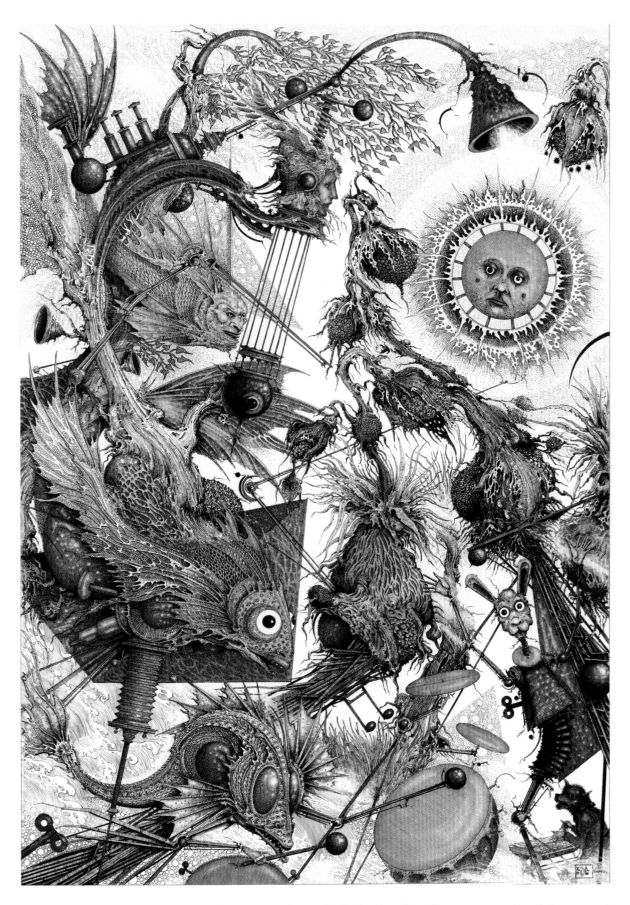

When asked to produce a drawing for a private client who had a deep love for music I produced this artwork as the first in a series. It features musical and lyrical elements in a healthy sunlight. Later in the series (p.123), the drawings became increasingly dystopian with a consumptive bleeding sun (p.122) and increased insanity.

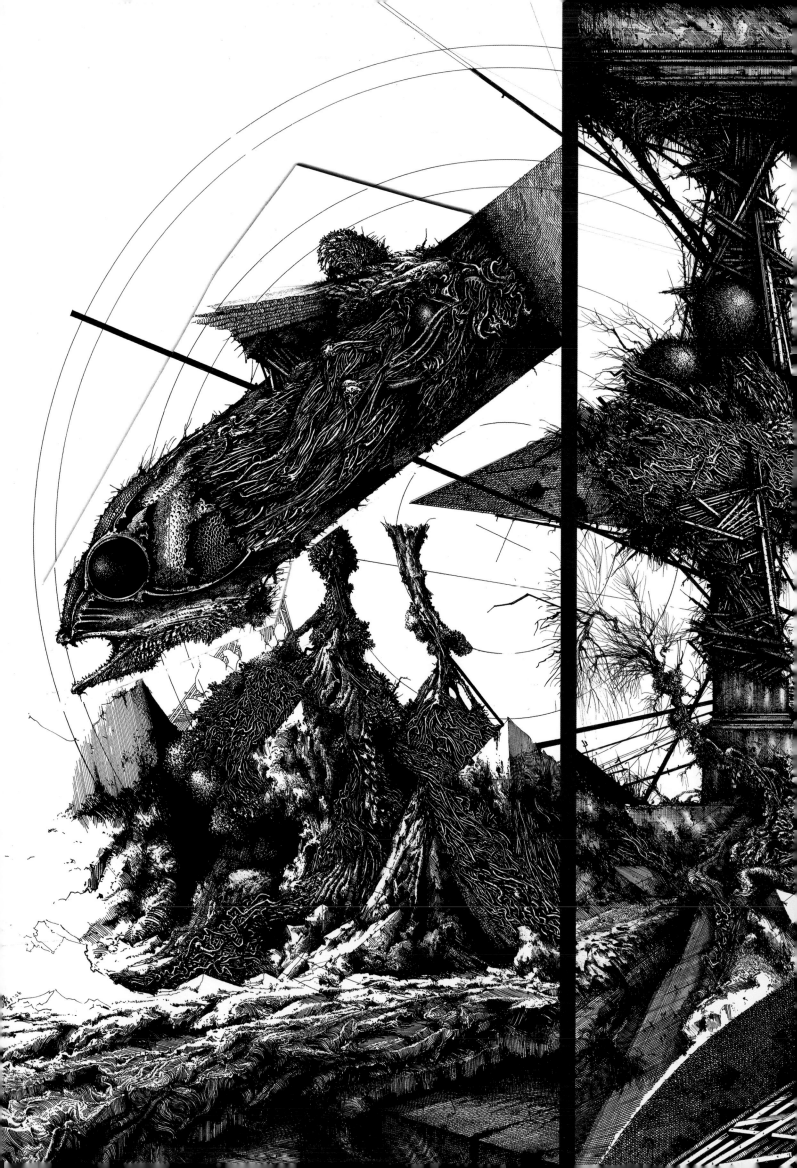

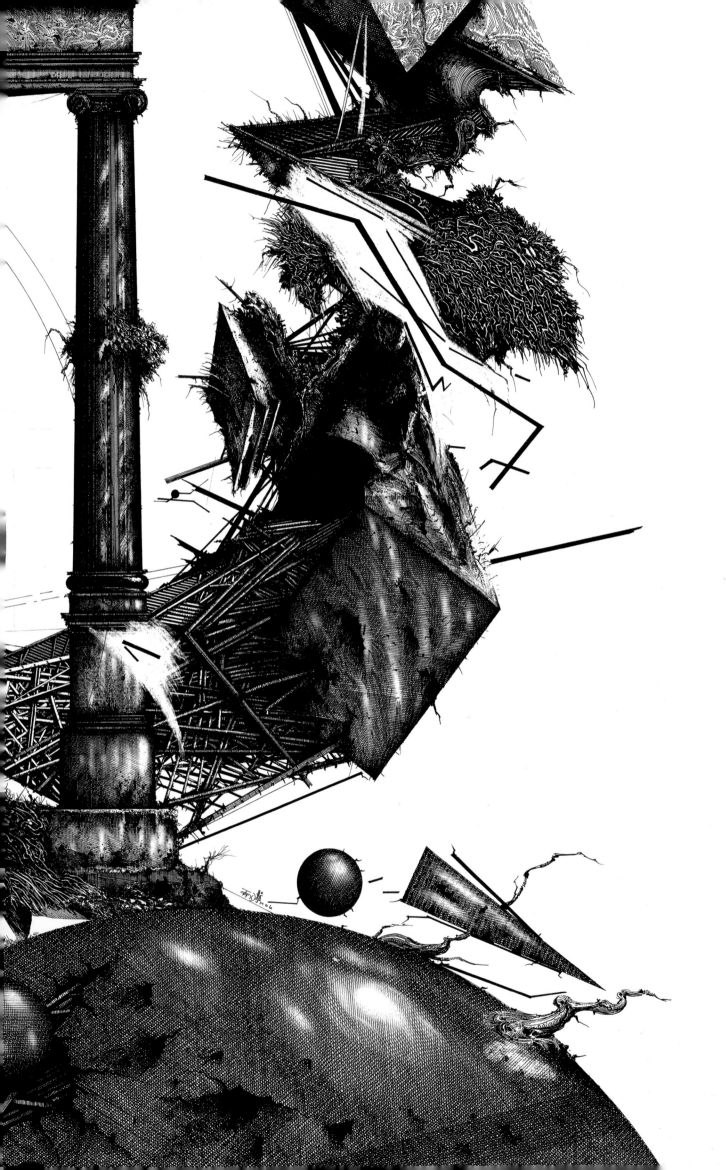

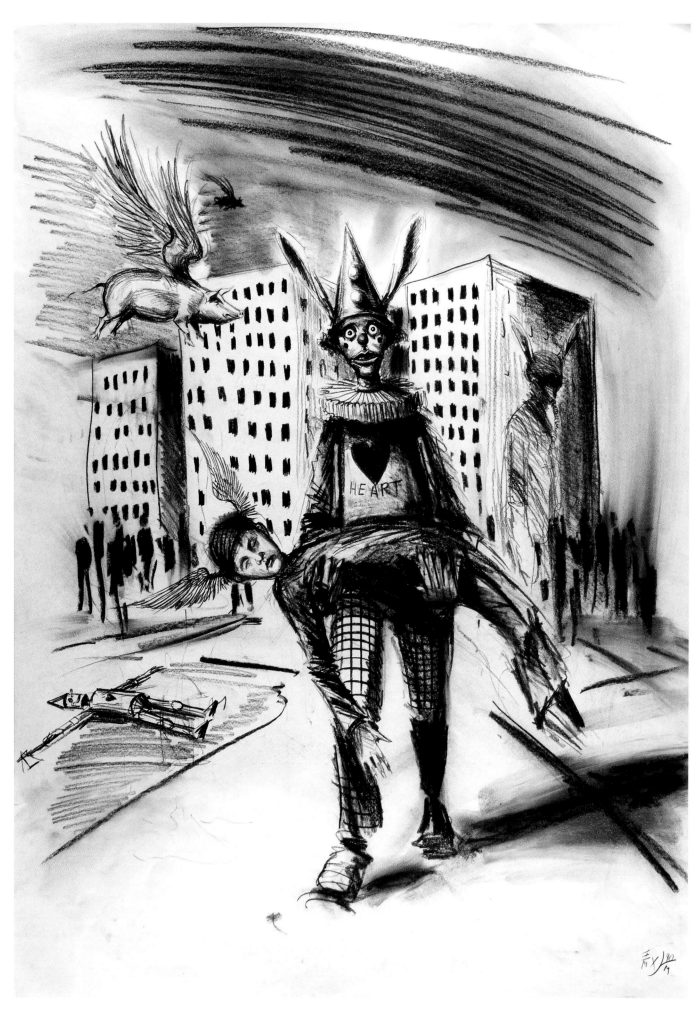

This is one of the roughs for a project I didn't get because the client didn't go for them.
I like the roughs and the strangeness of the world that is represented.

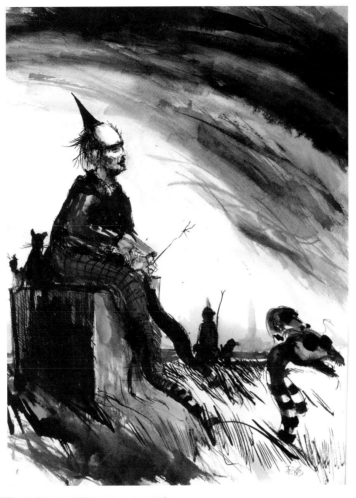

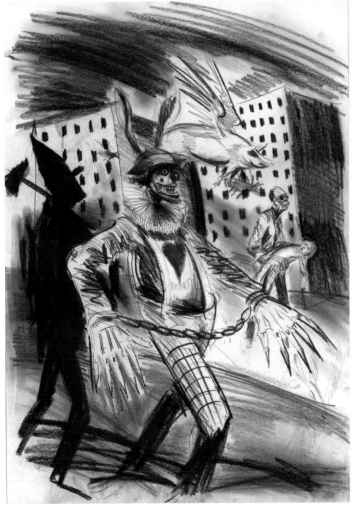

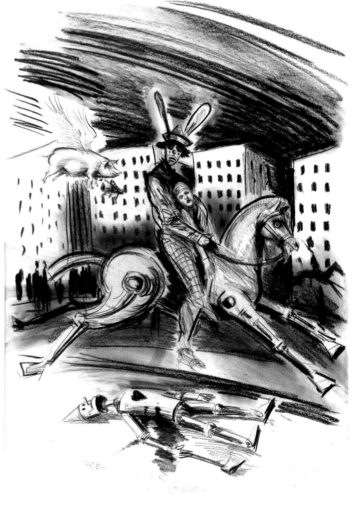

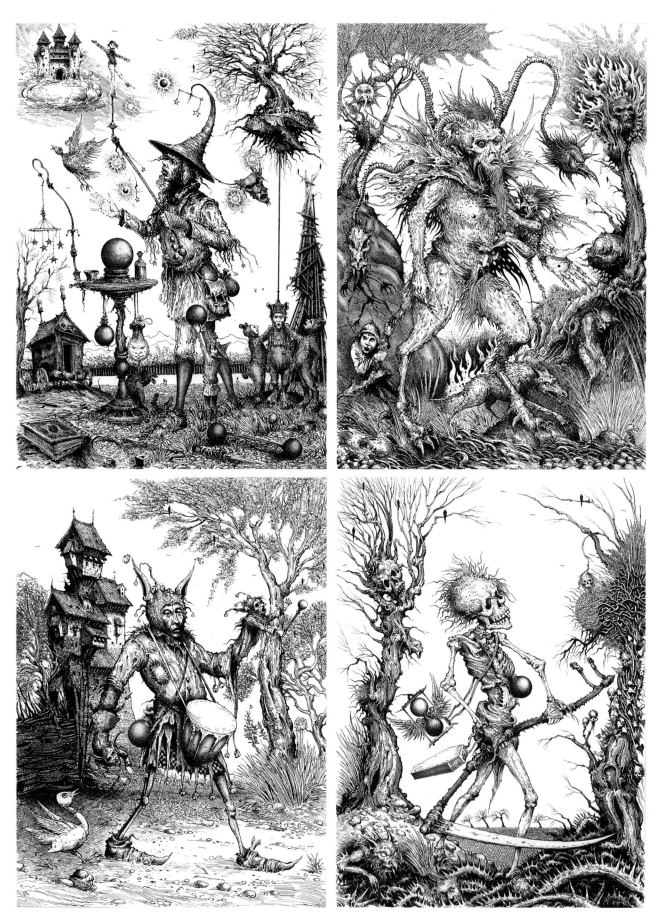

These are individual tarot cards for a pack that I began to draw but did not complete. Other projects took precedent. I may try again some day, if the fancy takes me, and the project is funded.

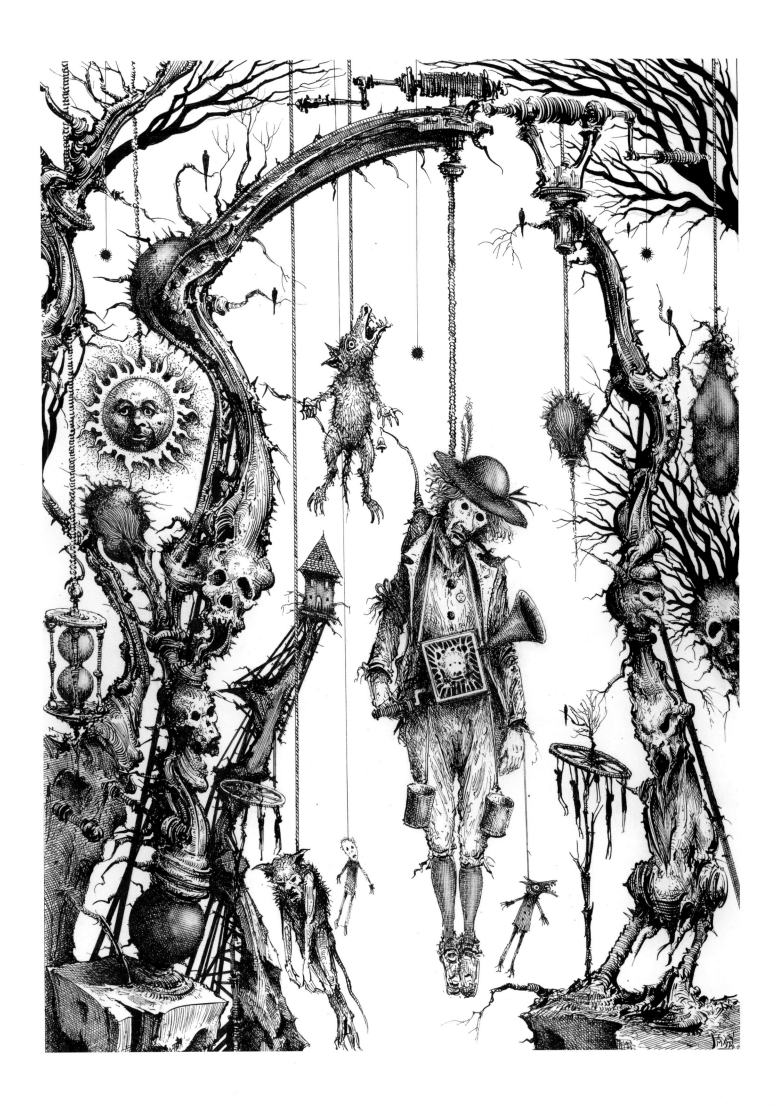

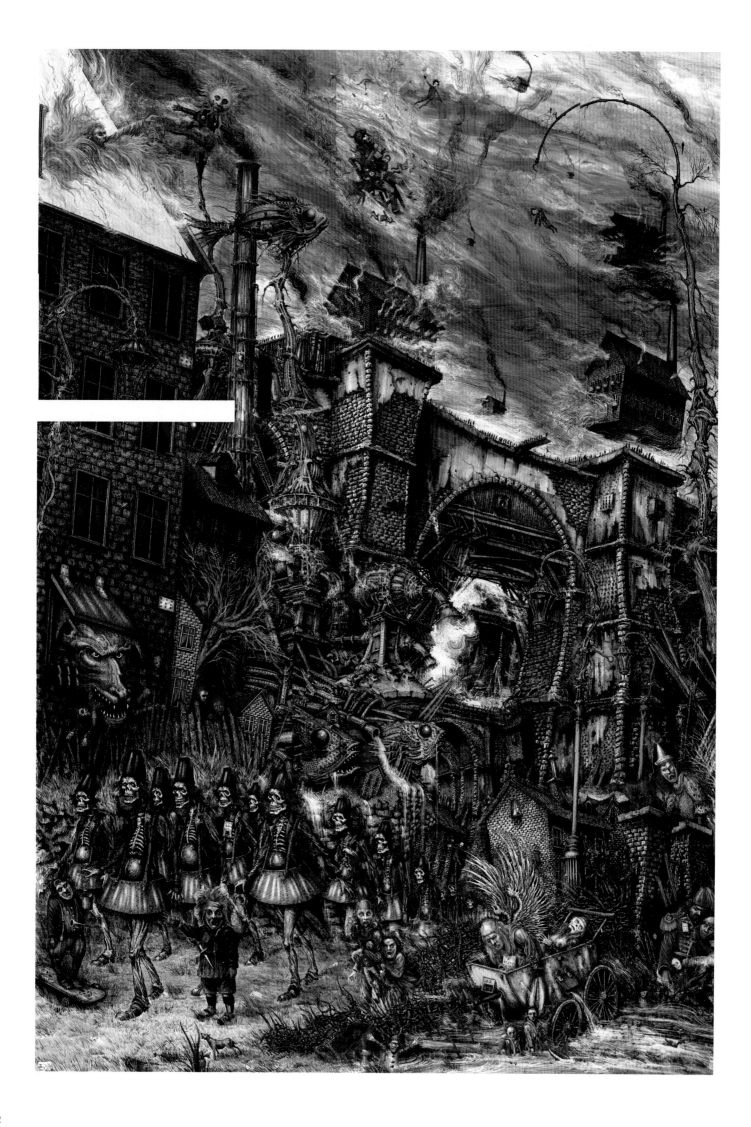

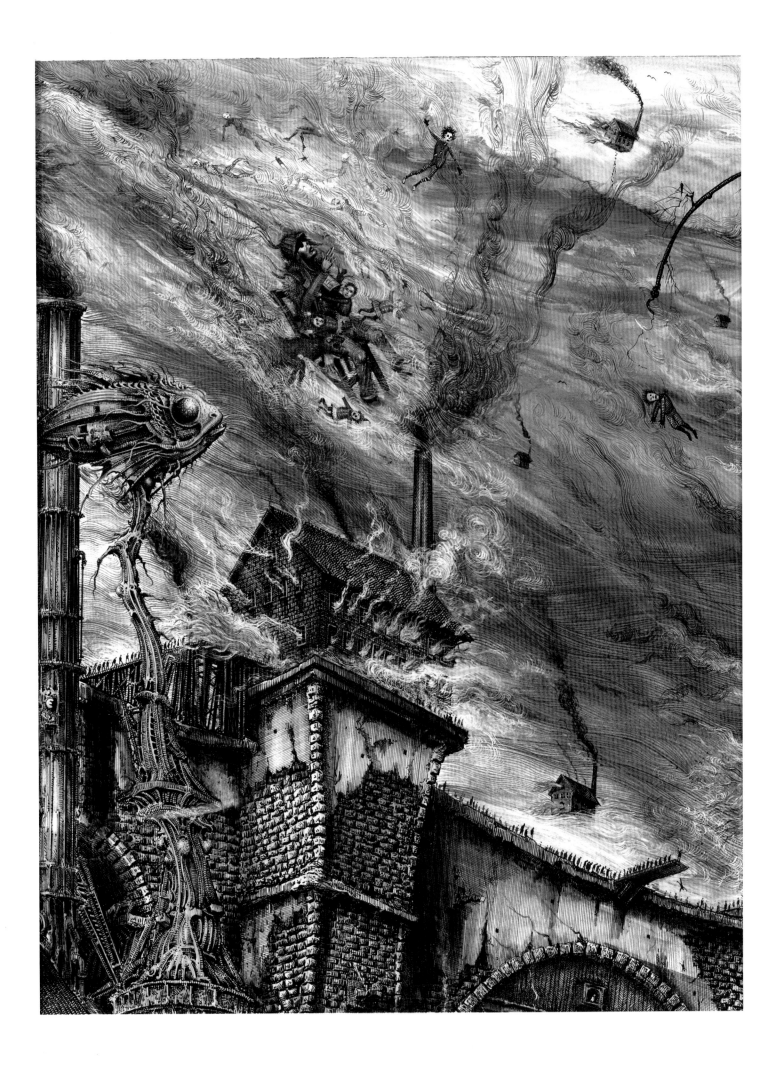

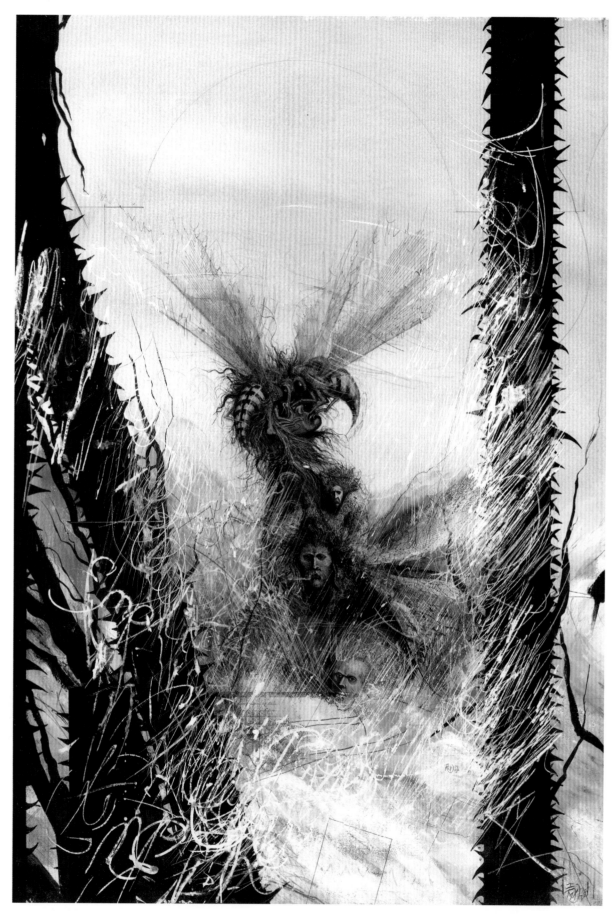

Waspeye was executed not long after I returned from LA in the late 70's. After seeing my imagery animated on a big screen I became very frustrated with the still composition and tried to express this feeling in graphic terms by filling the painting with a great deal of agitating brush work. Somebody said it reminded them of static and I thought this was a rather good way of describing it. They also said it hummed and that pleased me immensely. All was not lost.

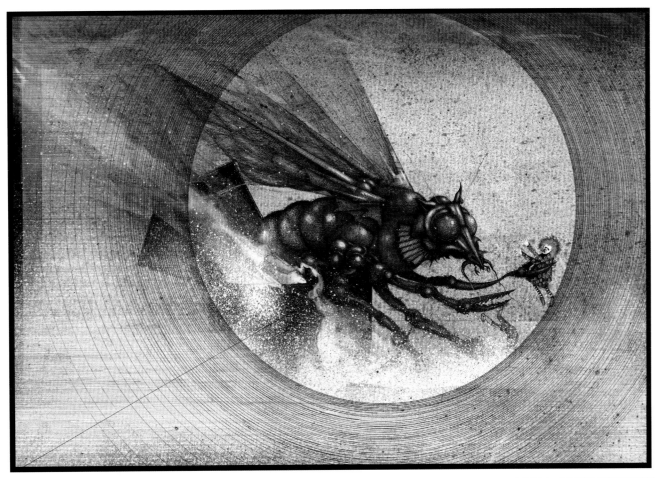

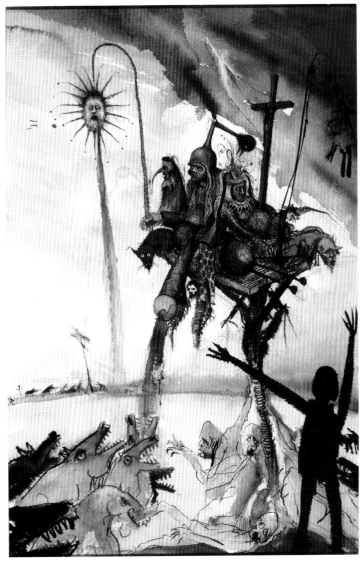

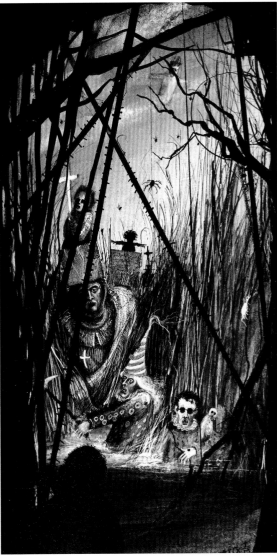

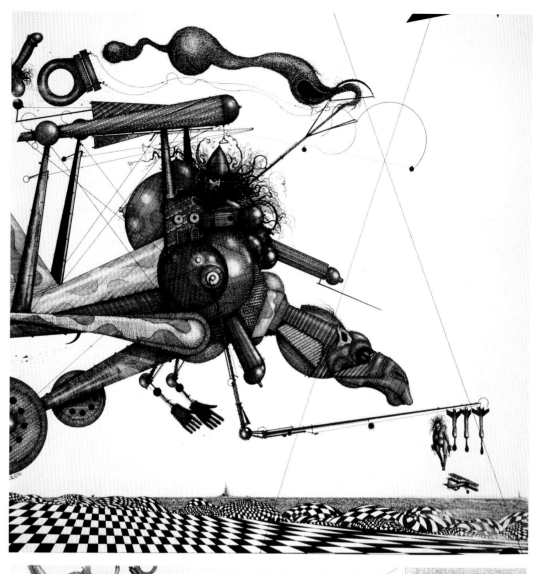

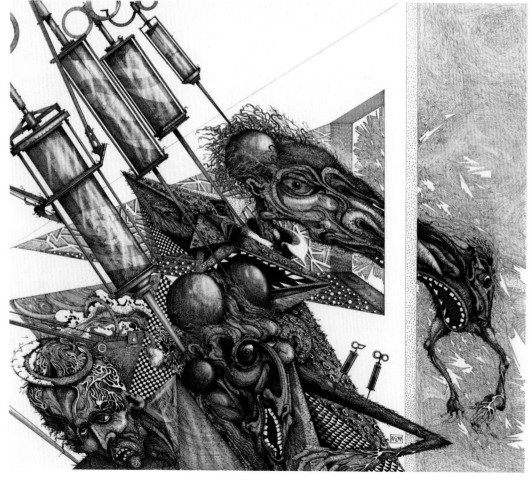

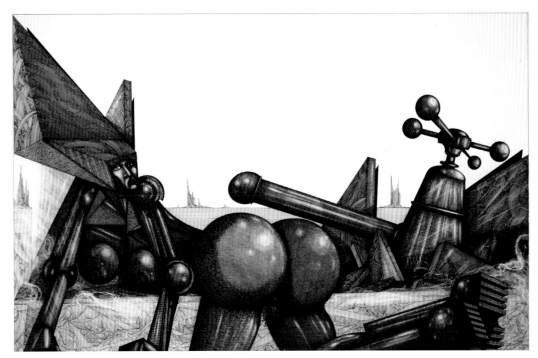

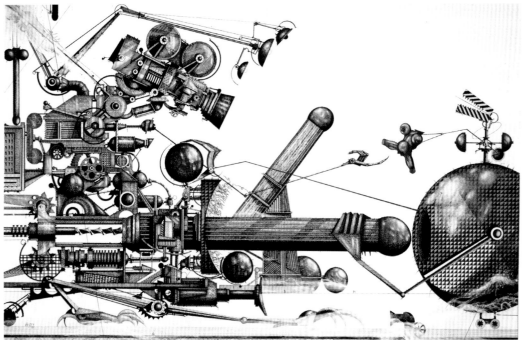

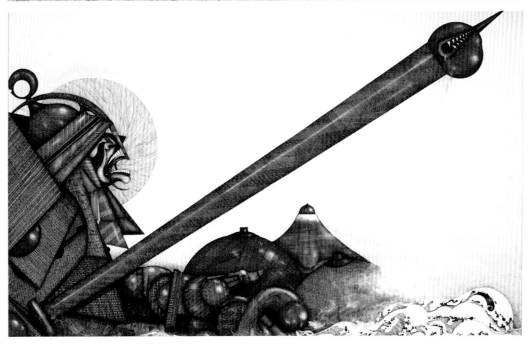

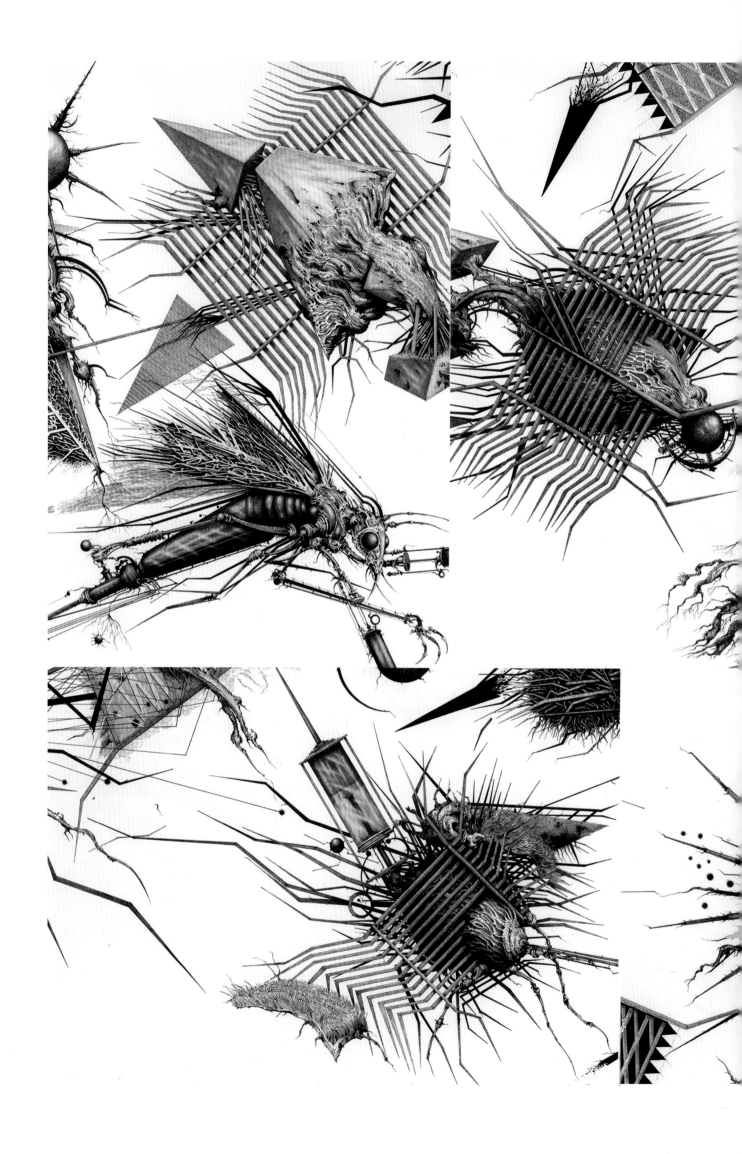

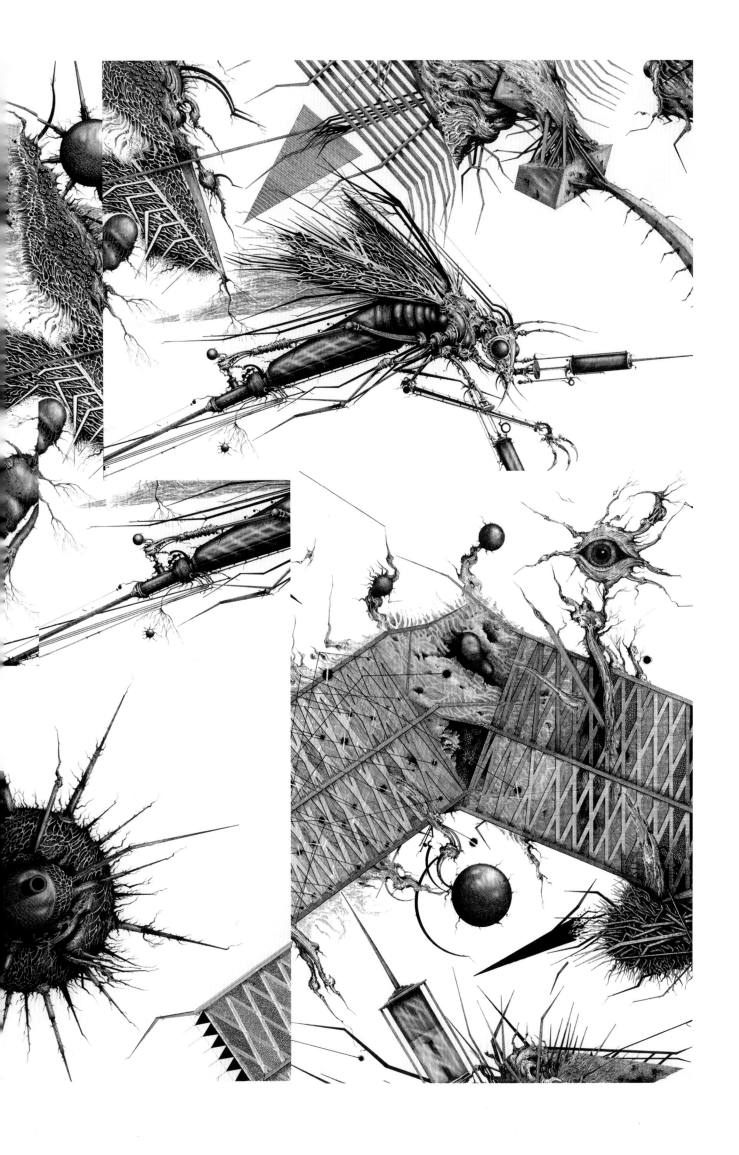

ALSO AVAILABLE FROM TITAN BOOKS

The Art of John Harris is a stunning new collection of his world-renowned futuristic art, capturing the Universe on a massive scale, from epic landscapes to alien vistas. Also included are his striking book covers for esteemed SF authors including John Scalzi, Orson Scott Card, and Jack McDevitt.

This is a must have for any SF fan!

FOR MORE INFORMATION VISIT WWW.TITANBOOKS.COM